The Geography of Taste

THINKING ART

Series Editors
Noël Carroll and Jesse Prinz, CUNY Graduate Center

Thinking Art fills an important gap in contemporary philosophy of art, focusing on cutting edge ideas and approaches to the subject.

Published in the Series:

The Geography of Taste

DOMINIC MCIVER LOPES,
SAMANTHA MATHERNE,
MOHAN MATTHEN, AND
BENCE NANAY

OXFORD
UNIVERSITY PRESS

OXFORD
UNIVERSITY PRESS

Oxford University Press is a department of the University of Oxford. It furthers
the University's objective of excellence in research, scholarship, and education
by publishing worldwide. Oxford is a registered trade mark of Oxford University
Press in the UK and certain other countries.

Published in the United States of America by Oxford University Press
198 Madison Avenue, New York, NY 10016, United States of America.

Library of Congress Cataloging-in-Publication Data
Names: Lopes, Dominic. Cultures and values. | Matherne, Samantha.
Beyond the either/or in aesthetic life. | Matthen, Mohan. Emergence of tastes. |
Nanay, Bence. Everyday aesthetic injustice.
Title: The geography of taste / Dominic McIver Lopes, Samantha Matherne,
Mohan Matthen, and Bence Nanay.
Description: New York, NY : Oxford University Press, [2024] | Series: Thinking art |
Includes bibliographical references and index. | Contents: The emergence of tastes /
Mohan Matthen—Cultures and values / Dominic McIver Lopes—Beyond the either/or in
aesthetic life : a new approach to aesthetic universality / Samantha Matherne—Everyday aesthetic
injustice / Bence Nanay—Discussion : the allure of universals and how far we should resist it?
Identifiers: LCCN 2023044248 (print) | LCCN 2023044249 (ebook) |
ISBN 9780197509067 (hardback) | ISBN 9780197509074 (paperback) |
ISBN 9780197509098 (epub)
Subjects: LCSH: Aesthetics. | Culture.
Classification: LCC BH301.C92 G46 2024 (print) | LCC BH301.C92 (ebook) |
DDC 111/.85—dc23/eng/20231122
LC record available at https://lccn.loc.gov/2023044248
LC ebook record available at https://lccn.loc.gov/2023044249

DOI: 10.1093/oso/9780197509067.001.0001

Paperback printed by Marquis Book Printing, Canada
Hardback printed by Bridgeport National Bindery, Inc., United States of America

MIX
Paper from
responsible sources
FSC
www.fsc.org
FSC® C103567

To our interlocutors, Whitney Davis,
Joshua Landy, and Jennifer Lena

Contents

Acknowledgments

We would like to thank the Jackman Humanities Institute at the University of Toronto and the *Canadian Journal of Philosophy* for supporting a workshop dedicated to a draft of this volume. We also thank Whitney Davis, Joshua Landy, and Jennifer Lena for carefully reading and constructively commenting on our work.

Introduction

Cultural Diversity: A Challenge and an Opportunity for Aesthetics?

Let's set a scene. A globetrotting scholar lands in a city on another continent and has a free evening to pass. She does not know the language or the people, but she's an accomplished musician who loves live music. The concierge finds her a performance he says everybody in the city is excited about. It's an inspired choice. She thoroughly enjoys herself: The melodies are intriguing, though the scales and rhythms are completely new; the performers' hands and fingers fly, and she is awestruck by their evident virtuosity; the voices, though very foreign sounding, are haunting. She feels that she has had a privileged glimpse into the musical culture of people in this new country.

The next day she converses with her local acquaintances and finds some who were at the same performance. They too loved what they heard, but they say a lot that she's completely unable to assess. They were thrilled by the boldness of the performance, which, they say, was a challenge to tradition. They get into a spirited debate about the singing; all agree that it was gorgeous, but many say that one of the singers was not properly trained. As for the instrumental players, everybody agrees that they were bit showy. So the conversation goes. Our globetrotter cannot contribute to it, except to say that she loved what she heard.

If she had had the opportunity to probe deeper, our scholar would have encountered other differences. Her local friends find the progressions in one of the performed pieces evocative of the

The Geography of Taste. Dominic McIver Lopes, Samantha Matherne, Mohan Matthen, and Bence Nanay, Oxford University Press. © Oxford University Press 2024. DOI: 10.1093/oso/9780197509067.003.0001

early morning; she just found them strange, though calm and pleasant. She finds some of the rhythms in this piece overly simple; they think it complemented the slow progression of dawn. The music employs a range of devices that affect her differently than those who grew up around here. She has a well-trained ear, and she can easily identify and re-identify the elements of this music as she listens. Yet she doesn't understand the compositions and doesn't react to them as the denizens of this foreign country do.

Today, this scene would be commonplace. Some centuries ago, it was unfamiliar enough that travelers expressed their alienation without self-consciousness; some were apt to be condescending or even disparaging (see Chapter 1 for some examples.) Today's globetrotters are more willing to be pleased. Either way, their appreciation of the foreign form is assisted by knowledge of their own music, but they cannot truly appreciate its depth. Much the same kind of thing can be said of other artistic media—such as literature, painting, and dance—as well as aesthetic practices of cooking, gardening, and personal ornamentation.

Of course, we find geographical and temporal variation of taste in a wide range of contexts. We find it in the appreciation of natural beauty and landscapes. Generally speaking, people cannot appreciate the subtleties of unfamiliar natural scenes: There are subtle differences among snowfalls that make some inviting and others frightening to those who live in Arctic regions, though they may all look the same to someone who has lived her life in Sri Lanka. By the same token, as Allen Carlson says, "knowledge about . . . the functional utility of cultivating huge fields devoted to single crops" can lead us to appreciate "the vast uniform landscapes that are the inevitable result of such farming practices" (2000: xiv–xv). Nevertheless, as we all argue, cultural variation has a more ramified effect on the appreciation of the arts and aesthetic practices centered on artifacts. We'll return to this a bit later.

One more point about our globetrotter. She's in an unfamiliar country, and this is at least a part of why she is disoriented.

However, the same sort of thing could have happened to her at home. She could be very familiar with the devotional music of her own country, but not with folk dance. If she happened to attend a performance of folk dance at home, she would find herself in a similar position of superficial appreciation. Artistic and aesthetic cultures are propagated within communities, and in this case, two distinct communities coexist within a shared geographical region, albeit overlapping and influencing each other on account of their proximity. This is typical. Coherent national or sub-national cultures such as those of Quebec or Rajasthan accommodate multiple artistic communities, each of which might show the marks of an encompassing ethos marked by climate, history of colonial domination, shared religious beliefs and rituals, and so on. Of course, there are many more distant connections as well, especially in the intensely interconnected contemporary world. Some global networks are vestiges of what were local communities; diaspora is an afterimage of geography. Some aesthetic and artistic communities are created and subsist entirely in the social media, occupying virtual spaces that our globetrotter might find as strange and unfamiliar as any she might find as she travels abroad.

Of course, there are things one can appreciate generically. After all, music is music, and storytelling is storytelling. Something of the narrative of the *Ramayana* can be appreciated by someone thus far familiar only with Homeric epics or the Harry Potter series; the flavors of Keralan cooking can affect an untraveled denizen of Spain. We all want to acknowledge this. The point that we would, nevertheless, want to insist on is that there is more to our artistic and aesthetic endeavors than these basic elements. A song is not effective simply because a chord progression is "fitted by nature" (as Hume says) to evoke some appreciative response. It's effective largely because people familiar with its genre appreciate specifically how it employs devices such as chord progressions to evoke appreciation. The idea is encapsulated in the North Indian expression of appreciation for musical flourishes and ornaments: *wah-wah*. This

exclamation doesn't just express appreciation; it says: "That's exciting, and I see exactly what you are doing to make it so."

This makes it difficult to explain our globetrotter's predicament. When we say merely that it's rooted in unfamiliarity and lack of exposure, we leave it open whether natural human capacities suffice for the appreciation of art. Think again of the untraveled Sri Lankan exposed to snowfall in Tuktoyaktuk. After a while, she adds newly acquired knowledge of snow to her previous familiarity with tropical rain. But artistic creations and performances have qualities that cannot, it seems to us, be comprehended independently of the genre. The globetrotter does not ultimately acquire an umbrella expertise that covers both her native culture and the one she has traveled to—a knowledge that would enable her to judge them side by side. These creations are not beautiful just in themselves, or without qualification for all human beings qua human. They are beautiful at least in part because of how the artist uses the expressive style of their particular genre, a style she assumes her audience will recognize. It remains to explain how taste depends on this. How shall we understand the local variability of taste?

1. Diversity

This book explores aesthetic and artistic diversity. More precisely, it explores the causes, nature, and practical significance of that kind of diversity. Our globetrotter experiences the performance very differently from the local who happens to be sitting next to her. What *constitutes* the difference? Is it a perceptual difference? An evaluative one? One concerning judgment? How might any of these add up to a social difference? What are the *origins* of the difference? Her perceptual history? Her values? Her belief system? Her peers? And what *follows* from the difference? What should she do? Try hard to experience the performance the way other audience members do? Attend a local conservatory? And finally, what are the theoretical

implications of answers to these questions about the constituents, origins, and consequences of aesthetic and artistic diversity? Should we revise aesthetic theory in light of it? If so, how?

Given the centrality of diversity to all these questions, more needs to be said about what kind of diversity is at play here. First of all, diversity could be seen as collective or individual. Our globetrotter and the spectator sitting next to her have different experiences just in as much as they differ personally. At the same time, there are some collective patterns of difference: People from Western Europe might have different experiences of the performance from those who grew up in South India.

One simple distinction contrasts cross-cultural with interpersonal diversity. The two are clearly related, but it's not entirely obvious how. Might differences between the experiences of individuals be explained by cross-cultural diversity? Or perhaps cross-cultural diversity is to be explained as an aggregate of individual differences?

The focus of this book is on cross-cultural diversity, but we do not want, for now, to commit to a specific understanding of culture (the first two chapters propose slightly divergent understandings of culture). All we assume here is that there are some group-level patterns in reactions to art and other aesthetic phenomena. Someone might react in ways that are similar to those with whom they share a (perceptual, historical, national, or other) background and in ways that are dissimilar to those with different (perceptual, historical, national, or other) backgrounds. There are many intriguing questions about interpersonal differences that will not count as cross-cultural—for example, differences in engagement between people of different ages, genders, and sexual orientations. This book does not focus primarily on differences among people that cannot be traced to culture.

These observations about diversity are somewhat general: They could be applied to any phenomenon, not just aesthetic and artistic ones. We need to make more distinctions about aesthetic and

artistic diversity, in particular—that is, the diversity of what we find beautiful or splendid or elegant (and so on). Very simply, we can distinguish diversity in aesthetic objects themselves, whether these be natural or human-made, in the production of the artifacts and in the experience of them.

Each object of aesthetic or artistic regard belongs to what we might call a "genre"—a distinctive style of work produced by and for a community. As our globetrotter demonstrates, it is possible to enjoy such an object without specific knowledge of the genre to which it belongs, given only knowledge of standard culture-crossing features: In music, these would include elemental features of pitch, meter, and timbre, for example. Familiarity with these culture-crossing features does not suffice for full appreciation, however. Appreciation from outside a genre is always shallower than that available to people who are at home in it. Every genre has its insiders and outsiders, and insiders find more to relish or criticize, with the consequence that outsiders' appreciations are shallower. This might seem obvious. What isn't immediately clear is how the insider differs from the outsider. The difference isn't just a matter of knowing the tropes of the genre. It's at least partially affective, and it is harder to understand how culture brings about this kind of change. It seems that for each genre and for each individual, becoming an insider is a unique process of acculturation to the norms, nuances, traditions, and expectations of that genre. This book explores artistic and aesthetic genres in order to contribute to an understanding of both the cultural and the individual processes through which they are formed.

The diverse effects of aesthetic objects are widely studied in the empirical sciences, where a great deal of research concerns what are often referred to as "aesthetic universals." The question is this: Are there any features of aesthetic objects that trigger the same reaction in any and all observers, regardless of their individual or collective differences? Or does every feature trigger different reactions depending on the observer's background?

Important research in cross-cultural empirical aesthetics considers whether some simple aspects of music are cultural universals. On the one hand, in all cultures, healing songs have slower tempos and comparatively flat melodies, with pitches closer together, whereas love songs are faster in tempo and have comparatively less flat melodies (Mehr 2019). On the other hand, it has been argued that tonality, which was historically the most promising candidate to be a cultural universal, is not in fact universal. For example, Tsimané subjects, who live in the Amazonian rainforests, do not have a preference for tonal music (McDermott et al. 2016).

Another focus of cross-cultural empirical aesthetics concerns pictorial organization. The question here is whether some (often formal) features of pictures, such as symmetry, are cultural universals. It appears that symmetry is indeed evaluated, other things being equal, as positive by all observers from all cultural backgrounds. Other features—for example, complexity—are aesthetically relevant in all cultures, but they are evaluated as positive in some and as negative in others (see Berlyne [1971] for an influential summary). An especially promising candidate for an aesthetic universal is inward bias, the tendency to depict people (and actions) facing toward the center of an image and not toward its frame (Chen and Scholl 2014; Chen, Colombatto, and Scholl 2018). Note that the existence of culture universals does not presuppose that the propensity to favor some features and not others is innate. It might stem, instead, from the occurrence of a common environmental feature, such as the blueness of the sky (Child 1965; cf. Eysenck 1983).

Diversity in the features of objects is not the same as diversity in the mental states of their creators and appreciators. Supposing that symmetry or tonality turn out to be cultural universals, people might make or appreciate symmetrical compositions or tonal melodies for very different reasons or intentions, depending on their cultural background. In other words, symmetry may be

valued in all cultures, but its significance may vary with the cultural setting.

What mental states of producers might depend on their cultural background? The most widely discussed answer is the "artist's intention," what the artist wants to achieve by making the artwork. Artists' intentions also vary within a culture, but they vary even more profoundly across cultures.

Although more has been said in contemporary aesthetics about artists' intentions than about other mental states that are relevant in the creation of artifacts, intentions are only one of many types of mental states that go into the production of artifacts and that vary across cultures. They are also important sources of aesthetic diversity. Examples include background assumptions and knowledge, value assignments, and many seemingly more mundane processes, such as perception, attention, mental imagery, and emotion. All of these play into what artifact is produced and how it is produced, and all can be influenced by the producer's cultural background. There is no shortage of cultural diversity in terms of the producer's input.

Some aspects of artistic creation might not, of course, vary across cultures. Most artists have approximately five fingers with an opposable thumb on each hand, and this physiology constrains what an artist can do no matter what their culture. Less trivially, some features of human motor cognition and perception are the same without regard to the artist's origins. Nonetheless, given what we know about the human mind, it is safe to say that many mental states implicated in artistic creativity depend on our background beliefs, assumptions, and perceptual history, all of which are influenced by cultural factors.

Finally, aesthetic production and engagement is not limited to the arts. We engage aesthetically with nature, with non-artistic writing and ideas, with industrial design, urban and domestic space, the body and its adornment, just for a start (e.g., Carlson 2000; Saito 2007; Irvin 2016). Hence, to the forms of aesthetic diversity that have to do with art (the effects of various features of

artworks and the artist's intentions and other mental states), we can add another source of aesthetic diversity, namely diversity in aesthetic engagement, be it of artworks, nature, or everyday life. Even if we find that some features of artworks have universal effects and even if we find some cultural universals in the creation of artworks across cultures, there remains a further source of cultural diversity that stems from the reactions that make up aesthetic engagement. This source of cultural diversity applies not only to our aesthetic engagement with artworks but also to our engagement with natural and everyday scenes.

Obviously, little light can be shed on diverse engagement to natural scenes by cultural variation in artists' intentions and other mental states—an Alpine landscape was not created by an artist. Moreover, the importance of potentially universal features of objects, such as symmetry or tonality, is also limited here. Yet there can still be, and in fact there still is, significant diversity in how people of different cultural backgrounds react to Alpine landscapes, for example. The same is true of everyday scenes, such as the diagonal swath of sunshine irradiating a crumbling wall.

In many ways, this form of aesthetic diversity is the most important one, because it has the widest scope. It's also what was at stake in our original example of the globetrotter, whose aesthetic engagement contrasted with that of the person sitting next to her. What needs to be emphasized is how cognate differences in aesthetic engagement also occur outside the art world. Had our globetrotter taken a journey on a slow boat through the Kerala backwaters, her aesthetic experience would still have been very different from that of locals familiar with the passing scenery.

Acknowledging all these forms of aesthetic diversity should be the starting point of any attempt at understanding the geography of taste. Only just a starting point. Many more questions clamor for attention. Is the mismatch—sometimes the necessary mismatch—between the aesthetic engagement of people from different cultures something we can ever overcome? Is it something we should

overcome? And what ideological considerations should we keep in mind in answering these questions?

2. The History of European Aesthetics and Its Biases

Although these (and other) dimensions of aesthetic diversity and the geography of taste are by no means the purview of philosophy alone, we approach them in this volume through our respective philosophical lenses. We believe that philosophy promises to shed valuable light on these issues, though we acknowledge that we're also proceeding in the shadow of various traditions in philosophical aesthetics that haven't always acknowledged the importance of aesthetic diversity.

If we cast our glance back to the rise of philosophical aesthetics in Britain and continental Europe in the work of thinkers such as David Hume, Edmund Burke, Immanuel Kant, and G. W. F. Hegel, we see that although the fact of aesthetic diversity was by no means denied, it was situated in philosophical frameworks that privilege universality over diversity.

Let's begin with Hume. Hume opens "Of the Standard of Taste" (1985b [1757]; hereafter "ST") by acknowledging aesthetic diversity:

> The great variety of taste. . ., which prevails in the world, is too obvious not to have fallen under every one's observation. Men of the most confined knowledge are able to remark a difference of taste in the narrow circle of their acquaintance, even where the persons have been educated under the same government, and have early imbibed the same prejudices. But those, who can enlarge their view to contemplate distant nations and remote ages, are still more surprised at the great inconsistence and contrariety. (ST 226–267)

Here, Hume cites cross-individual and cross-cultural aesthetic diversity as an "obvious" fact. But rather than devoting the essay to an analysis of the nature, sources, and consequences of aesthetic diversity, he argues that in spite of such diversity, there is nevertheless a "standard of taste" that tracks "universal beauty": beauty that should appeal to any human being, regardless of individual or cultural differences (ST 233). He aligns this standard with the "joint verdict" of "true" judges of "so rare a character," whose taste is marked by "strong sense, united to delicate sentiment, improved by practice, perfected by comparison, and cleared of all prejudice" (ST 241).

When Hume does address aesthetic diversity, he often treats differences in taste as an initial starting point that tends to melt away as one is exposed to more and more art: "though prejudices may prevail for a time, they never unite in celebrating any rival to the true genius, but yield at last to the force of nature and just sentiment" (ST 243). Some differences remain, he allows: Young men, for instance, are more moved by "amorous" images than older men, who tend to "take pleasure in wise, philosophical reflections concerning the conduct of life and moderation of the passions" (ST 244). Nevertheless, Hume assumes that taste is grounded in universal human nature. This has the effect of backgrounding culture. For if we were to grant to Hume that beauty involves qualities that are "fitted by nature" to produce in *any* human the same "sentiments" of appreciation, then it would follow that cultural differences are, to use his phrase, merely "peculiarities of manners." It is from this universal perspective of what is "fitted by nature" to pleasure, rather than a local perspective attuned to culturally situated genres, styles, and practices, that Hume thinks we should ultimately evaluate art. For him, the standard of taste provides us with a comparative framework in which we can "assign . . . proper rank" to all works of art in a particular medium, simply as music or as painting, setting aside the local "peculiarities" relevant to how it was produced (ST 238).

Were Hume to assess our globetrotter, he would most likely say that her discriminatory abilities and delicacy of taste are inferior only because she has not been sufficiently exposed to local musical forms. Given enough time and commitment, however, he would predict that the globetrotter's taste would expand to assimilate that of the locals, yet remain an exercise of the same universally shared capacity for taste that she had employed before.

Hume posits this process of assimilation in order to account for what he takes to be a "standard of taste," a standard for judging a great author such as Milton more worthy of approbation than a slighter writer such as Ogilby (to use his example). However, the consequence of his analysis is that (assuming an adequate discriminative capacity) the globetrotter would, given adequate exposure, acquire an ability to respond to music not just as an exemplar of the genre to which it belongs, but just as music. After due exposure, then, she would be able to listen to Ravi Shankar's Raga Bhairav and Mozart's Piano Concerto no. 21 side by side without any adjustment of her underlying aesthetic attitudes. She would simply respond to one more deeply than the other; one would be "better." It's unclear to us that this is the right outcome. Works of art are fully understood, and hence fully evaluated, only in the context of the genre in which they were created.

Now, it is an unfortunate fact that Hume was a racist, as evidenced, for example, by his essay "Of National Characters" (1985a [1757]), which is a compendium of degrading, clichéd generalizations about ethnic groups. Given his Euro-superior assumptions, his comparative framework leads him to judge foreign music as embodying "a different set of customs" that the globetrotter would have to adjust to: "a man of learning and reflection can make allowance for these peculiarities of manners" (ST 245). Once such allowances have been made, however, given Hume's comparative assumptions, he would predict that the globetrotter would rapidly come to judge any differences from European forms to be imperfections. In this vein, it seems the

music heard in lands outside Europe would be judged "not entirely destitute of harmony or nature," but as having "great inferiority" that would only "affect the mind of a peasant or Indian with the highest admiration" (ST 238).

As vicious as his racist and Euro-centric assumptions are, our primary concern here is to highlight the position that brings Hume to his treatment of aesthetic diversity and to his narrow-minded assessment of cultures outside Western Europe—the idea that music, literature, and the other fine arts can be assessed from a universalist perspective.

Or, to take another moment in the modern European tradition, consider how issues of aesthetic diversity are configured in Hegel. In the early nineteenth century, Hegel delivered a series of lectures on aesthetics that are rife with detailed consideration of the diverse ways in which art and art forms, such as architecture, painting, and music, manifest in different cultures over time (1975 [1835]). Page after page is filled with analysis of specific artworks and practices that arose in ancient Egypt, India, Greece, and Rome, as well as in the Middle Ages, Renaissance, early modern, and modern periods in Europe. In so far as he chooses to develop his philosophical aesthetics by way of close engagement with how art is configured in different cultural contexts, Hegel acknowledges the importance of aesthetic diversity. Indeed, unlike Hume, who takes the fact of aesthetic diversity for granted, Hegel endeavors to explain it. However, he situates this explanation in a larger argument to the effect that these cross-cultural developments are ultimately manifestations of an "absolute" spirit (*Geist*) that is progressing toward "absolute" truth on a world-historical scale. He also analyzes art forms in terms of how cultures deploy architecture, painting, music, and the like in ways that advance ever closer to the ideal of a work of art that presents "absolute" truth in sensuous form. The progressive narrative Hegel offers is one in which the art of Greece represents an advance over art from the cultures, nations, and peoples of ancient Egypt and India. For Hegel, forms of aesthetic diversity are

not on a par: Certain forms are privileged from the point of view of the absolute.

For all their differences, we find in Hume's and Hegel's treatments of aesthetic diversity a certain set of assumptions prevalent in the modern philosophical tradition they belong to. For one thing, they assume that there's something that all human beings share in common, whether it be the makeup of the mind or "absolute spirit," which transcends whatever cross-individual and cross-cultural differences there are between us. For another thing, they situate discussions of aesthetic diversity in a larger philosophical theory in which this universal or absolute element is normatively privileged. In this vein, they index aesthetic norms and taste to something that transcends any particular individual or culture. This universalism is, in turn, coupled with assumptions about comparability, according to which works of art from different cultures are to be evaluated not in light of practices or genres (understood as merely local accidents of creative technique), but rather in terms of a "standard of taste" indexed to universal art forms, such as painting, music, and the like. This through line in Hume and Hegel is representative of a central tenet of much modern philosophical aesthetics: True taste has no geography; it has its source in and normative inflection from what holds for human beings universally.

This universalism was challenged even in its day. Alexander Gerard, for example, exposed Hume's assumption that true judges from different cultures are apt to converge in their verdicts: "there are regions in the East, exceeding Europe in extent, and in the number of their inhabitants, who have never given their suffrage in favor of these works [Hume's masterpieces]" (1759: 232). In *A Vindication of the Rights of Men* (1790), Mary Wollstonecraft challenged the sexist assumptions underwriting Edmund Burke's (1757) theory of the beautiful and the sublime. In the German context, Johann Gottfried Herder championed a theory of aesthetic pluralism (see Zuckert 2019).

Starting in the mid-twentieth century, the criticism intensified, and the tradition was challenged on the grounds of its ideology—the charge was that the tradition is not merely mistaken but based in self-interested dogma designed to justify imperial conquest and oppression. According to this ideological critique, far from having uncovered a genuinely universal source and normative standard of taste, the aesthetic theories of Hume, Kant, Hegel, and the like illicitly treat as universal the taste of groups dominant in the unequal power structures pervasive within modern Europe and imposed by force of conquest abroad.

Famously, in *Distinction: A Social Critique of the Judgement of Taste*, the sociologist Pierre Bourdieu argued that modern aesthetic theories, notably Kant's, turn on a "universalization of the dispositions associated with a particular social and economic condition," namely the condition of cultural capital possessed by the dominant class in a society (1984: 493; see also Lena 2019). In *The Ideology of the Aesthetic* (1990), Terry Eagleton later argued that the universal subject of taste championed in the modern period amounts, in fact, to the bourgeois subject struggling for political dominance (see also Horkheimer and Adorno 1972 [1947]; Adorno 1984 [1970]; Marcuse 1978; Mattick 1990). Rather than alighting on the taste of a universal subject, the taste defended in modern European philosophy tracks the preferences of a dominant social class interested in using the aesthetic to mark their "distinction" from other classes.

In addition to classist ideology, texts such as Frantz Fanon's *Wretched of the Earth* (2004 [1961]), Edward Said's *Orientalism* (1978) and *Culture and Imperialism* (1993), Homi Bhabha's *The Location of Culture* (1994), and Gayatri Spivak's *A Critique of Postcolonial Reason: Toward a History of the Vanishing Present* (1999) paved the way for thinking through the colonialist and imperialist ideology underwriting this aesthetic tradition. Seen from this perspective, the modern European aesthetic tradition centers and privileges the taste of the European subject, while othering and

denigrating the taste of non-European subjects. For example, when citing canonical examples of "universal beauty," the touchstone for the modern aesthetic theorist is typically Eurocentric: Homer, Sophocles, Polykleitos, Milton, Cervantes, Shakespeare, French cathedrals, Dutch Masters, and the like. When aesthetic objects from non-European traditions are considered, they are often denigrated as falling outside the realm of beauty or even art. Hegel, for example, describes the aesthetic products of ancient India and Egypt as "pre-art" (2004: 74). Beyond this canon formation, however, there is a Eurocentrism built into accounts of differences in taste, which upholds European taste as "true" or "pure" and denigrates non-European taste as "savage" or "barbaric." This difference in taste is, in turn, couched in developmental stories, according to which taste progresses as it moves from a "savage" or "barbaric" state outside Europe to the "refined" and "cultured" state within Europe—a narrative exemplified on a world-historical scale in Hegel's aesthetics.

As many theorists have emphasized, the colonialist and imperialist ideology that shapes this modern philosophical aesthetics is accompanied by a racist ideology that invokes an aesthetic hierarchy in which the taste and aesthetic practices of white subjects are regarded as normative and representative of what is universal, whereas the taste and aesthetic practices of non-white subjects are regarded as deviant (see Wynter 1992; Bindman 2002; Roelofs 2014). Calling attention to the unjustness of this hierarchy, James Baldwin writes

> The South African coal miner, or the African digging for roots in the bush, or the Algerian mason working in Paris, not only have no reason to bow down before Shakespeare . . ., or Westminster Abbey, or the cathedral at Chartres: they have, once these monuments intrude on their attention, no honorable access to them. Their apprehension of this history cannot fail to reveal to them that they have been robbed, maligned, and rejected: to bow

down before that history is to accept that history's arrogant and unjust judgment. (1972: 47)

Still other critics have examined how much modern philosophical aesthetics is inflected with ideologies bound up with gender and sexuality. In this vein, some critics take up Wollstonecraft's line of critique, arguing that traditional aesthetic categories are underwritten by sexist assumptions, according to which, for example, beauty is a function of properties like weakness, delicacy, and smallness that are the proper purview of women. Feminist philosophers, such as Peg Brand (Weiser), Hilde Hein, and Carolyn Korsmeyer, have continued to develop this critique, exposing the aesthetic implications of essentialist theories of gender and assumptions of heterosexuality that underwrite the theories of taste, aesthetic categories, and aesthetic examples defended in much modern philosophical aesthetics (see Hein and Korsmeyer 1993: Part IV; Brand and Korsmeyer 1995: Part I; Schott 1997; Korsmeyer 2004). In another vein, in *Queer Beauty* (2010), the art historian Whitney Davis has examined how modern philosophical aesthetic theories, such as those of Kant and Hegel, borrow a classical ideal of beauty from the ancient Greek context that suppresses the homoerotic ideals that were inflected in the Greek ideal (an inflection that their predecessor Johann Joachim Winckelmann had not failed to see).

Throughout these various ideological critiques, we find a suspicion that much modern philosophical aesthetics problematically privileges aesthetic universality over aesthetic diversity. On this critique, not only was this privileging a matter of an illicit universalization of the taste of a dominant group in an unequal power structure, but also it served as a means through which the taste of non-dominant groups was marginalized, oppressed, or excluded.

We take it as foundational to our project that a philosophical effort to understand aesthetic diversity needs to acknowledge how classist, colonialist, imperialist, racist, sexist, and heteronormative

prejudices shaped much modern philosophical aesthetics. Moreover, these ideological critiques raise important questions as to how contemporary philosophical aesthetics, in light of its past, can proceed appropriately with respect to aesthetic diversity.

3. Recent Aesthetics

Recent aesthetics has inherited the European tradition's ambivalence about cultural diversity in the arts and other aesthetic genres. Diversity is not denied, of course, but it simply doesn't come up in such foundational texts as Monroe C. Beardsley's *Aesthetics* (1958), Frank Sibley's influential essays of 1959 and 1965, or Richard Wollheim's *Art and Its Objects* (1968). Others did assign a role in aesthetic and artistic creation and appreciation to what is usually labeled "context." For the most part, though, "context" figures as a placeholder, standing for something significant, evidently social, that is not given anything close to a full theoretical treatment. In retrospect, appeals to context in aesthetics are missed opportunities, hence invitations to future inquiry.

A good example is Nelson Goodman's *Languages of Art* (1976). Goodman provides a systematic characterization of the broadest artistic genres. Imaging, music, dance, and literature: Each of these makes use of a symbol system with distinctive semantic and syntactic features. For example, musical scores are syntactically and semantically disjoint and differentiated—each mark belongs to no more than one symbol, which represents no more than one element in the domain, and it is always possible to determine the symbol to which a mark belongs and also which element the symbol represents. By contrast, images are analogue, neither disjoint nor differentiated in these ways. These differences in the symbol systems of modes of art make an aesthetic difference, for Goodman. By contrast, differences within each mode of art are products of arbitrary choices of symbols and what they represent. For example,

both Venetian Renaissance painting and *ukiyo-e* woodblock printing are imagistic, hence analogue; they differ in what symbols represent what features of scenes. This difference is, for Goodman, a matter of habit or custom in a group. Yet he has nothing more to say about the groups, their customs or habits, or the artistic and aesthetic significance of their customs or habits.

The art historian E. H. Gombrich pointed out that one painting can be appreciated in different art genres (1960: 368–370). His example was Piet Mondrian's *Broadway Boogie Woogie* of 1940. *Broadway Boogie Woogie* is a work of De Stijl, of which Mondrian's grids of black lines are typical, but it is also an example of mid-century abstraction, of which works by Paul Klee and Lee Krasner are more typical. Gombrich observed that, seen as De Stijl, *Broadway Boogie Woogie* gives an impression of "gay abandon," though this is not at all the impression it gives when seen as a work of mid-century abstraction. The conceit is to probe the difference that genre makes by considering an actual or imaginary genre crossing work. Three of the most influential papers in aesthetics of the second half of the twentieth century use genre crossing works to demonstrate the significance of something along the lines of social context.

In "The Artworld," Arthur Danto (1964) reports his first encounter with Andy Warhol's *Brillo Boxes* at the Stable Gallery in New York. He took *Brillo Boxes* to be perceptually and aesthetically indistinguishable from the Brillo boxes in the grocery store. Although the grocery store Brillo boxes had been designed by James Harvey, an abstract expressionist painter, and although Warhol regarded Harvey's design as an aesthetic triumph, Danto thought that Warhol's *Brillo Boxes* could not differ more from Harvey's in meaning and artistic status. To explain this, Danto famously proposed that "to see something as art requires something the eye cannot decry—an atmosphere of artistic theory, a knowledge of the history of art: an artworld" (1964: 580). Surprisingly, Danto never detailed the social infrastructure of art worlds. Moreover, despite

his interest, as a critic, in Chinese painting, he never had much to say, as a philosopher, about art worlds populated by anyone except the cultural elites of Paris and New York. His history of art is just the history of the tradition that culminates in Warhol (see Danto 1997).

Kendall Walton's "Categories of Art" (1970) centers on Picasso's *Guernica*, which we can imagine appreciating either as a painting or as what Walton called a "guernica" (see also Laetz 2010). All guernicas are surfaces with the same colors and two-dimensional shapes as *Guernica*, but some have rolling surfaces, some are sharp and jagged, and so on. Seen as a painting, Picasso's *Guernica* is dynamic; seen as a guernica, it's dull. Isn't *Guernica* actually dynamic, though, and not dull? Walton answers that it's actually dynamic because it's dynamic when seen as a painting and it's correct to see it as a painting and not as a guernica. The genre in which it's correct to appreciate it is ultimately the genre for which it was intended or the genre that's well established in and recognized by the society where it was produced (Walton 1970: 357–358). Again, Walton leaves the nature of social recognition and establishment—as well as the processes that sub-serve them—for others to investigate (e.g., Ransom 2020).

The third headline-grabbing application of Gombrich's conceit is in Jerrold Levinson's paper on "What a Musical Work Is" (1980). Levinson imagines a counterfactual composer, Toenberg, with exactly the same history as Schoenberg, except that he never writes *Verklärte Nacht*. The Toenberg and Schoenberg oeuvres comprise works that have the same sonic structures, but the difference in history will have an artistic or aesthetic impact. For example, "one hears something in Schoenberg's piece by virtue of resonance with *Verklärte Nacht* that is not present in Toenberg's piece—perhaps a stronger reminiscence of Expressionist sighs?" (Levinson 1980: 13). The thought experiment highlights what Levinson calls "contextual differentiation": context matters to appreciation (and therefore composition too). Again, "context" is a placeholder for whatever, historically and socially, makes a difference to appreciation in

addition to sonic structure. Nothing is said about what precisely context is, why it varies, or why its varying matters.

The gap is a product of the use of Gombrich's conceit. The conceit is deployed in opposition to a kind of formalism on which all that matters to appreciation is an item's manifest features. *Brillo Boxes*, *Guernica*, and the inclusion of *Verklärte Nacht* in the Schoenberg oeuvre show that context matters. However, in showing that context matters, they tell us little about what context is and what it is about context that's responsible for its mattering. For that, we must examine the particulars of a variety of social circumstances—that is, social circumstances with social reality. Thought experiments such as those set up by Gombrich, Walton, Levinson, and even Danto (for he handles Warhol as a thought experiment) are the wrong tools to use. An entirely different approach is needed than is provided by Gombrich's conceit.

Happily, since the 1990s, some philosophers have broadened their inquiries in aesthetics to embrace literally "worldly" phenomena, no longer limiting themselves to art in the European tradition for highbrow markets. Gene Blocker (1991), Larry Shiner (1994), David Novitz (1998), Stephen Davies (2000), and Denis Dutton (2000) reconsidered issues in aesthetics by paying attention to Indigenous art. This literature focuses on a pair of related questions. One is whether art is a phenomenon properly limited to the European tradition, or whether the category of Indigenous art might be a colonial imposition that yields a distorted view of Indigenous aesthetic life. A major source of concern is the possibly harmful intrusion of the international art market, and it's this concern that motivates a second focus on authenticity in Indigenous art. The quandary is how to preserve the authenticity of Indigenous art without imposing it in a way that stifles innovation—in other words, what is authenticity such that it permits innovation?

Attention to art around the world isn't the same as attention to the global diversity of philosophical thinking about art and aesthetics. They are doubly dissociable. A scholar might study the diversity of

art among different peoples while ignoring their own perspectives on their art, viewing what they do through the lens of philosophy in the European tradition, in particular. Equally, a scholar might look into South Asian *rasa* theory for the light it sheds on theatrical practice, without paying much attention to South Asian theatrical traditions. In 2007, Susan Feagin edited a special issue of the *Journal of Aesthetics and Art Criticism* dedicated to Global Theories of the Arts and Aesthetics, sparking a growing interest in theory from around the globe (see also Higgins 2017; Higgins, Maira, and Sikka 2017).

Of course, attention to the global diversity of aesthetic thought can be paired with attention to global artistic and aesthetic cultures. Some recent philosophy has sought to reverse the neglect or subversion of artistic and aesthetic cultures outside the European tradition specifically by spotlighting the theoretical resources they have to understand themselves. K. C. Bhattacharyya followed up his reflections on philosophical *svaraj*, or self-rule, with a revisioning of *rasa* theory intended both as a way to understand all beauty and as a way to understand the special character of South Asian art (2011 [1929] and 2011 [1930]). Brand (Weiser), Hein, and Korsmeyer organized a program not only to expose patriarchal thinking about art but also to replace it with a feminist aesthetics that foregrounds women's aesthetic and artistic endeavors (Hein and Korsmeyer 1993; Brand and Korsmeyer 1995). Likewise, Paul Taylor's *Black Is Beautiful* (2016) provides a philosophical framework for thinking about black aesthetic and artistic cultures. As a rule, the literature also champions non-artistic aesthetic culture, in concert with the work of Yuriko Saito (2007) and others on everyday aesthetics.

In sum, for three decades now, philosophers have built on the argument that context makes a difference to appreciation and creation by examining a diverse array of contexts—theoretical ones as well as practical ones. This research gives us rich materials to work with in closing the gap left open by Gombrich's conceit, but

it doesn't actually close the gap. On the contrary, it makes more vivid the need to close it. The field continues to lack a general account of the nature, origin, and significance of "context" at different scales, from the historical, to the social, to the cultural. That is, we still do not know what it is for genres to vary by cultural context. In other words, what is the geography of taste? We still do not know what cognitive and social factors determine the variations, both with respect to making artifacts and also appreciating them. In other words, why does taste have a geography? The significance of context also remains an open question: Is difference a feature or a bug of aesthetic and artistic life? We do know that the tradition of European philosophy strove to downplay the significance of the geography of taste in an attempt to establish its own dominance over the geography. We also know that it's going to be a challenge to think with care and clarity about the significance of the geography of taste unencumbered by the biases that are the legacy of Eurocentrism. For these very reasons, a final question is all the more pressing: Why does the geography of taste matter?

References

Adorno, Theodor W. 1984 [1970]. *Aesthetic Theory*, ed. Gretel Adorno and Rolf Tiedemann, trans. Christian Lenhardt. Routledge.

Baldwin, James 1972. *No Name in the Street*. Dial Press.

Berlyne, Daniel E. 1971. *Aesthetics and Psychobiology*. Appleton-Century-Crofts.

Bhabha, Homi K. 1994. *The Location of Culture*. Routledge.

Bhattacharyya, K. C. 2011 [1928]. "Svaraj in Ideas," *Indian Philosophy in English: From Renaissance to Independence*, ed. Nalini Bhushan and Jay Garfield. Oxford University Press, pp. 102–112.

Bhattacharyya, K. C. 2011 [1930]. "The Concept of Rasa," *Indian Philosophy in English: From Renaissance to Independence*, ed. Nalini Bhushan and Jay Garfield. Oxford University Press, pp. 195–206.

Bindman, David. 2002. *Ape to Apollo: Aesthetics and the Idea of Race in the 18th Century*. Reaktion Books.

Blocker, H. Gene 1991. "Is Primitive Art Art?" *Journal of Aesthetic Education* 25.4: 87–97.

Bourdieu, Pierre. 1984. *Distinction: A Social Critique of the Judgement of Taste*, trans. Richard Nice. Harvard University Press.

Brand, Peggy Zeglin, and Carolyn Korsmeyer, eds. 1995. *Feminism and Tradition in Aesthetics*. Penn State University Press.

Burke, Edmund. 1757. *A Philosophical Enquiry into the Origin of Our Ideas of the Sublime and Beautiful*. Dodsley.

Carlson, Allen. 2000. *Aesthetics and the Environment: The Appreciation of Nature, Art, and Architecture*. Routledge.

Chen Yi Chia, and Brian J. Scholl. 2014. "Seeing and Liking: Biased Perception of Ambiguous Figures Consistent with the 'Inward Bias' in Aesthetic Preferences," *Psychonomic Bulletin and Review* 21.6: 1444–1451.

Chen Yi Chia, Clara Colombatto, and Brian J. Scholl. 2018. "Looking into the Future: An Inward Bias in Aesthetic Experience Driven Only by Gaze Cues," *Cognition* 176: 209–214.

Child, Irvin L. 1965. "Personality Correlates of Esthetic Judgment in College Students," *Journal of Personality* 33.3: 476–511.

Danto, Arthur C. 1964. "The Artworld," *Journal of Philosophy* 61.19: 571–584.

Davies, Stephen. 2000. "Non-Western Art and Art's Definition," *Theories of Art Today*, ed. Noël Carroll. University of Wisconsin Press, pp. 199–216.

Davis, Whitney. 2010. *Queer Beauty: Sexuality and Aesthetics from Winckelmann to Freud and Beyond*. Columbia University Press.

Dutton, Denis. 2000. "'But They Don't Have Our Concept of Art,'" *Theories of Art Today*, ed. Noël Carroll. University of Wisconsin Press, pp. 217–238.

Eagleton, Terry. 1990. *The Ideology of the Aesthetic*. Blackwell.

Eysenck, Hans Jürgen. 1983. "A New Measure of 'Good Taste' in Visual Art," *Leonardo* 16.3: 229–231.

Fanon, Frantz. 2004 [1961]. *The Wretched of the Earth*, trans. Richard Philcox. Penguin.

Feagin, Susan, ed. 2007. Special Issue on "Global Theories of the Arts and Aesthetics," *Journal of Aesthetics and Art Criticism* 65.1: 1–146.

Gerard, Alexander. 1759. *An Essay on Taste: With Three Dissertations on the Same Subject by Mr. De Voltaire, Mr. D'Alembert, and Mr. De Montesquieu*. Millar, Kincaid, and Bell.

Gombrich, E. H. 1960. *Art and Illusion*. Phaidon.

Goodman, Nelson. 1976. *Languages of Art: An Approach to a Theory of Symbols*, 2nd ed. Hackett.

Hegel, G. W. F. 1975 [1835]. *Aesthetics: Lectures on Fine Art*, trans. T. M. Knox. Oxford University Press.

Hegel, G. W. F. 2004. *Philosophie der Kunst oder Ästhetik. Nach Hegel. Im Sommer 1826. Mitschrift Friedrich Carl Hermann Victor von Kehler*, ed. Annemarie Gethmann-Siefert and Bernadette Collenberg-Plotnikov. Wilhelm Fink Verlag.

Hein, Hilde and Carolyn Korsmeyer, eds. 1993. *Aesthetics in Feminist Perspective*. Indiana University Press.

Higgins, Kathleen. 2017. "Global Aesthetics—What Can We Do?" Journal of Aesthetics and *Art Criticism* 75.4: 339–349.

Higgins, Kathleen, Shakti Maira, and Sonia Sikka. 2017. *Artistic Visions and the Promise of Beauty: Cross-Cultural Perspectives*. Springer.

Horkheimer, Max and Theodore Adorno. 1972 [1947]. "The Culture Industry: Enlightenment as Mass Deception," *Dialectic of Enlightenment*, trans. John Cumming. Herder and Herder, pp. 94–136.

Hume, David. 1985a [1757]. "Of National Characters," *Essays: Moral, Political, and Literary*, ed. Eugene F. Miller. Liberty, pp. 197–215.

Hume, David. 1985b [1757]. "Of the Standard of Taste," *Essays: Moral, Political, and Literary*, ed. Eugene F. Miller. Liberty, pp. 226–249. [ST].

Irvin, Sherri, ed. 2016. *Body Aesthetics*. Oxford University Press.

Korsmeyer, Carolyn. 2004. *Gender and Aesthetics: An Introduction to Understanding Feminist Philosophy*. Routledge.

Lena, Jennifer C. 2019. *Entitled: Discriminating Tastes and the Expansion of the Arts*. Princeton University Press.

Levinson, Jerrold. 1980. "What a Musical Work Is," *Journal of Philosophy* 77.1: 5–28.

Marcuse, Herbert. 1978. *The Aesthetic Dimension: Toward a Critique of Marxist Aesthetics*, trans. Herbert Marcuse and Erica Sherover. Beacon Press.

Mattick, Jr., Paul. 1990. "Beautiful and Sublime: Gender Totemism in the Constitution of Art," *Journal of Aesthetics and Art Criticism* 48.4: 293–303.

McDermott, Josh H., Alan F. Schultz, Eduardo A. Undurraga, and Ricardo A. Godoy. 2016. "Indifference to Dissonance in Native Amazonians Reveal Cultural Variation in Music Perception," *Nature* 535.7613: 547–550.

Mehr, Samuel A. et al. 2019. "Universality and Diversity in Human Song," *Science* 366.6468: 944–945.

Novitz, David. 1998. "Art by Another Name," *British Journal of Aesthetics* 38.1: 19–32.

Ransom, Madeleine. 2020. "Waltonian Perceptualism," *Journal of Aesthetics and Art Criticism* 78.1: 66–70.

Roelofs, Monique. 2014. *The Cultural Promise of the Aesthetic*. Bloomsbury.

Said, Edward. 1978. *Orientalism*. Pantheon.

Said, Edward. 1993. *Culture and Imperialism*. Random House.

Saito, Yuriko. 2007. *Everyday Aesthetics*. Oxford University Press.

Schott, Robin May, ed. 1997. *Feminist Interpretations of Immanuel Kant*. Penn State University Press.

Shiner, Larry. 1994. "'Primitive Fakes,' 'Tourist Art,' and the Ideology of Authenticity," *Journal of Aesthetics and Art Criticism* 52.2: 225–234.

Sibley, Frank. 1959. "Aesthetic Concepts," *Philosophical Review* 68.4: 421–50.

Sibley, Frank. 1965. "Aesthetic and Nonaesthetic," *Philosophical Review* 74.2: 135–159.

Spivak, Gayatri Chakravorty. 1999. *A Critique of Postcolonial Reason: Toward a History of the Vanishing Present*. Harvard University Press.

Taylor, Paul C. 2016. *Black Is Beautiful: A Philosophy of Black Aesthetics*. Wiley.

Walton, Kendall. 1970. "Categories of Art," *Philosophical Review* 79.3: 334–367.

Wollstonecraft, Mary. 1790. *A Vindication of the Rights of Men*. Johnson.

Wynter, Sylvia. 1992. "Rethinking 'Aesthetics': Notes towards a Deciphering Practice," *Ex-Iles: Essays on Caribbean Cinema*, ed. Mbye Cham. Africa World Press, pp. 237–279.

Zuckert, Rachel. 2019. *Herder's Naturalist Aesthetics*. Cambridge University Press.

1

The Emergence of Tastes

Mohan Matthen

1.1. Early Encounters

I begin with some glimpses of cultural discovery that illustrate the
geographical variation of artistic expression and taste that are my
concern in this chapter.

In the thirteenth century, the *Pax Mongolica* of Genghis Khan's
successors eased, or even normalized, travel on the Silk Road that
linked the West—North Africa and Europe—with China and India
and points in between. From this period and up to 1700 or so, we
have more than a dozen surviving accounts of European travelers
who encountered the visual arts, architecture, and music of India
and East Asia innocently, with few preconceptions. These memoirs
are from a time when little was known in Europe about Asian crea-
tive arts. Of course, this is a matter of degree. The longer and harder
the journey, the greater the isolation—the art and music of North
Africa and the Levant would have been more familiar to Europeans
and vice versa. But the inaccessibility of Indian art to Europeans
was not simply a matter of distance. The artistic traditions them-
selves had had little opportunity to mingle. In the Mediterranean
region, both eastern and western, there had been extensive inter-
action, borrowing, and hybridization in all directions (Reynolds
2013). This may well have made the nearer music and visual arts of
North Africa and West Asia objectively less alien to Europeans. The
arts of India and China were very different because for a long time
they had been isolated and evolved independently.

The Geography of Taste. Dominic McIver Lopes, Samantha Matherne, Mohan Matthen, and Bence Nanay,
Oxford University Press. © Oxford University Press 2024. DOI: 10.1093/oso/9780197509067.003.0002

Of course, there had been, for nearly two thousand years previously, well-established routes between Europe and Asia on both land and sea. But though material goods, religions, and ideas had moved back and forth across the Arabian Sea, over the landmass of Central Asia, and through the Khyber Pass for many centuries, it seems that before Marco Polo from Venice and ibn Batuta from Morocco, few non-commercial travelers from the West had had the curiosity or the leisure to observe or enjoy Asian creative arts or to record their knowledge for the benefit of others. Dispersed over East and South Asia, at one end of Eurasia, and over Europe at the other, a multitude of artistic cultures had developed in almost complete isolation from each other. It is only in the thirteenth century that travelers from the West began regularly to take serious notice of these Eastern cultures. And, of course, hybridizing ventures were still a way in the future.

To medieval Europe, India was still a fantasy world populated by "teratomorphous human races" (Braga 2015: 32). Easier and safer travel re-established the sanity of empirical observation. For four hundred years, chroniclers arrived in India with very little prior knowledge about the visual art and music they would encounter. Their naivete marks—or perhaps one should say "stains"—what Partha Mitter (1977: 2) has called the "formative phase in the [European] reception of Indian art." In the first two chapters of his path-breaking study, *Much Maligned Monsters*, Mitter uses these early memoirs to construct what can serve for us as a case study of "innocent" (albeit highly prejudiced) exposure to foreign creative arts.

Mitter's thesis, supported by detailed comparisons between travelers' descriptions and the actual objects they encountered, is that in their "total ignorance of Hindu iconography," these men's perceptions of Indian art were distorted by European stereotypes. In what was presumably a relic of medieval teratological fantasies, they interpreted the multi-limbed deities depicted in Hindu art as "monsters," a class in which "Biblical demons and Indian gods

were all indiscriminately lumped together" (Mitter 1977: 10). Consequently, they viewed a great deal of Indian art as expressions either of devil worship or alternately of mystical religious beliefs indirectly referred to by depictions of monsters.[1] Obviously, such interpretations of Indian religious art go entirely in the wrong direction. Starting with the perception of Hindu deities as monstrously malformed, it draws wildly mistaken conclusions about the meaning and purpose of Indian visual art. This illustrates the difficulties that cultural alienation throws up for artistic appreciation.

Now, it could be said that many of these shortcomings could have been overcome by instruction. If the travelers had viewed Indian art under the guidance of local experts, they wouldn't have relied on inappropriate pre-existing stereotypes. If they could have learned the mythological attributes of Hindu deities, their interpretation would have been less alienating. This is true, of course, but it doesn't fully address the problem. Works of art are not desiccated specimens that exist to be intellectually grasped and catalogued. We enjoy and appreciate them through a complex emotional response. For as Ānandavardhana's *rasa* theory insists, aesthetic experience includes a kind of objectless emotional reaction that renders it not "cold" or *merely* cognitive.[2] Indian Hindus were immersed in a

[1] Mitter refers to a "Neoplatonic tradition of an essentially mystical approach to the image" (1977: 30). This hermeneutic tradition opened the way to a more flattering construal: "The very monstrosities of these images prevented them from being accepted as real and stimulated the mind to seek a higher spiritual significance." Thus, he quotes Pietro della Valle's description of sculpture in a temple in Cambay: "I doubt not that under the veil of these Fables, their ancient Sages . . . have hid from the vulgar many secrets, either of Natural or Moral philosophy." Of course, the esoteric reading of Indian art was no closer to the mark.

[2] A philosophically insightful account of Ānandavardhana's theory can be found in Mysore Hiriyanna (2011 [1954]). Writing about poetry in particular, Hiriyanna says: "the mind of the responsive reader first becomes attuned to the emotional situation portrayed . . . through one or more of the knowing touches which every good poem is sure to contain; is then absorbed in its portrayal . . . and this absorption . . . results in the aesthetic rapture of *Rasa*." Hiriyanna emphasizes a kind of abstractness that Ānandavardhana found in emotional reactions to poetry—this is what I try to capture in my term "objectless." In some ways, it prefigures Kendall Walton's idea that emotional

cultural background that gave these works of art a certain affective resonance—no doubt different for different individuals, but highly formed nonetheless. This could not be re-created by our European travelers. No matter how much they learned about the iconography of depictions of Brahma or Śiva, an Italian or French traveler of the fifteenth century could not possibly experience what a pious, or for that matter, a secular native of the subcontinent would when confronting the sculpture of Elephanta or Hampi. Indian religious visual art expresses a range of emotions, ranging from the devotional to the erotic. In place of these indigenous reactions, the travelers substituted their visceral aversion to polytheism and the naturalistic depictions of superhuman deities.

These reactions were not just a matter of being uncomfortable with the unfamiliar. These men were travelers, after all, in an age where travel was arduous—they were in search of the unfamiliar. Moreover, the thrill of novelty was also known at home. Exotica such as Indian pepper and muslin and Chinese silk and ceramics found not only ready acceptance but lucrative European markets as long ago as Augustan Rome. Equally, European glass was in high demand in Asia in the time of the Han dynasty. But even fifteen hundred years later, the creative arts had not traveled in either direction, at least not since the Seleucids. (Some European techniques and devices had been absorbed by Asians much earlier and developed in their own idiom, for instance, by the Buddhist sculptors at Gandhāra, which show marked Greek influences.) Culturally based affective resonance tells us a lot about this difference. Anybody can find a use for pepper and for silk; they don't need to know anything about its origins. Art does not travel so lightly.

The point is perhaps more immediately clear when we consider a non-depictive art form, music. Our European travelers

reactions to art are "make-believe." The emotional response to art is not a reaction to a real situation.

encountered music like nothing they had heard before.[3] Unlike most imperialists in the eighteenth century,[4] earlier travelers did not scorn foreign music. Many were both curious and respectful; as we'll see in a moment, they even found it somewhat pleasant. But they didn't enjoy it in the way a native might have—there is no trace of Hiriyanna's "aesthetic rapture" (see note 2 above) in their accounts.

To illustrate the alienation of these travelers, here is François Bernier, a French physician who lived and worked in the court of Aurangzeb, describing a *naubat* (or military band):

> In the night, particularly, when in bed and afar . . . the music sounds to my ears as solemn, grand and melodious. This is not to be altogether wondered at, since it is played by persons instructed from infancy in the rules of melody, and possessing the skill of modulating and turning the harsh sounds of a hautboy and cymbal so as to produce a symphony far from disagreeable when heard from afar. (quoted in Brown 2000: 12)

"Particularly when in bed . . . a symphony far from disagreeable." Bernier apparently found the music pleasant, but not so pleasant that he found it rewarding to get out of bed and pay attention. Along similar lines, here is Christopher Farewell, a merchant with the East India Company, who wrote that "the Moors" (i.e., Muslims) don't drink alcohol, except at night, "and then their women, their wives and concubines . . . sing most melodiously, with such elevated and shrill voices, strained to the highest, yet sweet and tunable, rising and falling according to their art and skill, (for every country has its own, and more or less excelling)" (quoted in Brown 2000: 7). He was describing the entertainment of men by women with all its

[3] My recounting of the early European reception of Indian music follows Katherine Brown (2000). Many thanks to Joe Cadagin for the reference.

[4] Not untypical was a Captain Campbell, writing around 1780, who describes Indian music as "inelegant, harsh, and dissonant" (quoted in Hardgrave and Slawek 1989: 1).

erotic overtones. He acknowledges skill within this context. But again, his enjoyment is generic and lacking in nuance. Did he notice the musical ornaments and motifs used? Did he enjoy one singer or one song especially? The quote does not suggest that he did; the music was just a pleasant background to evenings spent drinking.

Now, the music that these men wrote about was not of the highest seriousness. It was made to be part of spectacles with other components—the pomp of the military, the sensuality of the *zanana*. Still, there was purer music to be had, and it is notable that, as Brown writes, "with one exception, there are no incontrovertible descriptions of the most prestigious genres of Indian classical music in the journals published in the seventeenth century, despite the fact that some of the travelers . . . must have been exposed to it at the Mughal court" (2000: 6, n. 10). The one exception she mentions was a highly educated and musically accomplished (and wealthy) Italian, Pietro della Valle (see note 1 above), who described "the excellent music of an Indian who sang quite well" (and offered detailed descriptions of certain instruments, such as the veena): "This pleased me greatly, because it was not strident music like the ordinary playing of the common Indians, but low-voiced and very soft; and the musician was skillful according to the mode of the country (quoted in Brown 2000: 14). Della Valle was perceptive enough to recognize high-art music for what it was. But though he was appreciative, this is hardly the tone he would have adopted at a concert in Rome. So, even the purest forms of music in the sub-continent did not stand out to these men as traditions that deserved the same discriminative attention or emotional response as the music of Europe or to be treated quite differently from military music (Bernier) and musical entertainment in the *zanana* (Farewell).

These travelers were aware, and all explicitly acknowledged, that they were confronting a musical culture different from their own. But they did not seem to think that this in any way decreased the credibility of their reports or weakened their right to judge. In this respect, they aligned quite well with the philosophical orthodoxy

of the time—"music is music," they seem to say, "but this is strange music that is not the equal of what Europeans play, as I, a European, am particularly well-equipped to judge." Underneath this bluff dismissal, though, their reactions reveal something quite puzzling. I'll try to bring this out by posing two groups of questions.

The first group of questions is about the unity of rubric that covers diversity of form. The travelers found music in India, but this music was very unfamiliar. By what mark, then, did they recognize it as music? They speak of Indians following the "rules of melody" and singing "most melodiously." So, perhaps, melody was for them the essence of music. But what makes a tonal sequence a melody? How did they recognize this? (Speech and birdsong can be melodic or musical, but this is not enough to make them music.) And how did Indians, in all the centuries of their isolation from European musical culture, come by melody recognizable to Europeans? (And vice versa.) How did they discover ways to train their voices and manufacture instruments that enabled them to follow cross-culturally recognizable "rules"? And given the commonalities, how should we explain the differences? Given that there is melody in India, why is it so different from what they knew in Europe? Why does "every country have its own" arts and skills?

At the time, it was sometimes said that the most plausible answer to these questions of diversity within a single recognizable rubric is that music has common origins. In the beginning, there was music, and it went to India and to Europe, being transformed in both journeys but still staying recognizably itself. Many of these authors are likely to have adopted a Biblical version of this; they believed that, as Brown writes, "all societies had originated in Eden, and subsequently degenerated" (2000: 7). Humanity was created with the capacity for ideal music, painting, literature, and decoration, and subsequent diversity is the product of independent degenerative (or, as some believed, in Europe, progressive) histories. As I will explain later in this chapter, I too believe in common origins,

though not singular origins—and obviously I do not subscribe to the Edenic narrative.

The second group of questions is about the discrepancies of appreciation. Why do these travelers, and for that matter why do we today, often find that the artistic products of another country are, on the one hand, pleasant to attend to but, on the other hand, almost always impossible to fully appreciate? Music isn't like poetry or painting. There isn't a linguistic barrier to enjoyment, and there is no literal depiction in it, so factual knowledge about history and society isn't needed to grasp its significance. So, since Indian music is music, and since Indians enjoy it as such, why is it not equally enjoyable by anybody who enjoys music? This question must be approached delicately. We can't *just* appeal to difference of culture because, as noted, there's some degree of enjoyment across the divide by even the naive. Nor can we posit a simple one-size-fits-all capacity for musical enjoyment because this does not account for the shallowness of the travelers' enjoyment.

I think it will be agreed that, bracketing European arrogance, these travelers' responses are pretty much what one would expect from people outside a culture. Of course, most of these travelers were not truly immersed in music or art. But how different would it have been if a European "true musician" were to have traveled to Srirangapatam or Delhi? A great composer like Corelli would perhaps have been more curious about foreign music than our travelers—certainly, he would have been more able to discriminate and appreciate mode, phrase, rhythm, and skill. So, it is no accident that Pietro della Valle, who was a talented composer, was the most appreciative of our chroniclers. But even he did not enjoy it in the same way or to the same degree as a native, even one less talented at music. Why? This needs to be explained.

I want to be clear right from the outset that these are not questions just about "high" art. There were and are underlying similarities and also many differences of style and taste from country to country. Partly, of course, this is a matter of

circumstance and material technology. Indians dress for a warmer climate than the English do; moreover, they use cotton, and this too makes for sharp differences from the wool and linen traditionally used in Europe. With respect to food, each culture uses grain, meat, and flavorings found and developed in their own climates and soil. Still: since personal decoration is just personal decoration and flavor just flavor, shouldn't there be universal preferences regarding these things? (To some extent, of course, there are. As I remarked earlier, Indian pepper and muslin were highly prized in ancient Rome—but they were incorporated into local cuisine and couture. It wasn't as if the Romans discovered foreign cuisine.) Whatever foods were traditionally available in a given country, shouldn't a European just agree with Indians that *biriyani* is preferable to *risotto alla Milanese* and chapatis to baked bread? And yet this does not happen. So, here's the question: How can this kind of preference have a geography? This is the broader context for our questions about the way our travelers appraised the art they found in unfamiliar lands.

1.2. The Standards of Taste

Where there is a difference of enjoyment among individuals, we speak of taste—the pattern of enjoyment that marks each of us as individuals. Each of us has a particular taste determined by our sensory sensitivity, psychological makeup, and history of exposure. This helps explain some of the discrepancies of appreciation mentioned in Section 1.1. Some of these are purely individual— some individuals are excited by strong rhythmic beats; others are not. Others trace to national origins. Indians and Europeans are exposed to different musical (and other artistic) experiences and so develop different tastes. Pietro della Valle grew up in Italy. Naturally, he developed a taste for Italian music. Taste developed in Italy does not immediately respond to Indian music. So, della Valle

did not enjoy Indian music, at least not as much as people who grew up in India did.

Of course, this doesn't do much more than label the phenomenon. The question is why and how art, and consequently taste, comes to differ by nation. To illustrate one of the difficulties that needs to be addressed, think of David Hume's famous essay, "Of the Standard of Taste" (1985 [1757]; see the Introduction). Hume did not believe that individual taste is shaped by external norms. He didn't think that it makes sense to say that della Valle preferred Italian to Indian music because it was objectively better— for him, there is no such thing as objective value. Nevertheless, he felt obliged to acknowledge that the appreciation of art appears to respect some sort of intersubjective norms. Taste is subjective, he said, but it seems nevertheless to be governed by a "standard." If somebody preferred Ogilby to Milton, he famously said, we would pronounce them "absurd and ridiculous"—"The principle of the natural equality of tastes is then totally forgot" (1985 [1757]: 231). The non-objectivity of artistic evaluation is tempered by the tendency of the most sensitive and refined individuals to converge.

Hume's attempt to resolve this apparent inconsistency is based on what he takes to be a natural tendency among persons of fine sensory discrimination and elevated sensibility. When such individuals immerse themselves in literature and other fine arts, they naturally converge on certain works as more lastingly rewarding than others. Taste is not governed by objective standards, but persons of refinement behave as if it is.

Hume's strategy, familiar from his epistemological works, is to posit a psychological regularity to explain away the appearance of objectivity. Objectivists believe that taste converges on an external fact—beauty or something of that sort. Hume regards this as an illusion: Taste converges because increasing exposure to great art produces in all refined human beings a greater psychological receptivity to, or preference for, some works of art over others. He says that people whose senses are sharp, who are discriminating and

consistent in their tastes, and who have been sufficiently exposed to art and music tend to enjoy and appreciate the same works, which are for this reason the most highly esteemed.

Unfortunately, though, Hume's application of this idea does not even begin to address the problems posed in the foregoing section. For obviously there were painters and musicians of exquisite sensibility both in India and in Italy. Why then did they not agree in their judgments—why did the Italians find little in India to match their painters and musicians (and, presumably, vice versa)? Hume, of course, was willing simply to cut the Gordian knot at this point—he would have said that once refined Indians encountered Italian music, they would simply appreciate it more than their own. Either this, he would say, or there are no Indians of refinement equal to that of Europeans. For their failure to appreciate Italian art would simply mirror their inability to create something that appealed as well to the most discriminating audiences. This, obviously, is not the approach that either I or my co-authors would recommend. We take it as a starting point that there is a diversity across nations of aesthetically appealing qualities. The question is how this could be.

Putting Hume's Euro-superiority to one side, though, there is a deeper problem here. For the unfortunate downside of his appeal to human psychology is that it implies a side-by-side comparability across cultures and locations. To understand why, imagine what would have happened if della Valle had spent a few years learning and listening to Indian music and had come to enjoy it in the way that Indians of that time and place did. According to Hume, he would then have acquired a more expansive *but still unified* faculty of musical taste—he would exercise the very same propensity of musical taste when listening to Hindustani music as he would at a concert in Rome. And just as he might have enjoyed Corelli more than Vivaldi, he might also have preferred Corelli to a Hindustani *raga*, comparing them side by side in the same way. His receptivity to music is, from Hume's perspective, a single unified capacity that takes both in.

For reasons that will become clearer later, I think this is not correct. In my view, the appreciation of Indian music brings into play a different armory of acquired skills than that which is deployed in listening to Italian music. From my perspective, a better account of della Valle's hypothetical musical education in India would have been that when he listened to Hindustani music, he would have gradually become able to switch out of Italian mode and into a newly acquired Hindustani mode. Hume's model predicts the expansion of a pre-existent skill; I want to propose the acquisition of a new skill, and a new taste—though with some overlap with what he already possessed—specific to this new music.

1.3. An Outline of the Theory

The view of taste that I will develop has three parts, summarized as follows:

(1) *Culturally coordinated appreciation.* I have been saying that differences of taste between the European travelers and Indians recounted in Section 1.1 trace back to differences in their cultures. This has to be explicated. Accordingly, I will begin by explaining how I am using the notion of culture and offer an account of how cultures figure in artistic expression.

(2) *Cultural evolution.* How do differences in the cultures of art develop? Actions based on a culture are not necessarily conformant; they can be very different from one another and even transgressive, while still being based on the same culture. Cultures accommodate variety. Sometimes, however, transgressions become entrenched in a new culture that operates independently of the one from which they came. When cultures evolve separately, they will, in all probability, diverge and split into separate cultures.

(3) *Common origins.* The culture-based kinds that fall under broad rubrics such as music, dance, visual image-making, and poetry have historical origins determined by natural human preferences. When they originated, these forms of artistic expression were minimally culture-laden. Commonalities of taste across cultures—the shallow but positive reactions of some travelers—are accounted for by these common origins.

1.4. Culture: How It Works

I'll begin with some broad conceptions relevant to culture. I will be arguing that culture is inherently unstable and prone to change.

(I) A *culture* is a body of beliefs, preferences, and behavioral dispositions—"mental attitudes," for short—that are transmitted from one individual to another within an intercommunicating network of individuals (a "community").[5]

(II) Cultures include culture-reflexive beliefs—beliefs, explicit and tacit, about the mental attitudes broadly shared by transmission among members of the community.

(III) *Culture A differs from culture B* if either the subject matter of A is different from that of B or the community within which A is transmitted is different from that within which B

[5] Culture has been understood as an all-encompassing way of life associated with ethnic origin. In this book, Dom Lopes (Chapter 2) and I use it more narrowly to describe sets of socially formed practices that characterize a single activity, such as a game or artistic pursuit. There is a difference in our usages, however. He says that a culture is "a regularity in the behavior of a group that is due to group members sharing a common formative background." I want to focus on the synchronic and diachronic *variations* (as opposed to his regularities) of behavior that can exist among individuals who share a common formative background. I differentiate cultures in a way close to Alan Patten, who writes that the content of culture "consists in various beliefs, meanings, and practices, but what makes these the beliefs, meanings, and practices of a shared culture is that the people who hold them share a common social lineage" (2014: 51).

is communicated, and, for this reason, the mental attitudes that constitute A are different from those that constitute B.

One talks in this sense about the "culture" of groups such as political parties, groups of interacting scholars, cities, and so on. These cultures are bodies of mental attitudes that help explain why people act in ways characteristic of these communities—that is, because community members influence each other by passing on beliefs and preferences, and by their own behavior serving as examples for others to emulate or avoid. The culture of a literary society in a city is different from that of a sports club in the same city, even when the membership overlaps, because the subject matter of these bodies of mental attitudes is different. The cultures of literary societies in different societies are different because they are distinct networks of transmission.

Here are two central paradigms of action influenced by culture.

(IV) An action is *culture-influenced* if the agent's reasons for that action are parts of a culture that is hers.

(V) An action is *culture-based* if the agent's reasons for that action are consequences of beliefs about a culture that is hers.

Actions are not culture-based merely because they are based on mental attitudes shared within a culture. Rather, they are culture-based because they are based on beliefs that certain mental attitudes are part of her culture.

Here is an example that I hope makes the point clear. Suppose that an agent, A, gets vaccinated because she believes that this prevents illness. Now, it may be that this belief is shared by mutual transmission within A's community. If so, culture influences her action. But this would not be enough to make her action culture-*based*. For it to count as such, it must be based on her belief that some belief is part of her culture. This further condition is not satisfied in this case.

Now, suppose that S gets vaccinated *not* because (or not merely because) she believes that vaccination prevents illness but because she believes that members of her community generally believe that vaccination prevents illness. She might reason, for example, that it would be a good thing to conform to community behavior whether or not it makes her safe from illness. Or suppose she *doesn't* get vaccinated because she wants to be tagged as a rebel against mandatory vaccination. These actions *are* culture-based because they are based on beliefs-*about*-culture. Note that culture-based actions do not have to conform to culture. S believes, rightly, that the culture includes belief in vaccination efficacy. Actions that are influenced by this belief are culture-based. But as our two cases show, these actions need not conform to any norm prescribed by the culture. Thus, culture-based actions can admit of variation. Action that violates a cultural norm might still be based on the culture—in many cases, this is the only way to understand them.

This brings us to a crucial point. Communities have practices that are based on culture-reflexive beliefs. Dress codes are a good example. Why do Europeans wear dark clothes to funerals? For no reason other than that they believe that members of their community think that this is appropriate—they could just as easily have believed that one should wear light clothes to funerals, and then these same people would have followed along. Here, culture propagates beliefs about cultural beliefs, and these beliefs-about-beliefs are the basis of people's actions. Let's call this *cultural coordination*:

(VI) An action is *culturally coordinated* if the agent's reasons for that action include beliefs-about-culture that are parts of the agent's culture.

As before, cultural coordination does not necessarily imply universal conformity. Someone might wear light clothes to a funeral

as an idiosyncrasy—this would be a non-conformant, culturally based action.

Culturally coordinated actions are of particular interest for questions regarding art. Artists create works for audiences to consume. They do so against the background of a culture they share with the audience. For example, a poet might write a verse to be heard in a certain meter, knowing that the audience will be aware of the rhythmic possibilities of her words—that's a collection of cultural-beliefs-about-cultural-beliefs. The audience receives the poem assuming that listening to it in this way will unlock its potential to be enjoyed—the same. Both acts are culturally coordinated. Both the poet and her audience have, by virtue of a shared culture, the capacity to act in culturally coordinated ways.

Importantly, much of this is unspoken and in the background. Neither the artist nor the audience need *explicitly* be aware of more than a small part of this cultural background. As Michael Baxandall puts it: "Some of the [mental attitudes assumed by artist and audience] may have been implicit in institutions to which the actor unreflectively acquiesced: others may have been dispositions acquired through a history of behaviour in which reflection once but no longer had a part" (1985: 42).[6] This kind of transaction is not limited to "high art": It is equally constitutive of cuisine, couture, decoration, and the like.[7]

[6] Thanks to Lopes for emphasizing Baxandall in discussion. Lopes, in Chapter 2, characterizes the Baxandallian background as "norms." He is on the same page as I am, though I would quibble with the term—norms are conformity-expectant; culture is non-conformity permissive. So: visual perspective is part of the European painting culture of the fifteenth century. For this reason, knowledgeable fifteenth-century Europeans would interpret a painting that violates the rules of perspective as provocative. But they would not automatically think that the painter had fallen short. They might enjoy the provocation because it is a provocation.

[7] See Matthen (2021) for a discussion of cultural coordination in cuisine.

1.5. Cultures and Categories of Art

The above account of cultural coordination is relevant to understanding a phenomenon that has assumed a great deal of importance in recent aesthetic theory—the dependence of artistic appreciation on genre-dictated attitudes taken up by artist and audience. When I look at a photograph, my expectations and attitude with respect to its representational realism, color, and texture are different from those when I look at an expressionist painting. Why? Aren't photographs simply superior with respect to depiction? No: for superiority depends on aims. Most agree that this is because these are different genres of depiction backed by different culturally acquired mental attitudes. Depiction functions within such a genre. A man painted with a blotchy green face can be appreciated as a depiction of Max Ernst, even though (of course) Ernst's face was not that color. A high-quality color photograph of Ernst cannot be appreciated as an expressionist depiction—it is something else. Each item has to be appreciated as an example of its kind, contributing to aims understood in the context of the culture of the genre.

Probably the best and most cited account of genre-dictated appreciation is Kendall Walton's (1970) account of "categories of art." (The example of depictive realism above is his.) Walton proposes that works of art are understood relative to categories; they cannot be properly appreciated independently of the category to which they belong. He writes:

> We are likely to regard, for example, cubist paintings, serial music, or Chinese music as formless, incoherent, or disturbing on our first contact with these forms largely because, I suggest, we would not be perceiving the works as cubist paintings, serial music, or Chinese music. But after becoming familiar with these kinds of art we would probably retract our previous judgments, admit that they were mistaken. (1970: 356)

Walton's device seems relevant to understanding the history recounted in Section 1.1. These travelers failed to regard Indian music and painting as exemplars of the categories of art that they in fact belonged to; instead, they treated them as if they were exemplars of categories with which they were already familiar (or perhaps not as exemplars of any particular category at all). Consequently, they adjudged them as "formless" or "incoherent" (though pleasant enough) and not of any particular interest.

Walton's categories are maintained by cultural coordination. Taking his example of cubist painting, a person who is able properly to appreciate cubist painting has culturally acquired mental propensities that enable her to view them in a certain way. And, as Baxandall says, the artist relies on her audience sharing these capacities. The necessary coordination between them is achieved by transmission among members of the community. What I would now like to argue is that the culture that supports categories of art is not stable. It is *essentially* open to change. This is why cultures diverge across communities, and ultimately why there is a geography of taste.

I'll begin by recounting a small misstep by Walton. He thinks that culture is not essential to categories of art—what matters is that the audience should know what category a work belongs to, and though this might normally be achieved by culture, it would be fine if it were not. Here is his argument. Consider a genre-breaking art category like twelve-tone music. When Schoenberg first composed serialist works, Walton says, "this category was certainly not then well established or recognized in his society" (1970: 360). So, someone who listened to Schoenberg's twelve-tone compositions at the time they were first performed would have no pre-existing culturally recognized category to place them in. But, says Walton, this would not necessarily prevent this person appreciating the music. A listener could appreciate this music if she knew Schoenberg's intentions (1970: 360–361). The source of her knowledge is inconsequential. Culture need not be her source.

Now, Walton is interested in a slightly different question than I am. He is concerned about what makes it *right* to assign a work to a category, and about the correctness of the evaluative judgments that follow. An example of an evaluative judgment: Is this work a first-rate example of serial music or a poor example of tonal music? I am more concerned with affective response, or *taste*—what category-specific ways of listening must one employ to enjoy a piece of music? So, I do not want to argue about the facts of this specific historical example. It's logically possible that art could be created and appreciated in groups within which an artist's intentions are divined without relying on culture. Perhaps one could have artists who create works for themselves and only themselves—such an artist would not rely on culture to find the right category to assign her productions. My point is that notwithstanding all of this, culture accommodates transgression, and that art constantly changes by transgression.

I'll illustrate my point by sketching an alternative to Walton's narrative of the Schoenberg case. It could have been that Schoenberg's twelve-tone innovation was culturally transgressive, but that the audience's response was nonetheless culturally coordinated. For it is possible that the culture of the time included culture-reflexive beliefs about tonality—that is, that it not only included certain expectations about tonality but also the belief that these expectations were a part of the culture. Then, twelve-tone music could have a deliberate violation of known cultural expectations that the audience recognized as such. Schoenberg's audience had a pre-existent culture of listening that had its roots in traditional tonality, but he found an elaborate and highly rule-bound way to cut loose from tonality. This violated existing culture; moreover, it was a part of that culture that this was a transgression. When people of that time went to a Schoenberg concert, they could recognize where it conformed to the prevalent musical culture—the instruments, the singers, the twelve-tone mode, and so on. Schoenberg created a situation in which understanding

the culture of the time was a precondition of recognizing his violations of that culture. In short, the audience was able to appreciate twelve-tone music in a culturally coordinated way. It's true that they recognized Schoenberg's intentions, but they did so in just the way that they would have when they recognized that Richard Strauss's compositions were still tonal.

Let me now add one further point. In time, serialism produced (or could have produced) a new way of listening specifically adapted to the new form. By doing this, it modified the old culture. If this new way of listening became autonomous, a new category of art would have emerged. This is the kind of evolution and separation that were responsible for the emergence of other art forms like rock 'n' roll and rap—what starts as a deliberate tweak of existing culture is responsible for a new way of listening.

These theses help explain the existence of distinct artistic cultures in different geographical locations. As people migrated, they formed communities and cultures that were isolated from one another for many centuries. They brought music and other arts with them. These arts are inherently unstable. Their reliance on culture makes them prone to transgression and change. Thus, they evolved both in the places out of which migration occurred and in the migratory endpoints. This brings divergence. The European travelers described earlier were moving from one evolved culture to another. They could recognize and appreciate similarities due to shared origins. But their own culture could not give them ways of appreciating what they encountered in India.

The account of cultural learning that follows is meant to fill out the outline just given. It is supposed to elucidate what a way of listening is, or more generally, a way of engaging with art achieves. I should say that my account of audience engagement is somewhat independent of the outline of cultural coordination just offered. Thus, Lopes's account of artistic culture in Chapter 2 is very different from mine. But he might still agree with the outline of cultural coordination and change offered above.

1.6. Aesthetic Pleasure

First, let me characterize the audience response[8] that, in my view, is the desired product of a culturally agreed upon mode of engagement and the goal of artistic creation—aesthetic pleasure.[9] There are three reasons why I invoke pleasure in this role.

First, pleasure is generally directed at an object or state of affairs outside the subject; so, it can serve as the basis for response to an external object, art in this case.

Second, it is a subjective state of positive affect modulated by cognitive states that respond to external circumstances. The positive affect explains why an individual wants to engage with an art object; the subjectivity explains why different individuals can, without error, respond differently to the same object. And cognitive influences on pleasure open up a role for culture because culture shapes cognition.

Finally, pleasure grounds learning: If you get pleasure from doing something, you are more likely to do it again. Thus, pleasure influences the mental attitudes that constitute culture.

It is important for me to emphasize right at the outset that I don't mean pleasure in this context to denote a feel-good psychological state incompatible with negative emotions associated with its object—I do not take it to be synonymous with something like "fun" or "joy." Antonia Peacocke gives us a nice example that illustrates the point:

Consider a monument to the victims of a disaster, one which offers a deeply painful but unifying way to grieve communally

[8] Sections 1.6 and 1.7 are derived from earlier works, particularly Matthen (2017, 2020).

[9] *Rasa* theory generally uses "*priti*," often translated as pleasure, as just such a stand-in.

when properly experienced and not otherwise. That is a valuable, *if not pleasurable*, form of experience; its being so valuable can similarly ground the monument's own aesthetic value. (2023: 94; emphasis added)

Peacocke is right to suggest that it would be inapposite to say that the victims' experience of this monument is pleasurable. For them, it is inextricably bound up with a heavy burden of grief. But this descriptive tension between two aspects of the situation masks a deeper truth: Their engagement with the monument is one of positive affect. The pain and grief arise from the original disaster, not from the monument—the monument evokes recalled grief, but it is not itself an object of grief or pain. (It would add to the victims' trauma if it was.) Contemplating the monument brings the victims relief, unity, acceptance, and possibly resolution. These are states with positive affect. It would thus not be right to suggest that the experience is "valuable" but at the same time subjectively aversive—it isn't like painful chemotherapy. The experience reinforces certain ways of appreciating the monument and thus it bears another psychological mark of pleasure. I'll return to this example at the end of this section.

Here's my plan. To begin with, I will introduce a unit of action that I call an *assembled routine*. The appreciation of art is an assembled routine, I will argue. Then, I will try to establish the following concepts, which will enable me to give an account of the diversity of taste across cultures.

(1) *Facilitating pleasure*: a psychological complex that helps us execute difficult assembled routines.
(2) *Aesthetic pleasure*: facilitating pleasure associated with the execution of a particular kind of mental assembled routine: open-ended cognitive engagement with an object.

(3) *Pleasure in art*: a form of aesthetic pleasure, distinguished from the genus by its dependence on a culturally learned manner of engagement.

(4) *Art form*: a family of artworks that compete with one another for audiences that engage with them in accordance with a culturally coordinated manner of engagement.

My aim is to use these concepts to elucidate how art forms diverge and demand specialized forms of appreciation. Engaging enjoyably with works of one form does not imply the capacity to enjoy works of another because the culture required to enjoy the two forms is different.

1.6.1 Assembled Routines

Assembled routines are acts that consist of sequences of component acts that are willed as a single unit. (All willed acts are assembled routines, I would claim—an act without components is never willed.)

To illustrate assembled routines and their ubiquity, here's a simple example: standing still. One tends, naively, to think that this is a simple homogeneous activity. It is not. It is rather an assemblage of heterogeneous components. For there are many forces, internal and external, that act on one's body when one is attempting to stand still, each of which has to be counter-balanced by muscular effort. Standing still thus requires an assemblage of separate muscular efforts, each of which precisely counteracts a force that pushes the body away from equipoise. These component actions are not separately willed; they are coordinated in the cerebellum, out of the reach of conscious access. Standing still is the exercise of an internalized ability to execute a coordinated assemblage as a whole. Its seeming homogeneity is a result of unitary volition.

More complex examples are walking, dancing, and so on. A good dancer does the bhangra by executing many fine movements in sequence. She doesn't attend to, and may not fully be aware of, each step she takes. Rather, she releases a coordinating control mechanism learned by practice, saving her attentional and conative resources for the music, her companions, her surroundings, and, of course, the dance. The more practiced she is, the more the control mechanism is hidden from her conscious awareness. She simply responds to the beat without counting it out in her head.

Importantly, the assembled routine of dancing the bhangra is, unlike walking or standing (which are developmentally acquired), learned. It is only by being well learned that it can be executed as a unit without willing each component separately. Learning is an important factor in the assembled routines I am concerned with here.

Some *mental* acts are learned assembled routines. Reading is an example. A child learning to read must recognize each individual letter and its sound, put strings of these together, and sound them out to form words. She must also perform the linguistic operation of comprehending what the words mean. She does this painstakingly, letter by letter. The practiced reader executes the act at a more assembled level; she simply reads without separately willing, or being separately aware of, each component act that she performs. Like a practiced dancer, she has learned to execute an assembled routine as a unit.

1.6.2 Manner-Focus

Assembled routines can be goal-directed or manner-focused (or both). A goal-directed routine is one that is assembled in a certain way in order to achieve a particular result. A tennis player hitting a backhand must rotate her body, position the racket head, swing, and follow through in a well-timed sequence. This sequence of actions is precisely constructed to achieve a particular goal—a

well-hit ball to the right place. It is an example of a goal-directed routine. By contrast, dancing is manner focused. The point of the steps, the turns, the holds, etc., lies in the shape of the routine itself, not its effectiveness in achieving an extraneous result—the steps are not aimed at getting to the other side of the room, for example. In such routines, the manner of doing something has significance over and above any goal or result that ensues.

The assembled routines I am interested in are learned, mental, and (with respect to their ultimate motivation) manner focused. Take re-creational reading. This is a learned mental routine. It has a goal-directed component: The writing on the page must be absorbed and comprehended, and many of the component acts of reading are designed to achieve this goal efficiently and quickly. Additionally, however, there are manner-focused aspects of re-creational reading—that is, aspects shaped by something other than the culminating goal. As you read, you may, for instance, inwardly recite the words to bring out the prosody, or open yourself up to the emotional resonance of the passage by dwelling on the text for longer than needed for mere comprehension. When you read in these ways, you still aim to achieve the culminating goal of comprehension. But the manner of reading has an additional purpose in re-creational reading: the enjoyment of reading. With literature considered as art, enjoyment is achieved by the manner of reading.[10]

Here's where I am going with this: The appreciation of art is a learned manner-focused assembled cognitive routine. As I'll explain in a moment, art is most attractive to an audience only if it is engaged with in a particular manner—poetry, for example, is attractive when the meter is emphasized. As Baxandall emphasized, the optimal *manner* of engagement is understood by both creator

[10] Close reading is, of course, a distillation of such methods for literature. Though my descriptions are inspired by close reading, I can't repeat often enough that I abjure any high-brow account of artistic enjoyment.

and audience. This coordination is achieved through the culture they share. Note, once again, that I am not saying that the culture necessarily *prescribes* the optimal manner of engagement, though it often does this. The point is rather that this manner of engagement is known by means of culture.

Once again, I am not preoccupied by high art alone. Think of cuisine (Matthen 2021). When an accomplished cook makes rasmalai, she assumes that the quality, quantity, and balance of saffron and cardamom make a difference to the consumer's enjoyment—explicitly so in the case of an experienced consumer, who expects this to be an element of savor. (A less experienced eater would just focus on the flavor, not on the balance of flavorings that create it.) Enjoyment of the dish as an artistic product (not merely as an agreeable confection) results from this kind of transaction between cook and consumer: a non-explicit understanding that this manner of tasting will be employed. The rasmalai is an art object because it *can* be eaten in this way.

And now to a theory of the kind of pleasure, or enjoyment, that's involved and how it involves culture and culture learning.

1.6.3 Facilitating Pleasure

Pleasure releases and facilitates assembled routines. Consider reading again. Clearly, it is an activity that taxes brain resources and competes with other resource-intensive activities. It is difficult to concentrate on a book when other cognitive and bodily demands compete. However, reading is easier when it gives pleasure. Even when tired and hungry, you can keep your mind on a good book. On the other hand, it is very hard even in favorable circumstances to keep your mind on a turgid legal contract. This difference does not mean that the book is intellectually less demanding than the contract—the opposite might well be true. What it shows, rather, is that the pleasure derived from reading the book agentially

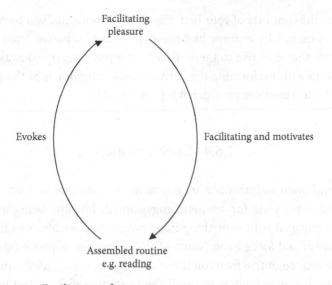

Figure 1.1 Facilitating pleasure

releases a particular manner of reading and facilitates your ability to conduct it as a unitary act, while displeasure disrupts the routine and ultimately holds it back. And the same is true of other assembled routines; they are self-reinforced by pleasure-in-doing (Fig. 1.1). Facilitating pleasure can function in this way as a part of the psychological complex by which one executes difficult assembled routines.[11] It is agential in this sense.

Facilitating pleasure is very different from another kind that philosophers talk about—consequential pleasure. The latter is pleasure that simply welcomes a fact. Think of getting into bed at the end of a tiring day. The pleasure you feel is just an effect; it is not part of any agential complex. (Of course, the pleasure you feel

[11] Reber, Schwartz, and Winkielman (2004) dwell on one half of the loop that I am describing. They propose that *fluency* in executing (what I call) an assembled routine is a source of pleasure. But they do not mention the reciprocal influence—pleasure contributes to and maintains fluency; displeasure disrupts it. So, the agential role of pleasure does not figure in their theory.

from the comforts of your bed *is* agential; it motivates you to stay.) Consequential pleasures like these are effects separate from the events that give rise to them. Facilitating pleasure, by contrast, is tied up with performing the activity. It's a component of the psychological complex by which it is performed.[12]

1.6.4 Contemplation

Now, I want to introduce an assembled routine that will serve as a broad template for aesthetic engagement. Imagine being mentally engaged with something in a manner that enables you to be aware of and focus in on (some of) its properties. Suppose further that your cognitive focus on this object is manner-focused—in the sense that what matters to you is the awareness of the object itself, not what you discover about it. For example, you might:

> look at a tree and be aware of its color and shape over a period
> of time (and by visual recollection after you stop looking), or
> listen to a lecture and be absorbed by the compact unfolding of
> its argument (separately from its content), or
> hear k. d. lang sing, and be aware of her articulation, attack, and
> rhythm.

These are acts of awareness that maintain focus on an object without regard to any cognitive achievement that might accrue as a consequence of this focus.

[12] There is another view of pleasure that has been in the literature ever since Plato— that it is a quasi-perceptual apprehension of the good. Aesthetic pleasure is, on this view, purported apprehension of beauty, or of aesthetic merit. Gorodeisky (2019) and De Clercq (2019) adopt approaches like this. Such views are (a) committed to a consequentialist view of pleasure, since perception of F is a causal consequence of F, and (b) assume that beauty is a transcendent quality. They are orthogonal to my employment of pleasure because of (a). They are ill-equipped to deal with cultural variation because of (b).

I'll call these assembled routines acts of contemplation, though the word has a connotation of passivity that I do not intend. (Another term that I'll use is "mental engagement," but this has too intellectual a connotation.) They are difficult assembled routines— they consist of coordinated component acts of perceptual or conceptual search, attention, and receptivity. For example, looking at a tree requires you to focus your eyes, saccade from one point to another, register and remember color contrasts, and so on. Looking at a tree in a way that makes it pleasurable to do so—this is a manner-focused routine. It is a different way of looking at it than when you are trying to identify what kind of tree it is or trying to measure its height.

Now, here is an important point. Manner-focused contemplation is unstable because it is difficult. Something is needed to maintain the focus; if it has no extrinsic goal, mental engagement is just as apt to wander off the object as to stay on it. This is where facilitating pleasure plays a role. It keeps your mind on the task. It is sustaining.[13]

1.6.5 Aesthetic Pleasure

Now think of an act of contemplation that produces facilitating pleasure. This is self-sustaining, hence stable. Facilitating pleasure stabilizes your focus on the object of contemplation. If you enjoy looking at a bird, you'll focus on it more; you'll even take in more of its visual characteristics. Note, here, that the reinforcing role of pleasure is manner-focused—it is the activity itself, not any goal state, that shapes how you contemplate the object. This open-ended pleasure-reinforced contemplative engagement with an object (Fig. 1.2) is my model for aesthetic enjoyment.

[13] This proposal has much in common with the attention theory of aesthetic enjoyment developed in Nanay (2015, 2016).

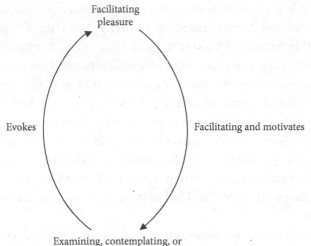

Figure 1.2 The aesthetic loop

To pull these threads together:

> Aesthetic pleasure is facilitating pleasure that arises from contemplating something in a manner-focused way. As facilitating pleasure generally does, it serves to reinforce the act it arises from. Thus, aesthetic pleasure makes the act of contemplation self-reinforcing.

Note that this definition of aesthetic pleasure is functional, in the sense that it is defined in terms of its agential role. Certain negative emotions—fear, disgust, sadness—can play a role in self-reinforcing an act of contemplation in accordance with the above definition. Aesthetic pleasure need not be fun in a narrow sense of the term.

The scope of aesthetic pleasure clarifies Peacocke's example of a monument that helps survivors of a disaster grieve when it is

"properly experienced." I can now say more about my attitude to this example. First, note that the example has the same structure as that of the aesthetic loop in Figure 1.2. The survivors contemplate the monument in an act of grieving. This contemplation, which (I assume) is different from that performed by a detached viewer, is manner-focused; it dwells on the monument in a certain way in the context of a larger act of grieving. Here's my contention: If aesthetically positive, this act of contemplation has the self-reinforcing structure of Figure 1.2. This is why I say it evokes (facilitating) pleasure.

1.7. Culture Learning and the Pleasure of Art

In Section 1.6, I linked aesthetic appreciation to a kind of pleasure. Now, I want to show how the pleasure is the basis of culture learning. If I am on the right track about the cultural coordination of art appreciation, my argument in this section will show how culturally based aesthetic pleasure is essential to appreciative engagement with art.

I'll introduce culture learning by first characterizing generic reinforcement learning and then noticing the specific features that distinguish culture learning as a kind thereof.

1.7.1 Reinforcement Learning

Pleasure is a fulcrum for learning. Here is one way this works.

Reinforcement Learning: if X performs action A_1 in circumstances C and A_2 in another occurrence of the same circumstances C, and if A_1 gives more pleasure than A_2, then X's tendency to perform A_1 in C is reinforced relative to her tendency to perform A_2 in C.

Reinforcement learning is standardly used by animal trainers. Normally, they utilize consequential pleasure rewards following spontaneous occurrences of the action they seek to establish. For example, they might train a dog to jump through a fiery hoop by giving it a reward every time it comes uncomfortably close to the hoop, ultimately inducing it to jump through (and rewarding it for so doing). In this pattern, a new action is learned by the subsequent pleasure-carrying reward that it elicits. The action is performed because it has provided consequential pleasure in the past and is lastingly associated with the pleasure as a result. (I'll qualify the last statement in a moment.)

In reinforcement learning, an animal learns a new action— jumping through a fiery hoop when commanded. The action is performed for the pleasure-linked "value" that has come to be associated with it. (I am not saying that an animal possesses a value concept, just that its preference for one action over another is an implicit value.)

1.7.2 Manner Reinforcement

I am interested in a related, but somewhat different, reinforcement pattern—learning to perform an already familiar action in a new manner by the facilitating pleasure that accompanies it when performed in that manner.

Manner Reinforcement: If assembled routine A is more facilitated by pleasure when X performs it in manner M_1 than when she performs it in manner M_2, then X's tendency to perform A in manner M_1 is reinforced relative to her tendency to perform it in manner M_2.

Note that X's tendency to perform A may not be reinforced as such. The act itself may not rise in her preference ordering. What is reinforced is a certain manner of performing the act: When she performs it, she does so in this way.

Dancing is an example of a manner-learned routine. When one struggles with a step or a move, the routine is forced and easily falls apart. But when one has mastered the timing of a step, dancing gives self-reinforcing pleasure—it just feels good to do it this way. This pleasure helps one learn the right manner of dancing. Dancing is manner-focused, and the pleasure that it creates when performed in a certain manner facilitates dancing in this manner (as in Fig. 1.1). And the value of dancing may be adjusted upward because there is a learned manner of dancing that affords greater pleasure than dancing in the old manner. Of course, this does not necessarily happen. One may still prefer to go to the bowling alley or to the movies. But if one is going to dance, this is the way one prefers to do it. And doing it this way may just make it more attractive than bowling.

1.7.3 Culture Learning

One engages with art in a manner that conforms to a culture shared with the creator. That's the transaction between creator and audience.

Suppose you read *A Suitable Boy* in the way Vikram Seth assumed you would when he wrote it. Then you will get greater facilitating pleasure out of reading it than if you read it in a less culture-informed way.[14] Note again that I am not saying that you are explicitly aware of Seth's intentions, or that you need to be. I am simply saying that if he is successful, your reading will be more facilitated by pleasure if it is shaped by the same culture as his writing. There is a coordination between artist and audience that results from the

[14] Of course, you might read it in the way that you read a historical essay and get a lot of facilitating pleasure by doing so. But this would take your reading into a different, though related, genre, and it is merely in virtue of the overlap that Seth's novel works in that form.

culture to which both have "unreflectively acquiesced" (to echo Baxandall, quoted earlier).

I can now articulate a general thesis (an elaboration of the view that I attributed to Baxandall):

The enjoyment of art rests on culturally coordinated expectations of production and appreciation that are parts of the relevant culture.

1.8. Art as a Special Kind of Aesthetic Object

Here is a characterization of art in terms of its relationship to cultural learning.

1. Works of art are created in accordance with the expectation that they will be engaged with in a specific culturally learned manner.
2. Consuming a work of art in the culturally learned manner assumed by the artist maximizes aesthetic pleasure (normally, non-accidentally).
3. The coordination between creator and audience implied by (1) and (2) is enabled by a culture they share.
4. Artworks are properly evaluated relative to the culturally specific terms of coordination implied by (1) and (2). (This is Baxandallian coordination.) Specifically, their acceptance in a community depends on how successfully they are able to generate pleasure that facilitates the cognitive focus of an audience (see Matthen 2017).

Here is one way of summarizing the results of the theory of taste that I have presented.

Call the features of artworks that afford facilitating pleasure their *attractors*.

Some attractors are culture independent. In music, certain harmonies and certain rhythms are universally attractive; perhaps the preference for these is innate. Other attractors become so by universal psychological processes. For an example of the latter, think of the mere exposure effect discussed by Bence Nanay in Chapter 4. It has been claimed that repeated exposure to a visual pattern (e.g., a brand logo) increases how much subjects "like" it or prefer it to others. Preferences traceable to mere exposure effect are not culture-based; that is, they do not arise from beliefs about culture.

These culture-independent attractors are the ones Hume was assuming. I'll call them the *primary* attractors because they are likely responsible for the historical origins of art. They also explain how cross-cultural appreciation is possible—they are what appealed to the travelers I talked about in Section 1.1. (I'll say more about primary attractors in the following section.)

In addition to these universal attractors, there are culture-specific attractors. They are artistic devices that are culturally learned through coordination between creator and audience based on information that both absorb from others in a social group. I'll call these the secondary attractors.[15] All art has secondary attractors; the appreciation of art is, to a much greater extent than the appreciation of nature, dependent on secondary attractors and this is culturally coordinated.

Specific art forms—Waltonian categories of art—are defined by secondary attractors. To fully enjoy them, an audience needs to absorb the culture on which they are specifically based. Thus, secondary attractors are always tied up with locally available information.[16] Often, the secondary attractors are second order. You enjoy the flat saturated colors that Turkish and other miniaturists use;

[15] For the distinction between primary and secondary attractors, see Matthen (2015).
[16] It can happen, and perhaps is happening, that there is a global culture. This is accidental. A global culture operates no differently because it is global. The preferences it generates are not Humean.

you also enjoy and notice the devices by which they deploy these colors. (More about this in the following section.)[17]

1.9. Origins

If art forms and secondary attractors are different in every culture and every genre, what explains the universality of the broad categories of art—music, dance, poetry, fiction, decoration, and so on? In Section 1.1, I mentioned the old theory that these had common origins in Eden. I don't (of course) believe in Eden or humanity's fall from it. But I do think it plausible that the broad categories of art have common origins.

Before I say more about common origins, let me make two remarks about change and divergence in art forms.

1. *Change within art forms.* As recounted earlier, artworks belong to categories, or art forms—groups of productions that presuppose a common cultural background and thus compete against one another for consumption by people who possess specific culture-based competencies—this group of similarly skilled people constitutes a market niche for the art form. The greater the aesthetic pleasure these consumers derive from a work consumed in accordance with these skills, the deeper their cognitive engagement with it. As a consequence, works that give greater aesthetic pleasure are in greater demand. This competitive niche exists within a wider economy: Artworks compete for resources against food, defense, housing, mating opportunities, and so on. The art market is shaped by aesthetic

[17] Samantha Matherne (Chapter 3) and I agree that there can be cross-cultural appreciation of art. But I think that there are barriers, limits, and risks. Engagement with works from unfamiliar genres entails learning the secondary attractors, however inexpertly. But incomplete knowledge of the secondary attractors puts one at risk of committing the aesthetic injustices discussed by Nanay in Chapter 4.

pleasure, as well as by other factors such as the existence of supporting productive entities, such as technology, wealth, and cultural institutions. (Lopes [2017] gives an original and important account of these supporting institutions.)

With this in mind, my first thesis is that artists target audiences they know; these audiences are interested in works they can appreciate with the cultural skills they possess. As argued earlier, these skills are coordinated: Artists succeed because they produce works their audiences know how to consume; audiences find cultural enjoyment because they have the skills that artists cater to. These skills are shaped on both sides by learning by exposure, imitation, and instruction. Skills that are shaped in this way are flexible; though they start with works of certain genres, they will be capable of enjoying works that transgress and innovate within certain bounds. A person who is familiar with strict perspective in visual art may, for example, be able to appreciate deliberate distortions of perspective. For example, if perspective is deliberately used to distort the apparent size of objects relative to one another, an experienced viewer might understand and appreciate the trick. And having enjoyed it, she might develop new ways of enjoying art within the tradition. This modifies the culture of the art form.

Now here's an important point: The cultural change I have described in this way is path dependent. That is, any cultural product is the result of innovations piled on innovations back through history; for this reason, its characteristics depend on its lineage. To continue with the example from the previous paragraph, a painting that distorts perspective depends on a tradition in which perspective is employed more literally. A Turkish miniaturist would not have distorted perspective in this way because his cultural background didn't use strict perspective in the first place— distorted perspective would not have had the same meaning for Turkish audiences.

Nanay (2018) likens this accumulation of cultural innovations to the path dependence of biological natural selection, an idea he attributes to George Kubler and Whitney Davis. This is insightful and helpful, but we must note an important difference. In cultural innovation, but very much less so in biological evolution, there is the possibility of borrowing, cross-fertilization, and returns to past cultural modes. Thus, European painters of the nineteenth century borrowed certain tropes from Japanese printmakers—but birds cannot borrow design features of insect wings by hybridization. Of course, cultural borrowing is also path dependent; the borrowed Japanese tropes have to "make sense" in their new context or be modified so that they make sense. But it's important to recognize that (by contrast with biological evolution) there is confluence as well as separation in the lineages of art. With this proviso, we should remember that because art is the product of a path-dependent series of innovations, it is culturally and historically bounded. It is misleading, for this reason, to think of it as a quest for some universal quality such as beauty, or a manifestation of some universal "standard of taste."

2. *Emergence of new art forms.* Modifications of art forms can lead to splits. Suppose that parallel series of changes of the above kind leads to the formation of separate sub-audiences, each of which is attuned to different culturally learned attractors in the art form. Cumulatively, this can lead to the formation of groups with skills that are learned independently of one another. In the Western world, this kind of change has been very accelerated by the invention of new technologies, the availability of culture to more and more members of society with diverse educational and economic backgrounds, and the cross-influence of artistic cultures made possible by travel. Just think of how photography and film developed, with the emergence of new technologies initially subordinate

to established art forms in painting and drama, and gradually developing incommensurable standards of their own.

These processes create increasing variety. Take technology. The invention of photography creates a new medium. This creates variety in the art form of "realistic" pictures—portraits and landscapes that could hitherto be made by pencils or brushes are now enriched by visual effects experienced in photographs. The culturally learned skills of appreciating portraits and landscapes are expanded to include the enjoyment of photographs, and these expanded skills feed back into painting to expand the expressive resources used there. So far, this is change of technique within an existing art form that does not require a completely new culture to appreciate. But it is easy to imagine changes that finally create a split in these pre-existent cultures—ways of manipulating digital images, for example, which are different from what can be achieved in a darkroom or with a paintbrush. These changes could create an entirely new culture of enjoying pictures, a culture quite different from that of enjoying charcoal sketches or painting. This is how new art forms are created. Note also that there does not have to be only one such event. It could have happened that different photography art forms emerged independently in Japan and in North America, both deriving from the same original event. (This is a disanalogy, once again, with biological macro-evolution.)

Origins. The processes of cultural evolution that I have described create variety, and together, they can explain the variety and geography of taste. So, as humans dispersed over the globe, thereby reducing, or even entirely severing, contact with other groups, the variety of artistic cultures would proliferate. Conversely, looking backward in time, we would expect that in the distant past there would have been less variety than now. For this reason, it is plausible to speculate that every art form traces back to one or more culturally transformative singular events. This is what my sketch of

diversification shares with the fall-from-Eden hypothesis. I would suggest that the broad categories of art—music, dance, depiction, fiction, poetry, decoration, and the like—arose from common origins. I would further suggest that the limited cross-cultural appeal of art is explained by these common origins.

The most discussed case of common origins in the literature is music.[18] The reason it is treated as a separate case is primarily that it seems to be a basic human, or possibly hominin, ability: like language, it has a universal syntactic structure (Lerdahl and Jackendoff 1983) and a hard-wired neural substrate (Norman-Haignere, Kanwisher, and McDermott 2015). So, though there is disagreement about the adaptive significance of music, it is generally agreed that it is an instinctive behavior in all humans tracing back to or before the emergence of *Homo sapiens*. However, there is no reason to suppose that these instinctive vocalizations were *art* at this stage. No doubt, some were pleasing to listen to. But my treatment of the nature of art indicates that this is not sufficient. The vocalizations have to be ritualized and codified before they become art music.

Art is, as I have argued, creation that gives aesthetic pleasure by means of culture—it has secondary attractors as well as primary ones. So, imagine the early accretions of culturally specific modes of singing: Over the base of instinctive rhythmic or melodious vocalization is added a technique that gives pleasure by culturally specific appraisal or appreciation—something like throat singing or warbling or harmony where a knowledgeable auditor can enjoy the appraisal of skill or technique or creativity. Such an accretion would be both inevitable and transformative. The kind of music that results from it is now art. This new art music has primary attractors that were already present before this innovation and now also secondary attractors attributable to the innovation. I would suggest that all musical art historically traces back in this way to singular

[18] For recent discussion, see Mehr et al. (2021) and Savage et al. (2021) and commentaries.

events that add a culturally transmissible feature to instinctive melodic and/or rhythmic vocalization that was pleasurable to hear.

Similarly, think of bipedal mobility, walking and jumping (etc.). Some people walk in a way that is aesthetically pleasant to watch; this doesn't make their movements art. It is only when these movements are ritualized, and the rituals are part of what an audience appreciates, that we have art—dance, processions, marching, and so on.

The methodology that I am suggesting is followed in an illuminating paper by Sandra Francis (1991). Francis hints that the question of origins is entwined with a non-ethnocentric understanding of dance, and she suggests that in discussions of origins, anthropocentrism is an extension of ethnocentrism. To broaden our species-limited horizons, she uses the work of the primatologists Wolfgang Kohler and Jane Goodall. Here's Kohler:

> When Kohler studied captive chimpanzees on Tenerife . . . from 1913 to 1917, he observed a number of behaviours that to him suggested "primitive forms of dancing." . . . Of particular interest is Kohler's description of the semi-rhythmic movements of a group of chimpanzees in single file around a pole, some of whom accented their movements by stamping heavily on one foot, and wagging their heads in time with the stepping. Self-decoration often accompanied the "ring-dancing," as the animals draped themselves in rags, strings, and bits of vegetation. (Francis 1991: 205–206)

Importantly, Francis distinguishes between dance and "dance-like" behavior very much along the lines I have suggested, where the former is (to paraphrase) intentionally rhythmic in conformity to a culturally learned pattern. She believes that chimpanzees are capable of dance; I cautiously agree that Kohler's evidence supports this.

Whitney Davis (1986) proposes another origin narrative—early uses of what he calls "the representational line" in the Aurignacian period about 30,000 years ago. He writes: "Sometime between 32,000 and 17,000 B.C., a continuous technology [of carving curved lines in stone] underwent one profound conceptual alteration. Image makers discovered the essential feature of the representational line—its analogical, continuously modulated, semantically 'dense' quality" (1986: 194). That is, they discovered that by altering the symmetry and curvature of a single line, they could represent "multiply linked and ever changing features of reality." The idea is that by initially seeing naturalistic images of parts of real-world objects in C- and S-curves, these sculptors acquired the capacity to use similar curves to represent similar things. To see the representational qualities of these curves, ordinary naturalistic vision has to be suppressed and an "image channel" has to be activated.

> Once marks were perceived as things . . . the full analogical, ex
> pressive power of the line could be quickly and logically derived
> and even detached from mere experiences of perceptual ambi
> guity. . . . As soon as *one* complex of lines could be interpreted
> representationally, potentially all lines could. . . . The emergence
> of images was, then, a "threshold discovery". (Davis 1986: 201)

Davis's claim is that images have a representational component; hence, the discovery of representational lines marks the origin of images. In my terminology, it marks a transition from an etching that relies solely on the universal human capacity to see real-world objects in scratchings, shadows, clouds, and the like to one that utilizes a systematic artifice to perform the representational function. It is thus a move to culturally based devices and marks a beginning of one kind of art.

In the view that I support, all art historically traces back to purely instinctive behaviors. Culture modifies such behavior by adding new pleasure points. Each cultural accretion is one of many that are

possible. These accretions pile up by a historically path-dependent process. The art forms we encounter today are points in a lineage that traces back to a founding cultural event.

We are trying in this book to describe and account for the plurality of artistic cultures, each of which leads to aesthetic enjoyment and appreciation, which is recognizable across cultures. The aesthetic life is the same everywhere—close enough to make no difference—but its content is not. This variety under a unified rubric is a challenge to traditional philosophical aesthetics, which takes aesthetic appraisal to be grounded in the descriptive properties of art objects with no clear place for culture or personal experience to play a role. The other authors of the book have described the malleability of different components of the aesthetic life. My aim has been to describe the psychological and cultural determinants of taste.

References

Baxandall, Michael. 1985. *Patterns of Intention: On the Historical Explanation of Pictures*. Yale University Press.

Braga, Corin. 2015. "Marvelous India in Medieval European Representations," *Rupkatha Journal* 7.2: 30–41.

Brown, Katherine. 2000. "Reading Indian Music: The Interpretation of Seventeenth-Century Travel Writing in the (Re)construction of Indian Music History," *British Journal of Ethnomusicology* 9.2: 1–34.

De Clercq, Rafael. 2019. "Aesthetic Pleasure Explained," *Journal of Aesthetics and Art Criticism* 77.2: 121–132.

Francis, Sandra T. 1991. "The Origins of Dance: The Perspective of Primate Evolution," *Dance Chronicle* 14.2–3: 203–220.

Gorodeisky, Keren. 2021. "On Liking Aesthetic Value," *Philosophy and Phenomenological Research* 102.2: 261–280.

Hardgrave, Robert L., and Stephen M. Slawek. 1989. "Instruments and Musical Culture in Eighteenth Century India: The Solvyns Portraits," *Asian Music* 20.1: 1–92.

Hiriyanna, Mysore. 2011 [1954]. "Art Experience 2," *Indian Philosophy in English: From Renaissance to Independence*, ed. Nalini Bhushan and Jay Garfield. Oxford University Press, pp. 217–230.

Hume, David. 1985 [1757]. "Of the Standard of Taste," *Essays: Moral, Political, and Literary*, ed. Eugene F. Miller. Liberty, pp. 226–249.

Lerdahl, Fred and Ray Jackendoff. 1983. *A Generative Theory of Tonal Music*. MIT Press.

Lopes, Dominic McIver. 2017. "Beauty, The Social Network," *Canadian Journal of Philosophy* 47.4: 437–453.

Matthen, Mohan. 2015. "Play, Skill, and the Origins of Perceptual Art," *British Journal of Aesthetics* 55.2: 173–197.

Matthen, Mohan. 2017. "The Pleasure of Art," *Australasian Philosophical Review* 1: 6–28.

Matthen, Mohan. 2020. "Art Forms Emerging: An Approach to Evaluative Diversity in Art," *Journal of Aesthetics and Art Criticism* 78.3: 303–318.

Matthen, Mohan. 2021. "Can Food Be Art in Virtue of Its Savour Alone?" *Critica* 53.157: 95–125.

Mehr, Samuel A., Max M. Krasnow, Gregory A. Bryant, and Edward H. Hagen. 2021. "Origins of Music in Credible Signaling," *Behavioral and Brain Sciences* 44.e60: 1–60.

Mitter, Partha. 1977. *Much Maligned Monsters: A History of European Reactions to Indian Art*. University of Chicago Press.

Nanay, Bence. 2015. "Aesthetic Attention," *Journal of Consciousness Studies* 22.5–6: 96–118.

Nanay, Bence. 2016. *Aesthetics as Philosophy of Perception*. Oxford University Press.

Nanay, Bence. 2018. "George Kubler and the Biological Metaphor of Art," *British Journal of Aesthetics* 58.4: 423–434.

Nanay, Bence. 2019. *Aesthetics: A Very Short Introduction*. Oxford University Press.

Norman-Haignere, Sam, Nancy G. Kanwisher, and Josh H. McDermott. 2015. "Distinct Cortical Pathways for Music and Speech Revealed by Hypothesis-Free Voxel Decomposition," *Neuron* 88.6: 1281–1296.

Patten, Alan. 2014. *Equal Recognition: The Moral Foundation of Minority Rights*. Princeton University Press.

Peacocke, Antonia. 2023. "What Makes Value Aesthetic?" *Journal of Aesthetics and Art Criticism* 81.1: 94–95.

Reber, Rolf, Norbert Schwartz, and Piotr Winkielman. 2004. "Processing Fluency and Aesthetic Pleasure: Is Beauty in the Processor's Processing Experience?" *Personality and Social Psychology* 8.4: 364–382.

Reynolds, Dwight. 2013. "Arab Musical Influence on Medieval Music: A Reassessment," *A Sea of Languages: Rethinking the Arabic Role in Medieval Literary History*, ed. Suzanne Conklin Akbari and Karla Mallette. University of Toronto Press, pp. 182–198.

Savage, Patrick E., Psyche Loui, Bronwyn Tarr, Adena Schachner, Luke Glowacki, Steven Mithen, and W. Tecumseh Fitch. 2021. "Music as a Coevolved System for Social Bonding," *Behavioral and Brain Sciences* 44.e59: 1–22.

2

Cultures and Values

Dominic McIver Lopes

Taste has a geography only metaphorically. Yet the metaphor is apt. Geography combines general or law-like explanations, such as those that invoke hydrodynamics, with natural history, as in studies of the impact of recent climate change on the Mackenzie River. Likewise, philosophical treatments of artistic, aesthetic, and hedonic cultures ought to serve inquiry at two levels. On the one hand, philosophy crafts general theories of artistic, aesthetic, and hedonic cultures, respectively. A theory of each of these sets out its constitutive features, which distinguish it from its sister cultures of taste. On the other hand, each of the three cultures of taste comprises countless sub-types or varieties, and it's the variant sub-types that focus inquiry in the human sciences. For example, a historian or a sociologist might trace the impact of technological change on the rise of the International Style in twentieth-century architecture. International Style isn't the same as Shintō architecture, let alone *śāstriya saṅgīt*, and the difference clearly matters. In philosophy, it matters because an adequate theory of any culture of taste is one that makes room for and invites explanations, especially in the human sciences, of its variants as effects of history, technology, and local social formation. The theory, at the general level, is to serve as—and to be assessed as—a framework for studies, in the human and social sciences, of variants within the culture (Lopes 2018a). Perhaps a useful model from another domain is Sally Haslanger's theory of gender, according to which a woman is someone marked, in a context, for social positioning as subordinate to men along

The Geography of Taste. Dominic McIver Lopes, Samantha Matherne, Mohan Matthen, and Bence Nanay, Oxford University Press. © Oxford University Press 2024. DOI: 10.1093/oso/9780197509067.003.0003

some dimensions (2000: 42). The theory is designed to make room for and invite studies of how gender varies from one society to the next, first with respect to marking and then with respect to the dimensions of subordination. In much the same spirit, this chapter crafts theories of artistic, aesthetic, and hedonic cultures as organized around values in distinctive ways. The argument for the theories is principally that they accommodate and invite empirical studies of variants within the three cultures of taste.

2.1 Backstory

To adequately accommodate and invite empirical studies of variants of artistic, aesthetic, and hedonic cultures, we are going to need theories that represent each kind of culture as organized around value in a distinctive way. Sections 2.5 to 2.8 lay out the theories and make the case for them. To prepare the ground, Section 2.2 showcases some examples of the three cultures and variants within them, Section 2.3 ratifies a minimal theory of culture, and Section 2.4 assembles a toolkit for making sense of how cultures, minimally conceived, are organized around values. The organization of cultures around values isn't as clear-cut as it first appears, and it will turn out that the organization of each culture of taste shapes how we should approach its variants. To begin with, though, the whole enterprise should be put into context because it cuts radically against tradition.

Once upon a time, philosophers and other scholars took for granted a tidy arrangement. The arts are aesthetic, the aesthetic is a hedonic phenomenon, and so the arts are too. The three unify metaphysically (Shiner 2001). They also unify axiologically: Artistic value is aesthetic value, and aesthetic value is hedonic value, where hedonic value is, roughly, a power to evoke pleasures—that is, finally valuable experiences (Van der Berg 2020). Finally, they unify culturally. Aesthetic and artistic cultures are constitutively

organized around hedonic values. For example, Johann Gottfried Herder took a group's artistic–aesthetic culture to consist in its members making artifacts that yield pleasure in the felt fit between other cultural elements and the group's physical or larger social environment (Zuckert 2019: 152–153).

Add a couple of premises and the tidy arrangement implies a universalism that is rejected by all contributors to this volume. One additional premise concerns the measurement of goodness: All pleasures can be rank-ordered on a single scale. What affords greater pleasure is better than what affords less. So much the worse for those who are unable to access the greater pleasure. A further premise has a normative implication. The greater pleasures are accessible to all, perhaps with effort. All should therefore access them; bad on those who do not.

The additional premises are optional. In the early nineteenth century, Bernard Bolzano endorsed the tidy arrangement but rejected both additional premises (2023 [1843/1849]). Since pleasure is, for Bolzano, an effect of learning in a cultural context, the goodness of a pleasure is indexed to the variant culture of taste in place in that context. And since pleasures are inaccessible to an appreciator when they lie beyond her cultural horizon, it's not the case that she should access them—it's not her bad if she does not. Mohan Matthen, in this volume, goes beyond Bolzano by conceiving pleasure as an effect of learning that motivates learning (see also Matthen 2015, 2017, 2018a, 2018b, 2020). He also reconciles the tidy arrangement with an aversion to universalism.

This chapter takes issue with the tidy arrangement itself, hence with both its universalist and also its localist versions.

Historically, the tidy arrangement began to come apart under pressure from a growing conviction that the importance of the arts far outstrips their capacities to please (e.g., Schaeffer 2000). The arts are important as sites of freedom or as conduits to a special kind of knowledge, for example (Schiller 1993 [1795]; Schopenhauer 2010

[1819]). Yet the break was never clean. Left intact were hedonic approaches to non-art aesthetic cultures—nature, scientific ideas, design, and what has come to be called "everyday aesthetics." At the same time, it's now routine for philosophers and other scholars to use "aesthetic" to mean "artistic." The inconsistency is swept under the rug.

Theories that represent artistic, aesthetic, and hedonic cultures as distinct complete the break, but care is needed to leave behind the tidy arrangement's baggage. In reducing artistic and aesthetic values to hedonic value, the tradition established a blueprint: Artistic and aesthetic cultures must be organized around value in just the same way as hedonic cultures are organized around value. Having jettisoned the reduction of artistic and aesthetic values to hedonic value, we ought to question whether all three cultures are organized around value in the very same way.

The details must await Section 2.4, which will set us up to make sense of how cultures can be organized around value in different ways. For now, the immediate task is to adopt a working conception of the three cultures of taste and their variants. After all, by lumping them together, we have obscured our intuitive sense of what sets them apart.

2.2 Artistic, Aesthetic, and Hedonic

The claim is that artistic, aesthetic, and hedonic cultures are distinct kinds of culture, each with variants. That claim is couched in abstract classifiers, "artistic," "aesthetic," and "hedonic"—all fighting words whose meanings are hotly contested. To take the heat off, here are some relatively clear cases of the three cultures and of variation within them. Nothing in the argument of the chapter should be read as committed to the cases' classification. If these cases seem not quite central to you, then perhaps they suggest some clearer cases. The intention is to make concrete and thereby clarify

abstract references to artistic, aesthetic, and hedonic cultures, where nothing hangs on the exact choice of examples.

Among the arts, the standing of music has never been disputed, musical instruments are among the earliest human artifacts, and music is globally endemic. In fact, the human auditory system is hardwired to hear musical structures (Levitin 2006). At the same time, musical traditions vary enormously. In 1883, a Haitian Kreyòl writer, Oswald Durand, wrote what was to become his most famous poem, "Choucoune," known popularly as "Ti Zwazo." The poem compares the Haitian experience of slavery ("*De pyé mwen nan chen*") to lost love, and vice versa (for context, see Averill 1997). Ten years later, a Haitian American composer, Michel Mauleart Monton, set Durand's lyrics to music as a méringue lente. The méringue lente is a Haitian dance form that marries European contradance with African rhythms, and Monton's music combines a dreamy melody delicately picked on the guitar with swaying, layered rhythms that perfectly echo the yearning of the lyrics— listen to the 1953 recording by Lolita Cuevas with Frantz Casséus (at folkways.si.edu). However, like many good songs, "Ti Zwazo" traveled far beyond its home, and it's now better known as "Yellow Bird." The lyrics of "Yellow Bird" are scrubbed of references to slavery and of the original's sensuality; the arrangement is usually calypso (as sung by Harry Belafonte) or pop (in the Mills Brothers hit). Without lyrics, it has become a steel drum band staple. Listening to a century of covers of "Choucoune" is an education in how musical meaning and its mode of expression transform as it transits traditions.

Music is an art, and works of music can engage us aesthetically, but the domain of the aesthetic goes far beyond the arts to include nature, scientific, mathematical, and philosophical ideas, industrial design, interface design, home decorating, clothing, food and drink, and more (Saito 2007; Lopes 2018b). In lieu of a principled demarcation of the domain, here is a second case, a personal example. Fabrics can be woven in patterns, and choice of pattern is

usually aesthetic. Indeed, a patterned weave is considerably more costly to produce than a calico, and it provides no additional protection against the elements. A striking example is plaid, and I have inherited a double dose of plaid aesthetics. My paternal ancestors hail from the Konkan Coast of the Arabian Sea, where plaid muslin is traditionally worn by men as lungis and by women in saris and dresses. In these plaids, vegetable dyes in brilliant colors are combined in busy, asymmetrical patterns. Meanwhile, the McIvers hail from Na h-Eileanan Siar, where *breacan* tartans have been woven for centuries (though their use as clan emblems is recent). Unlike Madras plaids, tartans are composed in symmetrical patterns, and the color palette is, believe it or not, more subdued. Nobody would ever mistake one for the other, and an aesthetic propinquity for one entails little appreciation of the other.

Talk of "hedonic culture" sounds odd as long as our paradigms are pleasures attached to basic human functions—the pleasure of quenched thirst, for example. We want cases of pleasing activities that go into non-artistic and non-aesthetic cultures. Take the exercise of physical prowess. Faced with long winter nights in the confined space of an igloo (or community center), young Inuit entertain themselves with activities such as akratcheak. The aim in akratcheak is to jump off two feet, touch a hanging target with one foot, and stick the landing on the same foot (e.g., vimeo.com/377565255). Watching a skilled performance is a joy for those brought up in akratcheak, and their skillful success is typically a joy for performers too. The same goes for kudoda, which my East African cousins taught me. A small group of children sit around a marble pit, and each takes a turn tossing a marble in the air and, before it lands, picking up as many marbles as they can. Keeping an eye on the tossed marble while getting busy with the fingers is much harder than it sounds. Skilled kudoda is great fun. In general, achievement merits pleasure (Bradford 2015).

The cases are samples. Each should give the characteristic flavor of one of the three cultures of taste while indicating something of its

range of variation. What Cuevas and Casséus do with "Ti Zwazo" isn't the same as what the Mills Brothers do with the same song, "Yellow Bird." There are many plaid aesthetics. Enjoyable game play varies with games played. Variation within each kind of culture expresses the character of the kind.

2.3 Culture, Minimally

Another abstract classifier figures in the claim that artistic, aesthetic, and hedonic cultures are distinct kinds of culture, each with variants. The same classifier no doubt figures in a great deal of merely verbal disagreement. For this reason, cautious uses of "culture" should stipulate to its meaning. Indeed, some usage is at odds with talk of the distinctness of and variation within the cultures of taste.

Thus we sometimes talk of cultures as groups of people, populations. The statement that all cultures have art evidently uses "culture" to refer to groups of people, Inuit or inhabitants of the Konkan Coast, for example. However, this use of "culture," whatever its merits in some contexts of inquiry, makes nonsense of the claims that artistic, aesthetic, and hedonic cultures are distinct types with variants. Surely, the idea isn't to divide the human population into artistic, aesthetic, and hedonic types and sub-types.

To make sense of our three kinds of culture, we need to represent them not as populations but as properties of populations. Not all properties of populations are cultural, though. The Inuit population has a lower incidence of genes coding for a high ratio of pheomelanin to eumelanin than there is among the population of Scots, but that's not a property in the same class as that of being players of akratcheak or speakers of Kreyòl. For one thing, playing akratcheak and speaking Kreyòl are behavioral properties. For another, the behaviors are learned. Therefore, let a culture be a regularity in the behavior of a population that is due to members of

the population sharing formative conditions distinct from the formative conditions shared by other populations (see Richerson and Boyd 2005: 5; Patton 2014: 51).

Briefly, then, a culture is a regularity in the behavior of a group that is due to group members sharing a common formative background. This theory is minimal. That is, it's compatible with many richer conceptions of culture that are incompatible with each other (e.g., Baldwin et al. 2006). Noting this, one might worry that the theory is so minimal as to be empty. However, we sometimes need to minimize our commitments in order to avoid the mistake of building what ought to be hard-won conclusions into the conceptual framework within which we express our assumptions. Moreover, the minimal theory steers past some pitfalls in thinking about cultures.

One pitfall is a view of cultures as homogeneous, uniform, or static. Such a view would be rather conspicuously unattractive when it comes to artistic, aesthetic, and hedonic cultures. For example, the tartan aesthetic has changed markedly over the centuries, and many musical traditions house factions with competing visions of how to move forward. Fortunately, a group's having a culture, in the minimal sense, implies neither that every member of a group displays the same behavior nor indeed that no member behaves in ways that disrupt the pattern. Behavioral regularities can change over time, and they can include side currents, sub-currents, and counter-currents.

A second pitfall is cultural adaptationism, understood as representing cultures as learned behavioral regularities that equip group members to flourish in their physical or larger social environments. Adaptationism has proven tempting; it was endorsed by the earliest theorists of culture, notably Georg Forster and Herder. True, playing akratcheak might help northerners to cope with long, dark winters stuck indoors, and plaid might signal group membership in social circumstances where misidentification is costly. Adaptationism goes much further, insisting that, in every

case, part of what explains why a group has its own particular he-
donic, aesthetic, or artistic culture is that the culture equips group
members to flourish in their physical or social environment. We
should be open to the possibility that what explains some variations
in hedonic, aesthetic, or artistic cultures has nothing to do with ad-
aptation to the local environment. It will be an empirical matter
whether facts about adaptation are explanatory in a given case. The
minimal theory articulates a commitment to this principle.

In point of history, adaptationism has allied with organicism, but
the alliance isn't a point of logic, and they deserve separate treat-
ment. Cultural organicism takes the culture of a group to be the
complex property of its having a bundle made up of an epistemic
culture, a legal culture, religious culture, a food culture, an artistic
culture, and the like (e.g., Tylor 1871: 1). Each element that goes
into the makeup of the organic culture is thought to contribute es-
sentially and ineliminably to the whole. According to a restricted
version of organicism, every artistic, aesthetic, or hedonic culture
is essentially bundled with some other kind of culture. As noted
above, Herder took a group's artistic or aesthetic culture to consist
in its members making artifacts that yield pleasure in expressions
of the felt fit between other cultural elements (such as political or
religious culture) and the group's physical or larger social environ-
ment. Here adaptationism is twinned with organicism, where ar-
tistic or aesthetic culture necessarily reflects upon other elements
of culture. Again, the objection isn't that cultures of taste are never
parts of organic wholes. Rather, we shouldn't assume that what
explains variations in hedonic, aesthetic, and artistic cultures al-
ways has to do, in part or in whole, with their relation to some other
element of a group's cultural repertoire. The minimal theory steers
us past the pitfalls of organicism.

The minimal theory is content-neutral, making no assumptions
about the kinds of facts we must appeal to in order to explain var-
iations in hedonic, aesthetic, or artistic cultures. Why akratcheak,
not kudoda, for these people at this time? Why this plaid aesthetic

and not that one? Why steel band rather than acoustic guitar? The answers might or might not appeal to adaptive benefits or to relations to other kinds of culture.

Putting it another way, the minimal theory of culture exerts no pressure that skews our theorizing about what makes some cultures artistic, aesthetic, and hedonic. We need not think of aesthetic cultures as just those that have certain adaptive benefits, and we need not think of artistic cultures as those that express other elements of an organic cultural whole. Our thinking may run in these directions only on independent grounds.

2.4 Etiological and Beneficial Functions

In ratifying a minimal theory of culture, Section 2.3 cleared the decks of some presuppositions about how to explain variants of a culture kind. Yet the minimal theory does impose a substantive commitment: Cultures are constituted, at least in part, by behavioral regularities. By extension, kinds of culture are constituted, at least in part, by kinds of behavioral regularity. Legal cultures are regularities of legal behavior, hunting cultures are regularities of hunting behavior, and aesthetic cultures are regularities of aesthetic behavior (of which Madras plaid aesthetic culture is one among many variants). What remains is to bring in value, for the cultures of taste are organized around values. This section distinguishes between cultures that are organized around values in different ways. The distinction matters if it turns out that aesthetic and artistic cultures aren't organized around values in the same way as hedonic cultures.

Drawing the distinction requires some apparatus. To begin with, some cultures are social practices. That is, they're learned regularities in a group's behavior that arise either from members of the group complying with social norms or from their settling into game theoretic equilibria (e.g., Lewis 1969; Schotter 1981; Bicchieri

2006). Arguably, the options are equivalent (Guala 2016). For sake of simplicity, assume that behavioral regularities in social practices result from compliance with social norms. Social norms can consist in mutual expectations on the part of those who comply with them, sometimes motivated by sanctions. Importantly, though, social norms can be built into the physical environment. For example, compliance with a norm to drive on the right is largely secured not by mutual expectations or sanctions but rather by the construction of driving infrastructure.

Social norms have a function, namely to equip interacting agents to coordinate with each other around an activity (Tuomela 2013; Guala 2016). A hunting party tracking its dinner might concoct a scheme of whistles to indicate the prey's position. Complying with the norm to use the signaling scheme promotes their coordinated activity. Likewise, complying with the rule, "take one, leave one," enables the coordinated activity of stocking the neighborhood book exchanges that have popped up everywhere.

The function of social norms to scaffold coordinated activity is characteristically their etiological function. An item's etiological function is what the item does that caused it to be selected in the recent past (Millikan 1984). For example, pumping blood is what hearts do that caused their recent ancestors to be favored by natural selection: Pumping blood is their etiological function. Glenn Parsons and Allen Carlson extend etiological functions to artifacts: an artifact has an etiological function just in case it's currently manufactured and distributed because its recent ancestors performed that function, thereby causing their success in the marketplace (2008: 75). Some philosophers of social science attribute etiological functions to social institutions. Money is the go-to example (e.g., Hindriks and Guala 2021; cf. Searle 1995). Ahnaf has meat, Brina has jackfruit, and Clara has onions, but Ahnaf wants onions, Brina could use some meat, and Clara cooks vegan. In a barter system, tricky workarounds are needed to get everyone what they want. Money functions to coordinate exchanges of goods. The

function is its etiological function if the institution of money is sustained because its having recently performed that function causes it to persist. In short, an item's etiological function is a self-sustaining one. With that it in mind, it's easy to see that scaffolding coordinated activity is the etiological function of social norms. The norm "take one, leave one" has caught on because recent compliance with it has kept the neighborhood book exchanges stocked. The etiological function of a social norm is what it does to sustain an activity that thereby sustains the norm.

We are ready for a handy principle. The constitutive elements of a culture that is a social practice include any norms whose etiological function it is to scaffold coordination of the very activity that is constitutive of the culture (Hindriks and Guala 2021: 2033). Hunting culture is constituted by a kind of behavior, hunting, and hence also by norms of the kind that scaffold coordination in hunting. Likewise, it's constitutive of legal cultures that they have the kind of norms whose etiological function it is to scaffold coordination in legal activities. Needless to say, the precise content of norm kinds and the precise activities of the kinds that they scaffold differ from one variant of the culture to the next. What is constitutive of a kind of culture is a kind of activity together with the kind of norm whose etiological function it is to scaffold that kind of activity.

Activities frequently entrain benefits. Hunting feeds the community, fosters social cohesion, hones martial skills, increases cardiovascular performance, and builds up ecological knowledge. Exchanging books widens readership, conserves trees, signals virtue, and, to our gratification, erodes Jeff Bezos's bottom line. An activity can have beneficial functions: It functions to generate benefits. The same goes for norms, which inherit activities' beneficial functions. The constitutive norms of hunting cultures, which have the etiological function of scaffolding coordination in hunting, thereby function to bring such benefits as deepening folk biology. Deepening folk biology might be a beneficial function of a hunting norm.

Sometimes a beneficial function of a social norm is also its etiological function. Espresso culture consists in learned regularities of behavior: growing beans, then roasting them, manufacturing equipment, pulling shots, and drinking them. Behind these regularities are some social norms, including design specifications for equipment and the rules of the barista. One norm that governs both design specs and barista behavior is this: keep dose size constant, around twenty grams; never adjust the dose in order to alter a shot's flavor, strength, or volume. Plausibly enough, espresso culture is organized to secure yummy shots of espresso. In other words, the behavioral regularities and the norms that scaffold them have the beneficial function of dispensing espresso yumminess. That is what it's all about. Clearly, the beneficial function is also an etiological function. Take the activities. La Marzocco continues to manufacture espresso equipment because that equipment has recently functioned to dispense espresso yumminess. Now the norms. Baristas continue to use twenty-gram doses because the norm has functioned to generate espresso yumminess. So, the norms and the activities that they scaffold both sustain and are thereby sustained by the flow of espresso yumminess. The beneficial functions are self-sustaining. Indeed, since dispensing espresso yumminess is an etiological function of the norms and activities that are constitutive of espresso culture, that beneficial function is also constitutive of the culture.

Not every beneficial function of the constitutive norms and activities of espresso culture is also constitutive of the culture. After all, not every beneficial function is an etiological function. Drinking espresso makes for good philosophy. Obviously. So that's a beneficial function of espresso norms and activities. Yet neither the norms nor the activities that they scaffold are sustained by their making for good philosophy. Philosophy is just not that important. Since making for good philosophy isn't an etiological function of espresso culture, neither is it constitutive of espresso culture.

What about deepening folk biology, honing martial skills, fostering social cohesion, and feeding the community? These are beneficial functions of hunting cultures, but are they etiological functions, hence constitutive? Arguably not. Trophy hunting is a variant of hunting culture, but it doesn't feed the community, so feeding the community isn't a beneficial function that constitutes the kind, hunting cultures.

To recap, some kinds of culture are constitutively organized to generate benefits. Let a kind of culture be internally beneficial with respect to beneficial function, f, just when f is an etiological, hence constitutive, function of the culture kind. Espresso culture is internally beneficial with respect to dispensing shots of espresso yumminess. Generalizing, let an internally beneficial culture be one that is internally beneficial with respect to some f. An internally beneficial kind of culture has at least one beneficial function that is constitutive of it. By contrast, an externally beneficial culture kind is one that is internally beneficial with respect to no f. It might well have beneficial functions, but none of them is constitutive of it, because none of them is its etiological function.

Even if the distinction between internally and externally beneficial culture kinds is logically kosher, one might wonder whether it's useful. Surely, one might think, every kind of culture that is a social practice yields the benefits of coordination, which are internal to it. Not so. Coordination isn't always a benefit in itself. Take linguistic cultures. Linguistic cultures are regularities of behavior that are due to an etiological norm kind, speak L hereabouts. In Port-au-Prince, and parts of Montréal and New York, the operative norm is speak Kreyòl, and local compliance with the norm gets folks coordinated, speaking the same language. However, speaking the same language isn't in itself a benefit; it's a benefit only in as much as it leads to downstream benefits, such as attending better parties and getting salt when you say "*tanpri pase sèl la.*" Getting those benefits isn't constitutive of Kreyòl linguistic culture. Since coordination isn't always a benefit in itself and since any downstream benefits need

not be constitutive, there are some externally beneficial kinds of cultures, where coordination isn't a benefit and no beneficial function is an etiological one.

This section distinguishes internally beneficial kinds of cultures from externally beneficial ones. Armed with the distinction, we can represent some beneficial functions of a culture kind as constitutive. However, not all culture kinds are constituted by beneficial functions. Espresso cultures are plausibly constituted by a beneficial function: To be an espresso culture is in part to yield espresso yumminess. Maybe linguistic cultures aren't constituted by the beneficial functions that they obviously perform: They are what they are no matter what their benefits, as profound as they might be. Having internal benefits needn't correlate with having greater benefits.

Section 2.1 described a tidy arrangement wherein artistic and aesthetic cultures reduce to hedonic culture. In breaking up the tidy arrangement, care must be taken to leave behind the baggage. Here is the baggage: since hedonic culture is internally beneficial, we are tempted to take aesthetic and artistic cultures to be internally beneficial too. The next section argues that hedonic culture is internally beneficial. The two subsequent sections argue that aesthetic and artistic cultures aren't internally beneficial. Viewing them as constituted by beneficial functions misleads us about their nature and hence how they vary in ways that submit to empirical explanation.

2.5 Hedonic Cultures

Take akratcheak and kudoda. What makes them hedonic cultures? In general, what features constitute the hedonic culture kind? The answer hangs on a viable theory of pleasure. Some theories of pleasure imply that there are no learned regularities in pleasure response. For instance, there are no hedonic cultures if pleasures are

subjective in the sense that they're resolutely intractable to social conditioning. Recent theories of pleasure, notably Matthen's (2015, 2017, 2018a, 2018b, 2020), accommodate the existence of hedonic cultures with variants (see also Bolzano 2023 [1843/1849]).

Matthen takes his cue from the brain and behavioral sciences, where anatomically distinct structures have been found to support functionally distinct pleasure systems (e.g., Kubovy 1999; Berridge and O'Doherty 2014). The phylogenetically more ancient system yields what Matthen (2017) calls "relief pleasures," which come with restoration of physiological equilibrium. Examples are sneezing, scratching an itch, and quenching thirst. Pleasures such as these aren't motivating; they're not impulses to perform a specific act. By contrast, the phylogenetically newer system generates facilitating pleasures, which motivate continued engagement in the very activities that give rise to them. A simple example would be the pleasure taken in a ping pong volley. Keeping the ball in play causes pleasure that motivates continuing to keep the ball in play, which causes pleasure, which Unlike relief pleasures, facilitating pleasures are forward-looking impulses to act.

Facilitating pleasure's motivating power drives performances that consume energy and demand attentive mental and bodily coordination. To keep the ping pong volley going, you must keep your eye on the ball and your opponent's whereabouts while positioning yourself to make well-executed returns, all the while planning what to do if the ball goes wild. The pleasure of keeping the volley going facilitates the exercise of a competence, a "coordinated group of mental and bodily 'preparations' that encourage, ease, and optimize" a performance (Matthen 2017: 8). Needless to say, facilitating pleasures can also encourage, ease, and optimize coordinated groups of strictly mental performances.

One more idea. Some competences develop spontaneously— for example, a toddler's learning a mother tongue—but most competences are learned through repeated, effortful trying. Learning of this kind is costly and difficult, but facilitating pleasure

incentivizes learning by immediately rewarding the learner's efforts. In as much as it arises directly from awareness of performing a difficult task and as long as it activates competences that facilitate and optimize task performance, facilitating pleasure "enables productive agency" (Matthen 2017: 13).

Many behavioral regularities are products of facilitating pleasure. When a behavioral regularity in a population involves the exercise of competences that are acquired by repeated, effortful trying, then facilitating pleasure sub-serves their being learned. As a result, the following first pass at a theory of hedonic culture won't do. Where P is a population and φing is a behavior,

> K is a hedonic culture of P = K involves a regularity of φing that implicates a facilitating pleasure's motivating learning a competence to φ.

The trouble lies with a vital corollary of the account of facilitating pleasure: Facilitating pleasure is involved in learning across the board. That is its raison d'être. Since facilitating pleasure is widespread, the first pass implies that just about all cultures are hedonic cultures. Hunting cultures, noox cultures, espresso cultures, philosophical cultures, artistic cultures, and aesthetic cultures all implicate facilitating pleasures; they turn out to be hedonic cultures. The first pass overgeneralizes.

The lesson isn't that it's a mistake to appeal to facilitating pleasures in a theory of hedonic culture. Rather, we must resist inferring from the observation that a cultural activity involves pleasure to the conclusion that it is hedonic. Plaids please, as does méringue lente, but it doesn't follow immediately that they're hedonic cultures. There is more to being a hedonic culture than being a culture where learning gets a boost from facilitating pleasure. Some additional feature is constitutive of hedonic cultures.

Consider akratcheak next to philosophy, and the following thought is plain: Akratcheak is a hedonic culture in the sense

that its special point—its special function—is hedonic. The same doesn't go for philosophy. Of course, philosophy does function to please, as smiling faces at the American Philosophical Association (APA) attest. In fact, any culture where pleasure facilitates learning is one that has a hedonic beneficial function. The thought must be that some "special" function sets hedonic cultures apart.

Deploying the apparatus devised above, hedonic cultures have it as their etiological function that they deliver pleasure; the function is constitutive of them. Recall that something has etiological function f just when it's there because it does f and f gets done because it's there. Accordingly,

> K is a hedonic culture of P = (1) there is a behavioral regularity R in P and (2) the etiological function of R is to yield hedonic benefits.

An added wrinkle is that hedonic cultures are social practices. Akratcheak has rules, which are constitutive of it, because following the rules helps secure the regularity plus its internal benefits. Building this into the above formula, we get

> HC: K is a hedonic culture of P = (1) there is a behavioral regularity R in P, (2) there are social norms N in P, (3) N secures R, and (4) the etiological function of R and N is to yield hedonic benefits.

The norms and behavioral regularities of akratcheak constitute a hedonic culture because they persist among Inuit today just as a result of the pleasure they brought to earlier generations. They're sustained just by the pleasure they bring. By contrast, the norms and behaviors of philosophy don't constitute a hedonic culture, even if they brought considerable pleasure to earlier practitioners, for they aren't sustained just by the pleasure they bring.

(HC) answers the question, what are hedonic cultures such that variant hedonic cultures are conditioned in ways that submit to

empirical explanation? The argument for (HC) is that it adequately frames empirical studies of variant hedonic cultures.

The explanatory resources shake out as follows. First, each variant of hedonic culture is a specific activity or behavioral regularity. We can describe the behavioral regularities specific to akratcheak. Second, variant hedonic cultures have norms whose etiological function is to secure a coordinated activity that in turn yields pleasure. The precise content of the norms of akratcheak is an empirical discovery. Third, cultures are behavioral regularities that are due to shared formative conditions. Variance in educational, technological, and economic conditions can explain variance in the norms and behavioral regularities of variant hedonic cultures. The method is to explain cultural transmission as an effect of education, technology, economic arrangements, and the like.

The standout virtue of (HC) is that it doesn't represent variant hedonic cultures as settings within which people simply have different pleasure responses. Hedonic cultures have the constitutive function of generating pleasure, but variants of pleasure responses cannot explain much by themselves. It's a mistake to think variation in hedonic culture is explained by people enjoying different things. That's not an explanation at all; it simply reiterates what needs to be explained. According to (HC), what explains variations in hedonic culture are behavioral regularities, norms, formative conditions, and physical and social context.

2.6 Aesthetic Cultures

Section 2.1 raised the question whether all three cultures of taste are organized around values in the very same way, and Section 2.4 distinguished two ways cultures can be organized around values, one seen in internally beneficial cultures and the other seen in externally beneficial ones. Section 2.5 made a case that hedonic culture is internally beneficial. So the question now is whether aesthetic

culture is internally or externally beneficial. Following some pre-
liminary setup, this section argues that aesthetic cultures aren't he-
donic cultures. They're so diverse that squeezing them into (HC)
fails to provide adequate resources for explaining their variants.
The lesson is that they're externally beneficial, hence structur-
ally disanalogous from hedonic cultures. The challenge will be to
represent how aesthetic cultures can be externally beneficial yet
constituted by a distinct kind of value.

If they are cultures at all, then aesthetic cultures are learned be-
havioral regularities. Thinking this way can demand something of a
shift in gestalts. What comes first to mind in thinking about *breacan*
tartan and Madras plaids is that they're the stuff of material cul-
ture. However, given the minimal theory of culture sketched above,
the concept of a material culture is derivative. Material cultures
just are the physical traces of learned behavioral regularities. Thus
plaid aesthetic cultures aren't, at bottom, inventories of materials
with aesthetic features; they're, at bottom, regularities of behavior
in which materials' aesthetic features are implicated. What ac-
tivities? Some of the activities of plaid aesthetic culture include
making items with certain patterns, wearing or displaying them,
and inventing the patterns themselves. The aesthetic features of the
materials focus on activities such as these.

Supposing that tartan and Madras plaid are aesthetic cultures
made up of activities focused on materials' aesthetic features, we
must ask what features are aesthetic. Unfortunately, no theoret-
ical consensus exists. Fortunately, we may rely on a consensus with
respect to paradigm instances, which are reflected in paradigm
aesthetic terms (Sibley 1959, 1965). In Frank Sibley's famous list,
paradigm aesthetic terms include "unified, balanced, integrated,
lifeless, serene, somber, dynamic, powerful, vivid, delicate, moving,
trite, sentimental, tragic" (1959: 421). This list isn't idiosyncratic: It
closely matches others' lists (De Clercq 2008). Nonetheless, it's paro-
chial, reflecting the critical discourse of a time and place. Aesthetic
terms manifestly vary from one context to the next. The Yoruba

"*jijora*" and "*tutu*" have no easy translations into English, for example (Thompson 1983). The question is whether one paradigm is a guide to others (Layton 2011). Does mastery of the Sibleyan lexicon give us confidence that "*wabi-sabi*" or "beausage" are also aesthetic terms? Let us assume—because we have no alternative—that we have a loose but adequate pre-theoretic grip on the boundaries of the domain of aesthetic features, even as they vary among aesthetic cultures.

Young women who belong to the Kunbi community inhabiting the Konkan Ghats wear a fabric whose plaid, predominantly in red, is vital and buoyant. Widows wear a plaid in yellow and lilac, somber colors. Here we have a regularity in behavior that turns on the aesthetic features of items in a social context. The idea is that it's not enough to say that young Kunbi women wear a fabric because it's red; rather, they wear red because red is vital and buoyant. That is, for them, the reason to wear red. Highlanders do not concur. A blend of yellow and lilac isn't particularly somber in the tartan aesthetic.

Some features of items are values, in a modest sense. Put modestly, values are features that have a negative or positive polarity, such that agents have reason to act in ways that promote the spread of the positive ones and that inhibit the incidence of the negative ones. A tartan's vividness is a merit if being vivid is reason for weavers to act in ways that promote more tartans being vivid. Another tartan's lifelessness is a demerit in it if being lifeless is reason for weavers to act in ways that lead to fewer items being lifeless. Values are, in the modest sense, features that figure in reasons to promote or inhibit.

As these examples suggest, variant aesthetic cultures are behavioral regularities that implicate different schemes of aesthetic value. In the Kunbi plaid aesthetic, red makes for buoyant and vital. In the tartan aesthetic, red makes for noble, and yellow plus lilac is light and lively, though those same colors are decidedly somber in the Kunbi plaid aesthetic. Each aesthetic culture has a repertoire of

ways of realizing aesthetic values in items' other features (Gombrich 1960: 367–370; Walton 1970). Call this the culture's "aesthetic profile" (Lopes 2018b). The aesthetic profile of a culture is the pattern of correlations that obtains between the aesthetic values of items and some other properties they have. Alternatively, it's a relationship between the distribution of aesthetic values over items and the distribution of some other properties over the items. In the aesthetic profile of Kunbi plaid, some two-dimensional designs make saris somber; in the aesthetic profile of tartan, the same two-dimensional designs make kilts light and lively.

One more preliminary. Aesthetic cultures are social practices if they are behavioral regularities scaffolded by norms. Plausibly, the behavioral regularities of members of the Kunbi community come from compliance with the norm to act in accordance with the Kunbi plaid aesthetic profile, not the one for tartan. Generalizing, for any aesthetic culture, there is a norm: act in accordance with the relevant aesthetic profile. The norm is constitutive of aesthetic cultures if it sustains and is thereby sustained by aesthetic activity.

This setup is common ground shared between two theories of aesthetic culture. On both theories, aesthetic cultures are behavioral regularities backed by a norm to act in accordance with an aesthetic profile. One theory stops right there. According to

AEC: K is an aesthetic culture of P = (1) there is a behavioral regularity R in P, (2) there is a norm N in P to act in accordance with K's aesthetic profile, and (3) N secures R.

On this theory, aesthetic cultures are externally beneficial, for (AEC) doesn't make any beneficial function constitutive of aesthetic cultures. The claim isn't that aesthetic cultures have no beneficial function. Their beneficial functions might simply differ from one variant to the next.

By contrast, a hedonic theory of aesthetic culture—part of tradition's tidy package—represents aesthetic culture as a special

case of hedonic culture by appending a further claim to (AEC). According to

aesthetic culture hedonism: K is an aesthetic culture of P = (1) there is a behavioral regularity R in P, (2) there is a norm N in P to act in accordance with K's aesthetic profile, (3) N secures R, and (4) the etiological function of R and N is to yield hedonic benefits.

Unlike (AEC), aesthetic culture hedonism singles out a beneficial function of aesthetic cultures, namely their providing pleasure, as etiological, hence constitutive. The claim isn't merely that aesthetic cultures are sources of pleasure. (AEC) allows for that, because pleasure motivates learning and aesthetic culture involves learning. The claim is more strongly that the norms and behavioral regularities of aesthetic cultures sustain and are sustained just by their hedonic benefits.

Reducing aesthetic cultures to hedonic ones taps the long and deep appeal of aesthetic hedonism, the default theory of aesthetic value. According to aesthetic hedonism, an item's aesthetic value is its meriting or being disposed to elicit pleasure in a given context (Lopes 2018b: ch. 3; Van der Berg 2020; Lopes 2021b). The vividness of a tartan is an aesthetic good because it merits or conduces to pleasure. Notice how the view makes perfect sense of aesthetic value as modestly conceived. Modestly conceived, a plaid's vividness is a value in the sense that it is reason for weavers to act in ways that lead to more tartans being vivid. Why is it a reason for weavers so to act? In so acting, they provide for more pleasure, and anyone always has reason to provide for more pleasure. This is the appeal of aesthetic hedonism.

Nonetheless, is clause (4) of aesthetic culture hedonism true? Madras plaid and tartan are two among many, many aesthetic cultures. Others are organized around the aesthetic profiles of natural environments, scientific, mathematical, and philosophical ideas, non-literary writing, industrial, graphical, and interface

design, home decorating, clothing, cosmetics and body shaping, animal breeding, food and drink, and more. Now consider the vast range of beneficial functions served by these aesthetic cultures. They help to convey ideas more clearly, smooth practical tasks, signal capacities to care for self and close associates, sharpen social distinctions, impose social benefits and burdens, foster a sense of community, boost ethnic or national pride.... Yet, on the hedonic theory of aesthetic cultures, the norms and regularities that are constitutive of aesthetic cultures are never there because they secure these benefits; they're always there because they secure pleasure.

The trouble with the hedonic theory is that it inadequately frames empirical explanations of variant aesthetic cultures. It rules out that tartan persists because it equips Scots with badges of identity, that aesthetically stylish academic writing persists (in some corners) because it amplifies the power of ideas, and that some female beauty cultures persist because they privilege males (Rhode 2010). Making matters worse, it's possible—indeed likely—that the beneficial functions that explain why a given aesthetic culture persists change over time. Bodily beauty cultures that persisted because they privilege males might now persist because they enable us to see ourselves not as givens but as "becoming, promising, and potential objects" (Widdows 2018: 185–186). These hypotheses might be true; only empirical study can settle the matter.

The alternative, (AEC), is open ended—that is, it's open as to the ends secured by any given aesthetic culture. Variant aesthetic cultures can persist because they perform different beneficial functions, sometimes changing ones. As a result, no beneficial function can be singled out as constitutive of aesthetic culture across the board. Aesthetic culture is externally beneficial—in this respect it's more like linguistic culture than hedonic culture.

That poses a challenge for (AEC). Linguistic cultures aren't organized around values, and one might wonder how cultures can be organized around values unless they're internally beneficial. Recall the appeal of aesthetic culture hedonism: a plaid's vividness is a

value because it provides for more pleasure, where providing for pleasure is the internal benefit of aesthetic culture. So, how are we to understand the values of aesthetic cultures without appealing in a similar way to their internal benefit?

Aesthetic cultures are regularities of behavior, but the behaviors span many different activities. The activities of plaid aesthetic cultures include appreciating, wearing, making, writing about, conserving, collecting, and displaying. Those who engage in each kind of activity have their own goals and draw upon competences suited to their goals (Lopes 2018b: ch. 5). Success in designing a tartan isn't the same as success in conserving one, and competence conducive to the one success needn't conduce to the other. Where achievement is success out of competence, achievement varies by kind of aesthetic activity. However, achievements interdepend. I cannot achieve in designing a tartan unless wearers, critics, collectors, curators, and others achieve in their specialized activities. Moreover, their achievements depend just as much on the achievements of designers. So the achievements of some float achievements overall. Here is the crucial point. Sometimes we all achieve together by bringing about the very same goal, but, in aesthetic cultures, we all achieve together by each realizing our specialized goals. When the designer achieves because the critic achieves and the critic achieves because the designer achieves, each has succeeded in realizing different goals.

What this kind of mutual achievement requires can be seen in failures to achieve, and one failure is key. Suppose a tartan designer needs to create a pattern that is light and lively, and she selects a blend of yellow and lilac. Now imagine a critic who is new to tartan but has a deep familiarity with Madras plaid. He says, "too somber." Each has to some extent failed, and the reason is that they aren't on the same page, aesthetically. They aren't both using the same aesthetic profile. She uses the tartan aesthetic profile; he goes awry in using the Madras plaid aesthetic profile, on which a blend of yellow and lilac is somber. Their mutual achievement requires that they

converge on the aesthetic profile (Lopes 2018b: ch. 6). That is why the generic norm for any aesthetic culture is to act in accordance with the culture's aesthetic profile.

The challenge was to answer how cultures can be organized around values unless they're internally beneficial. Put bluntly, what is a value, if not a benefit? The answer is twofold. On the one hand, aesthetic profiles, like languages, enable coordination. Coordination secures achievement, and achievement implies success, but those who achieve together needn't succeed with respect to a shared goal. On the other hand, the aesthetic features upon which participants in a culture coordinate, such as being light and lively, are values in the modest sense. When designers and critics get in sync, their acts increase the incidence of tartans that are light and lively and lower the incidence of tartans that are bland and forgettable. Being light and lively is a positive value, and being bland and forgettable is a disvalue. The modest sense of value doesn't imply that to be a good is to benefit (or that to be bad is to harm).

The case for (AEC) is that it provides a better platform for empirical explanations of variations among aesthetic cultures than does aesthetic culture hedonism. It provides a better platform specifically because it represents aesthetic cultures as externally beneficial.

In many respects, the two theories are on a par. Aesthetic cultures are regularities in aesthetic activity whose precise contours vary from one culture to the next. All incorporate a generic norm, to act in accordance with the aesthetic profile, but the profiles vary, and the constitutive norm might be supplemented by various other norms (Rohrbaugh 2020; Kubala 2021). Since norms and competences for success must be learned, variance in educational, technological, and economic conditions helps explain variance among aesthetic cultures. Maybe the norms and behavioral regularities of some aesthetic cultures can be explained as fitting

other elements of a group's cultural repertoire or as outfitting group members to cope with their environment.

The theories part ways on whether any beneficial functions are constitutive of aesthetic cultures. Aesthetic culture hedonism rules out explanations according to which aesthetic cultures vary because they cement social identity, buttress social injustice, amplify cognitive goods, and the like. (AEC) rules none of these explanations out, and that is a mark in its favor.

In addition, though, it's worth considering whether aesthetic cultures can serve certain beneficial functions specifically because they provide platforms for achievement, where those who achieve together needn't succeed with respect to the same goal. Philosophers have recently argued that aesthetic cultures are well suited to serve interests in positive causal networks and felt fulfillment (Lopes 2018b: 210–213), having experiences (Nanay 2022), negotiating value diversity (Lopes 2022), low-stakes disagreement (Nguyen 2023), building community (Polite 2019; Riggle 2021; Cross forthcoming), and freedom or autonomy (Lopes 2019; Matherne and Riggle 2020–2021; Lopes 2021a; Riggle 2022; Walden forthcoming). None of these ideas entails that aesthetic cultures are internally beneficial, because none entails that the benefit is constitutive of aesthetic cultures across the board. Yet, arguably, they leverage the characteristic structure of aesthetic cultures, where participation doesn't imply commitment to a shared goal.

The proposed theory is the one to prefer because it doesn't rule out perfectly good empirical explanations of variations in aesthetic culture. As a bonus, understanding how aesthetic cultures can be value cultures without constitutive benefits suggests how they're well suited to serve a menu of special interests. Empirical methods suss out whether any given aesthetic culture is to be explained as one that does serve those interests.

2.7 Artistic Cultures

Whereas hedonic cultures are internally beneficial, aesthetic cultures are externally beneficial, though organized around constitutively aesthetic values. What about artistic cultures? They instantiate a third structure. Like aesthetic cultures, they're externally beneficial. Unlike aesthetic cultures, they aren't organized around constitutive values. Instead they're organized around sundry values of artworks, and what is constitutive of them is kinds of works. The drill should be familiar: The case in favor of the theory is that it adequately frames empirical studies of variations among artistic cultures.

If they are cultures at all, then artistic cultures are learned regularities of behavior. This claim, like its analogue concerning aesthetic culture, requires a shift in gestalts. "Ti Zwazo" and "Yellow Bird" are works of art, and it's tempting to conceive each artistic culture as a collection of works. As we shall see, their products will play a pivotal role in understanding artistic cultures. Even so, the minimal theory of culture represents artistic cultures as, at bottom, regularized activities. The activities include making works of art, performing them, and appreciating them, but also arranging, editing, curating, conserving, and writing about. That's just for a start. The ways in which we can engage with works of art are myriad.

Assume that artistic activities pick up on artworks' values. Making, performing, editing, conserving, and other artistic activities are done with an eye to the values found in works of art. Someone making an arrangement of "Ti Zwazo" preserves some but not all features of the Cuevas and Casséus performance. We might ask, why those features and not others? An example of the kind of answer we expect might be that the lyrics meaningfully evoke the historical experience of slavery. The answer might echo Ralph Ellison: "art can reveal on its own terms more truth while providing pleasure, insight and, for Negro readers at least, affirmation and a sense of direction. We must assert our own sense of

values, beginning with the given and the irrevocable, with the question of heroism and slavery" (2003: 740). Notice also that the values to which we appeal in this way can be values in the modest sense. Providing a sense of affirmation and direction can be good just in the sense that successfully acting on these values leads to their increased incidence.

Given this assumption, here is a very rough schema, or placeholder, for any theory of artistic culture:

K is an artistic culture of P = (1) there is a behavioral regularity R in P, (2) there is a norm N to act in accordance with K's values, and (3) N secures R.

This is a schema because it details neither the norms nor the values that constitute artistic cultures. Various norms and values can be specified, and some specifications don't accommodate empirical explanations of variant artistic cultures.

According to the tidy arrangement that dominated traditional thinking, artistic cultures are hedonic cultures. Equipped with an adequate picture of pleasure and an adequate theory of hedonic cultures, we get

artistic culture hedonism: K is an artistic culture of P = (1) there is a behavioral regularity R in P, (2) there are social norms N in P, (3) N secures R, and (4) the etiological function of R and N is to yield hedonic benefits.

On this theory, K's values are hedonic: They're something like powers of works of K to yield pleasure—pleasure through active engagement with the works. To reject the theory isn't to deny that engagement with artworks can please. Pleasure is a byproduct of many forms of cultural engagement. Everyone can accept that. The trouble is rather that some empirical hypotheses about artistic practices clash with (4). Very often the norms and behavioral

regularities of artistic cultures aren't sustained just by their bringing pleasure. A couple of examples in a moment.

Since Section 2.6 proposed a non-hedonic theory of aesthetic cultures, why not reduce artistic cultures to aesthetic cultures? A vestige of the tidy arrangement is

> *artistic culture aestheticism*: K is an artistic culture of P = (1) there is a behavioral regularity R in P, (2) there is a norm N in P to act in accordance with K's aesthetic profile, and (3) N secures R.

To reject this theory isn't to deny that artworks realize aesthetic values. After all, just about anything can have the Sibleyan aesthetic values listed in the previous section. The trouble is rather that some empirical hypotheses about artistic practices clash with (2) and (3).

In *Painting and Experience in Fifteenth-Century Italy*, Michael Baxandall (1972) examines a painting practice that took advantage of patrons' visual skills, which they had learned in order to measure volumes in mercantile exchanges. Painters made images expecting patrons to exercise these specialized visual skills, and patrons were aware of the expectation. The practice was a learned regularity in the use of skill, and it was governed by a social norm (i.e., a mutual expectation). Baxandall adds that "we enjoy our own exercise of skill" (1972: 34). He is describing an artistic culture that might well have persisted because it served to generate hedonic benefits.

Jennifer Lena's (2019) *Entitled: Discriminating Tastes and the Expansion of the Arts* is a sociological history of art institutions in the United States. On Lena's history, social elites created and controlled these institutions—galleries, orchestras, and ballet companies, for example—which then functioned as signals of elite status. In the late twentieth century, a recalibration was needed, as "elitism" came to be seen as incompatible with genuine taste. The new signal of social status was being an artistic omnivore (minus heavy metal, top of the charts country, and Thomas Kincade's paintings). The artistic cultures that Lena examines don't persist

because they entrain hedonic benefits; they persist because they signal status. Arguably, status gets signaled through making aesthetic judgments—judgments about what is elegant or edgy. So they persist because they're organized around aesthetic profiles.

The story Lena tells is incompatible with hedonism about artistic cultures, but it's not incompatible with artistic culture aestheticism. Now consider the work of the cultural geographer Dennis Cosgrove, notably in *Social Formation and Symbolic Landscape* (1998). Large-scale private landscape design became the rage in eighteenth- and nineteenth-century Europe—the textbook examples are the constructions by Capability Brown and his collaborators at Stowe, Stourhead, and Blenheim Palace. According to Cosgrove, this practice functioned to make landownership seem natural. The use of such design elements as the ha-ha and picturesque planting schemes shaped perception and cognition of the landscape by altering viewers' concepts of nature, ownership, and stewardship. True, the landscapes are beautiful, but they served their social function only by blending messaging with beauty.

What is the alternative to hedonism and aestheticism about artistic cultures? How should we flesh out the schema for theories of artistic cultures? The answer is the one that should be most conspicuous. Artistic cultures concern the making and use of artifacts, and variant artistic cultures concern the making and use of discrete kinds of artifacts, including concrete and abstract objects plus events. Baxandall examines images, Lena institutions structuring interactions around works of various kinds, and Cosgrove techniques for making landscapes. "Ti Zwazo" and "Yellow Bird" are musical works, each from a tradition of music making. In sum, artistic cultures are the cultures of the various arts.

Each art has a medium (or a set of media). After all, to make a work of art, one must do something, using some technique (physical or cognitive) to operate upon some resource (physical or cognitive). Let a medium be a technical resource, a set of techniques for making available what a resource affords (Lopes 2014: ch. 7;

cf. Carroll 2021). The medium of music is very roughly a set of tools for replicating and modifying pitch–meter–timber+language structures. The medium of literature is a set of techniques for unlocking some of what is afforded by linguistic utterances. However, there must be more to an art than a medium. Obviously, most uses of language aren't literature, and even some uses of pitch–meter–timber+language structures aren't music—alarms and notification chimes, for example. Moreover, méringue lente and calypso are different artistic cultures, although they share a medium.

Here is the proposal. Artistic cultures are organized around media, on which values are centered. Filling in the placeholders in the schema above,

> AC: K is an artistic culture of P = (1) there is a behavioral regularity R in P, (2) there is a norm in P to act in accordance with values centered on the medium of K, and (3) N secures R.

Méringue lente and calypso are artistic cultures. What makes them so? More generally, what constitutes cultures as artistic? (AC) answers that artistic cultures are behavioral regularities resulting from and reinforced by a norm scaffolding coordination on some values of a medium, a technical resource for making things. On this theory, artistic cultures are externally beneficial: No beneficial function is constitutive of them. The claim isn't that artistic cultures have no beneficial function. Their beneficial functions, if any, differ among variants.

Contrast the proposal with (AEC). Aesthetic cultures constitutively involve coordination around one species of value, aesthetic value. The aesthetic is a domain of values, not a domain made up of items of a kind. Just about any kind of item has some aesthetic values, and there is no kind that is the kind of item that realizes aesthetic value. By contrast, artistic cultures are domains each populated by items of a kind—images, landscapes, dances, songs,

video games, stories, and the like. Items such as these can and do have many kinds of value, but none is constitutive of artistic cultures. Values vary from one artistic culture to the next.

As the tidy arrangement breaks apart, we must leave behind the baggage. The traditional reduction of artistic culture to aesthetic and hedonic cultures encouraged thinking about "artistic value" as on a par with aesthetic or hedonic values. However, artistic value isn't another species of value alongside aesthetic value and hedonic value. Any kind of value is an artistic value when it's a value realized by exploiting a medium in an artistic culture (Lopes 2014: chs. 5 and 8).

Méringue lente is an artistic culture constituted by behavioral regularities scaffolded by norms. The regularities include the activities of composing, performing, appreciating, but also editing, writing liner notes, designing covers, making playlists, and the like. All of these activities are musical, in the sense that they operate on pitch–meter–timber+language structures. There is more to the culture than the medium, though. After all, pitch–meter–timber+language structures can be made and used in indefinitely many ways, and méringue lente represents one point in a vast space of musical possibilities. It's not calypso, Lutheran Baroque, or Carnatic heavy metal. Participants in the culture must consequently be on the same page artistically.

According to (AC), they're on the same page artistically because they often enough comply with a norm that coordinates their use of the medium with an eye to value. Méringue lente serves an interest in preserving a memory of the past. Suppose a new arrangement of "Ti Zwazo" preserves the tempo of the Cuevas and Casséus performance because the lyrics meaningfully evoke the historical experience of slavery. Why is that a reason at all? In the background is the norm: Use the medium to enshrine and preserve memory so as to give Haitians, as Ellison put it, "affirmation and a sense of direction" (2003: 740). Preserving memory is a historical value, in the modest sense of value. When participants in méringue lente get in sync,

their acts increase the incidence of songs that realize the goods of affirmation and having a sense of direction.

Goods· such as these aren't constitutive of artistic cultures. They are axes of coordination in méringue lente, but not calypso, *śāstriya saṅgīt*, or International Style architecture. Coordination in these other artistic cultures serves other interests. In working with a medium, participants in an artistic culture can be guided by achievement, cognitive, ethical, religious, historical, ecological, commercial, practical, or social values, as well as hedonic and aesthetic ones, of course. All we can say of artistic cultures in general is that their constitutive norms lay down some values as relevant; (AC) doesn't make any one species of value constitutive of artistic cultures.

All three cultures of taste are cultures of value, but their organizational structures differ. Hedonic cultures are internally beneficial: In coordinating activity around hedonic value, they function to enlarge our store of pleasure. Aesthetic cultures are externally beneficial: They constitutively coordinate activity around aesthetic value profiles, entraining any of a range of benefits. Artistic cultures are also externally beneficial: They coordinate activity around sundry, non-constitutive, species of value. Some relevant values, such as hedonic and commercial values, are beneficial; some are not—aesthetic value in particular.

The case for (AC) is that it's a better platform for empirical explanations of variations among artistic cultures than the alternatives. As we have already seen, hedonism and aestheticism have trouble with the range of hypotheses in favor of which Baxandall, Lena, and Cosgrove marshal perfectly good evidence. (AC) accommodates all three hypotheses. More importantly, it puts the focus on art media and their value-laden uses. Two bodies of recent work by philosophers together with theoretically minded arts scholars sharpen the focus. One body of work treats art media as psychologically implemented representational modalities (e.g., Davis 2011; Kulvicki 2013). The other looks at how some arts can

realize some values, ethical and cognitive ones in particular (e.g., Nussbaum 1990; Lopes 2005; Kieran 2006; Eaton 2012; Landy 2012). These bodies of work thicken (AC) considerably, increasing its refractive power.

Finally, (AC) points to the factors that explain variance among artistic cultures. The precise regularities in value-laden uses of a medium vary from one artistic culture to the next. All incorporate a generic norm, namely to act in accordance with some values that the medium affords; however, the values vary across cultures. Changing educational, technological, and economic conditions can explain learning to comply with norms and to use media effectively. No doubt the downstream benefits of value-laden uses of media can play a starring role in explaining why social groups give artistic cultures a home. In tying artistic cultures to values as loosely as it does, (AC) doesn't commit us to thinking that artistic cultures are more homogeneous than they obviously are.

2.8 Explanans

Adequate theories of aesthetic and artistic cultures represent them as varying in ways that submit to empirical explanation. Each variant comprises a behavioral regularity and some norms whose etiological function it is to scaffold the activity. Each is a product of shared formative conditions: The method is to explain the norms and behavioral regularities as effects of education, technology, economic arrangements, and the like. Moreover, each can generate non-constitutive benefits: The method is to explain a variant aesthetic or artistic culture by appeal to its beneficial functions. In aesthetic cultures, coordination on an aesthetic profile enables agents to achieve their individual goals in concert with others. In artistic cultures, the practice is to use technical resources in order to realize sundry values. Either way, the method is to explain a norm-governed behavioral regularity by appeal to values or benefits that

aren't constitutive of the culture kind. Possibly, a group has a variant of an aesthetic or artistic culture because they have some other kinds of cultures. Local organicism isn't ruled out. By the same token, a group might have a variant of an aesthetic or artistic culture because it helps its members to adapt to their physical or social environment. Local adaptationism isn't ruled out. The method is to explain a variant culture of taste by appeal to its physical and social context.

In closing, let us revisit the history. Given some auxiliary assumptions, the tidy arrangement represented the cultures of taste as common ground for interaction across cultures. Such was the appeal of aesthetics for Kant (2000 [1790]), for example, and also for *rasa* theory, especially as developed by Abhinavagupta in the tenth-century Sanskrit cosmopolis and K. C. Bhattacharyya in twentieth-century Bengal (Pollock 2016; Bhattacharyya 2011 [1930]; Lopes 2019). The appeal has waned, and rightly so, for ours is an era that celebrates difference. Yet we must not forget that difference only signifies against a backdrop of similarity. A balance is required. The emphasis, here, is on how scholarly inquiry in philosophy and in the human and social sciences should regard differences as those that obtain between things of a kind. Perhaps the same balance, now in the form of an implicit understanding of difference in unity, is also essential for appreciators who engage in the cultures of taste, but that is a matter for another occasion.

References

Averill, Gage. 1997. *A Day for the Hunter, a Day for the Prey: Popular Music and Power in Haiti*. University of Chicago Press.

Baldwin, John R., Sandra L. Faulkner, Michael L. Hecht, and Sheryl L. Lindsey. 2006. *Redefining Culture: Perspectives Across the Disciplines*. Routledge.

Baxandall, Michael. 1972. *Painting and Experience in Fifteenth-Century Italy: A Primer in the Social History of Pictorial Style*. Oxford University Press.

Berridge, Kent C. and John P. O'Doherty. 2014. "From Experienced Utility to Decision Utility," *Neuroeconomics*, 2nd ed., ed. Paul W. Glimcher and Ernst Fehr. Academic Press, pp. 335–351.

Bhattacharyya, K. C. 2011 [1930]. "The Concept of *Rasa*," *Indian Philosophy in English: From Renaissance to Independence*, ed. Nalini Bhushan and Jay L. Garfield. Oxford University Press, pp. 195–206.

Bicchieri, Cristina. 2006. *The Grammar of Society: The Nature and Dynamics of Social Norms*. Cambridge University Press.

Bolzano, Bernard. 2023 [1843/1849]. *Essays on Beauty and the Arts*, ed. Dominic McIver Lopes, trans. Adam Bresnahan. Hackett.

Bradford, Gwen. 2015. *Achievement*. Oxford University Press.

Carroll, Noël. 2021. "The Return of Medium Specificity Claims and the Evaluation of the Moving Image," *Philosophy and the Moving Image*. Oxford University Press, pp. 21–39.

Cosgrove, Dennis. 1998. *Social Formation and Symbolic Landscape*, 2nd ed. Wisconsin University Press.

Cross, Anthony. forthcoming. "Social Aesthetic Goods and Aesthetic Alienation," *Philosophers' Imprint*.

Davis, Whitney. 2011. *A General Theory of Visual Culture*. Princeton University Press.

De Clercq, Rafaël. 2008. "The Structure of Aesthetic Properties," *Philosophy Compass* 3.5: 894–909.

Eaton, Anne. 2012. "Robust Immoralism," *Journal of Aesthetics and Art Criticism* 70.3: 281–292.

Ellison, Ralph. 2003. "A Very Stern Discipline," *The Collected Essays of Ralph Ellison*, ed. John F. Callahan. Modern Library, pp. 730–758.

Gombrich, E. H. 1960. *Art and Illusion: A Study in the Psychology of Pictorial Representation*. Princeton University Press.

Guala, Francesco. 2016. *Understanding Institutions: The Science and Philosophy of Living Together*. Princeton University Press.

Haslanger, Sally. 2000. "Gender and Race: (What) Are They? (What) Do We Want Them to Be?" *Noûs* 34.1: 34–55.

Hindriks, Frank and Francesco Guala. 2021. "The Functions of Institutions: Etiology and Teleology," *Synthese* 198: 2027–2043.

Kant, Immanuel. 2000 [1790]. *Critique of the Power of Judgement*, ed. Paul Guyer, trans. Paul Guyer and Eric Matthews. Cambridge University Press.

Kieran, Matthew. 2006. "Art, Morality and Ethics: On the (Im)Moral Character of Art Works and Inter-Relations to Artistic Value," *Philosophy Compass* 1.2: 129–143.

Kubala, Robbie. 2021. "Aesthetic Practices and Normativity," *Philosophy and Phenomenological Research* 103.2: 408–425.

Kubovy, Michael 1999. "On the Pleasures of the Mind," *Well-Being: Foundations of Hedonic Psychology*, ed. Daniel Kahneman, Edward Diener, and Norbert Schwartz. Russell Sage Foundation, pp. 134–154.

Kulvicki, John V. 2013. *Images*. Routledge.

Landy, Joshua. 2012. "Formative Fictions: Imaginative Literature and the Training of the Capacities," *Poetics Today* 33.2: 169–216.

Layton, Robert. 2011. "Aesthetics: The Approach from Social Anthropology," *The Aesthetic Mind: Philosophy and Psychology*, ed. Elisabeth Schellekens and Peter Goldie. Oxford University Press, pp. 208–222.

Lena, Jennifer C. 2019. *Entitled: Discriminating Tastes and the Expansion of the Arts*. Princeton University Press.

Levitin, Daniel. 2006. *This Is Your Brain on Music: The Science of a Human Obsession*. Dutton.

Lopes, Dominic McIver. 2005. *Sight and Sensibility: Evaluating Pictures*. Oxford University Press.

Lopes, Dominic McIver. 2014. *Beyond Art*. Oxford University Press.

Lopes, Dominic McIver. 2018a. *Aesthetics on the Edge: Where Philosophy Meets the Human Sciences*. Oxford University Press.

Lopes, Dominic McIver. 2018b. *Being for Beauty: Aesthetic Agency and Value*. Oxford University Press.

Lopes, Dominic McIver. 2019. "Feeling for Freedom: K. C. Bhattacharyya on *Rasa*," *British Journal of Aesthetics* 59.4: 465–477.

Lopes, Dominic McIver. 2021a. "Beyond the Pleasure Principle: A Kantian Aesthetics of Autonomy," *Estetika: European Journal of Aesthetics* 57.1: 1–18.

Lopes, Dominic McIver. 2021b. "Two Dogmas of Aesthetic Empiricism," *Metaphilosophy* 52.5: 583–592.

Lopes, Dominic McIver. 2022. "Getting into It: Ventures in Aesthetic Life," *Aesthetic Life and Why It Matters*. Oxford University Press, pp. 61–86.

Matherne, Samantha and Nick Riggle. 2020–2021. "Schiller on Freedom and Aesthetic Value," *British Journal of Aesthetics* 60.4: 375–402 and 61.1: 17–40.

Matthen, Mohan. 2015. "Play, Skill, and the Origins of Perceptual Art," *British Journal of Aesthetics* 55.2: 173–197.

Matthen, Mohan. 2017. "The Pleasure of Art," *Australasian Philosophical Review* 1.1: 6–28.

Matthen, Mohan. 2018a. "Art, Pleasure, Value: Reframing the Questions," *Philosophic Exchange* 47.1: 1–16.

Matthen, Mohan. 2018b. "New Prospects for Aesthetic Hedonism," *Social Aesthetics and Moral Judgment: Pleasure, Reflection, and Accountability*, ed. Jennifer A. McMahon. Routledge, pp. 13–33.

Matthen, Mohan. 2020. "Art Forms Emerging: An Approach to Evaluative Diversity in Art," *Journal of Aesthetics and Art Criticism* 78.3: 303–318.

Millikan, Ruth Garrett. 1984. *Language, Thought, and Other Biological Categories*. MIT Press.

Nanay, Bence. 2022. "Unlocking Experience," *Aesthetic Life and Why It Matters*. Oxford University Press, pp. 11–31.

Nguyen, Thi. 2023. "Art as a Shelter from Science," *Aristotelian Society Supplementary Volume* 97.1: 172–201.

Nussbaum, Martha C. 1990. *Love's Knowledge: Essays on Philosophy and Literature.* Oxford University Press.

Parsons, Glenn and Allen Carlson. 2008. *Functional Beauty.* Oxford University Press.

Polite, Brandon. 2019. "Shared Musical Experiences," *British Journal of Aesthetics* 59.4: 429–447.

Pollock, Sheldon, ed. 2016. *A Rasa Reader: Classical Indian Aesthetics.* Columbia University Press.

Rhode, Deborah L. 2010. *The Beauty Bias: The Injustice of Appearance in Life and Law.* Oxford University Press.

Richerson, Peter J. and Richard Boyd. 2005. *Not by Genes Alone: How Culture Transformed Human Evolution.* University of Chicago Press.

Riggle, Nick. 2021. "Toward a Communitarian Theory of Aesthetic Value," *Journal of Aesthetics and Art Criticism* 80.1: 16–30.

Riggle, Nick. 2022. "Individuality and Community," *Aesthetic Life and Why It Matters.* Oxford University Press, pp. 32–60.

Rohrbaugh, Guy. 2020. "Why Play the Notes? Indirect Aesthetic Normativity in Performance," *Australasian Journal of Philosophy* 98.1: 78–91.

Saito, Yuriko. 2007. *Everyday Aesthetics.* Oxford University Press.

Schaeffer, Jean-Marie. 2000. *Art of the Modern Age: Philosophy of Art from Kant to Heidegger,* trans. Steven Rendall. Princeton University Press.

Schiller, Friedrich. 1993 [1795]. "Letters on the Aesthetic Education of Man," *Essays: Friedrich Schiller,* ed. Walter Hinderer and Daniel O. Dahlstrom, trans. Elizabeth M. Wilkinson and L. A. Willoughby. Continuum, pp. 86–178.

Schopenhauer, Arthur. 2010 [1819]. *The World as Will and Representation,* trans. Judith Norman, Alistair Welchman, and Christopher Janaway. Cambridge University Press.

Schotter, Andrew. 1981. *The Economic Theory of Social Institutions.* Oxford University Press.

Searle, John. 1995. *The Construction of Social Reality.* Free Press.

Shiner, Larry. 2001. *The Invention of Art: A Cultural History.* University of Chicago Press.

Sibley, Frank. 1959. "Aesthetic Concepts," *Philosophical Review* 68.4: 421–450.

Sibley, Frank. 1965. "Aesthetic and Nonaesthetic," *Philosophical Review* 74.2: 135–159.

Thompson, Robert F. 1983. *Flash of the Spirit.* Random House.

Tuomela, Raimo. 2013. *Social Ontology.* Oxford University Press.

Tylor, Edward B. 1871. *Primitive Culture: Researches into the Development of Mythology, Philosophy, Religion, Art, and Custom.* John Murray.

Van der Berg, Servaas. 2020. "Aesthetic Hedonism and Its Critics," *Philosophy Compass* 15.1: 1–15.

Walden, Kenny. forthcoming. "Agency and Aesthetic Identity," *Philosophical Studies*.

Walton, Kendall. 1970. "Categories of Art," *Philosophical Review* 79.3: 334–367.

Widdows, Heather. 2018. *Perfect Me: Beauty as an Ethical Ideal*. Princeton University Press.

Zuckert, Rachel. 2019. *Herder's Naturalist Aesthetics*. Cambridge University Press.

3

Beyond the Either/Or
in Aesthetic Life

A New Approach to Aesthetic Universality

Samantha Matherne

3.1. Introduction

What is a flourishing aesthetic life? What does it look like for our
temporally extended pursuit of aesthetic value to go well for us?
Though they do not explicitly use the term "flourishing," we find a
classical answer to these questions in David Hume and Immanuel
Kant (see Section 3.2). According to this classical view, a flour-
ishing aesthetic life is one that is organized around experiences
of universal aesthetic value: aesthetic value that any human being
should appreciate. However, others have rejected this classical
view in favor of a more diversity-based picture, according to which
we flourish in our aesthetic lives when we find what aesthetically
speaks to us given who we are as individuals and as members of
local communities. We thus appear to be left with a choice between
two competing models of how to aesthetically flourish. Either we
should pursue what has aesthetic value, universally defined, or we
should pursue what has aesthetic value, diversely defined.

Yet when faced with this either/or, it might seem clear which
view we should favor. Not only do we find widespread divergence
and disagreement in matters of taste, but also a commitment to

The Geography of Taste. Dominic McIver Lopes, Samantha Matherne, Mohan Matthen, and Bence Nanay,
Oxford University Press. © Oxford University Press 2024. DOI: 10.1093/oso/9780197509067.003.0004

aesthetic universality has come under suspicion as a codification of ideologies of a classist, racist, Eurocentric, and sexist bent (see the Introduction to this volume and Section 3.3). Confronted with the choice between the two, don't we have reason to endorse a diversity-based account of how we should pursue aesthetic value in order to flourish in our aesthetic lives over a universality-based account?

Though there are versions of aesthetic universality that force this either/or, my aim is to propose a new account of aesthetic universality that complements aesthetic diversity vis-à-vis a flourishing aesthetic life. To this end, I present a radically revised version of the classical conception of aesthetic universality found in Hume and Kant. And I argue that we can not only pursue aesthetic value in line with both aesthetic diversity and aesthetic universality, so understood, but also that our aesthetic lives will be the better for it.

I proceed as follows. In Section 3.2, I open with the classical account of aesthetic universality, which I draw from Hume and Kant. In Section 3.3, I canvas several objections to the classical view of aesthetic universality, including an ideological objection, as well as objections about the impossibility and undesirability of what this view calls for. In Section 3.4, I consider diversity-based alternatives to classical universalism. Then in Section 3.5, I argue that although these diversity-based accounts do justice to a good in aesthetic life that I call the "good of resonance," they do not do justice to another good that I call the "good of aesthetic exploration." In Section 3.6, I propose a radically revised version of aesthetic universality as oriented not toward universal aesthetic value but toward aesthetic exploration. In Section 3.7, I make the case that the revised view of aesthetic universality promotes a vision of a flourishing aesthetic life that is not only compatible with but also complementary to the vision projected by diversity-based accounts. I conclude in Section 3.8.

3.2. The Classical Account
of Aesthetic Universality

My aim in this section is to articulate what I am calling the "classical" account of aesthetic universality, which I draw from Hume and Kant. To this end, I explore three universalist commitments that Hume and Kant share concerning, one, the nature of aesthetic value (Section 3.2.1), two, our capacities for appreciation (Section 3.2.2), and three, the aesthetic ideal that should govern our aesthetic lives (Section 3.2.3). However, some caveats are in order. There are many divergences between the aesthetics of Hume and Kant.[1] And there are many ways to read what commitments they share, not all of which are consistent with the classical account I sketch below. The sketch of the classical view I am offering is thus not exhaustive; it is meant as one way of reading a certain through line in Hume and Kant concerning aesthetic universality, which has especially worried proponents of diversity-based views.

3.2.1. The Universality of Aesthetic Value

Let's begin with the first commitment Hume and Kant share concerning the nature of aesthetic value, which emerges in their analysis of beauty.[2] According to Hume and Kant, beauty is to be understood in universal terms, qua that which should please all

[1] One notable divergence concerns method. Whereas Hume's approach to aesthetics is empirical in nature (see ST 231), Kant's is transcendental (see CJ 5: 231–232, 5: 287–289). For discussion of the relationship between Hume and Kant's aesthetics, see Schaper (1983: esp. pp. 39–56), Mothersill (1984: esp. chs. 7–8), Savile (1982), Kulenkampff (1990), Savile (1993: esp. ch. 4), Costelloe (2003), and Matherne (2021a).

[2] Here, I am setting aside Kant's account of the sublime as another basic type of aesthetic value.

human beings.[3] To this end, Hume characterizes beauty as something that is "catholic and universal" (ST 233). And Kant claims that

> It would be ridiculous if . . . someone who prided himself on his taste thought. . .: "This object (the building we are looking at, the clothing someone is wearing, the concert that we hear, the poem that is presented for judging), is beautiful **for me**." For he must not call it **beautiful** if it pleases merely him. . . . [I]f he pronounces that something is beautiful, then he expects the very same satisfaction of others. (CJ 5:212)

For example, from this classical perspective, to claim that the *Iliad* is beautiful is to claim that it should please all human beings, regardless of whether they lived in "Athens and Rome two thousand years ago" or live in "Paris and London" "still" (ST 233).

3.2.2. The General Capacities for Appreciation

The second commitment Hume and Kant share concerns our capacities for appreciation, and it will take a bit longer to spell out. According to both, there are a set of general capacities for appreciation required to respond to beauty. By "general capacities for appreciation," I have in mind capacities that enable us to respond to beauty as it is manifest in various types of objects, whether in nature, art, human bodies, design, and so forth. General capacities thus contrast with specialized capacities for appreciation, which are geared to appreciating a specific type of object, like Bollywood, flowers, epic poetry, or rococo. Though the details diverge, what I shall now argue is that both Hume and Kant take on a base-level

[3] This said, Hume's version of universality only requires that there be "considerable uniformity of sentiment among men" (ST 234), whereas Kant's version of universality is stricter and concerns what is valid "for every subject" (CJ 5:214).

commitment to there being four types of general capacities for appreciation.

First, both Hume and Kant endorse a hedonic view of aesthetic appreciation, as something that requires the capacity to feel pleasure in response to objects.[4] Second, Hume and Kant indicate that appreciation involves a capacity for making pleasure-based aesthetic judgments.[5] For them, aesthetic appreciation is not just a matter of feeling pleasure in an object but judging the object to be beautiful on the basis of a feeling of pleasure.[6]

Third, Hume and Kant regard what I shall label "capacities of apprehension" as requisite for appreciation. By capacities of apprehension, I have in mind capacities that enable us to grasp a beautiful object, whether through sensible, imaginative, or intellectual means.[7] In Hume's framework, this is what "delicacy," qua a capacity for sensible and imaginative discrimination,[8] and "good sense," qua a capacity for intellectual comprehension,[9] amount to (see ST 234–235, 240–241). And in Kant's framework, this is what the cognitive capacity of "imagination" and "understanding" are tasked with (see CJ §9). Note that in aesthetic appreciation, these capacities

[4] Hume refers to the relevant feeling as "pleasure" or "agreeable sentiment" (ST 233–234). And Kant describes it as a "feeling of pleasure": "In order to decide whether or not something is beautiful, we . . . relate it . . . to the subject and its feeling of pleasure or displeasure" (CJ 5:203).

[5] This is perhaps more implicit in Hume than in Kant. For whereas Kant outright says that judgments of the beautiful are "aesthetic" judgments, defined as judgments whose "determining grounds" are a feeling of pleasure (CJ 5:203), Hume indicates that appreciation involves us being in a "sound" state to feel pleasure in an object and "judge of the catholic and universal beauty" (ST 233, 241).

[6] For debate about how exactly to understand the complicated relationship between judgment and pleasure on Kant's view, see Guyer (2017) and Ginsborg (2017).

[7] Here, I am using apprehension not in Kant's technical sense (qua something that happens through the synthesis of imagination (see CJ 5: 189–190, 5: 240)), but in a looser sense to refer to the way in which we grasp an object.

[8] Hume illustrates delicacy with Sancho Panza's anecdote about two men tasting wine, one of whom detects leather, the other iron, and it turns out that there was a "key with a leathern thong" at the bottom (ST 235).

[9] Hume describes "good sense" in terms of the ability to rationally grasp the relations that obtain in a work of art, for example, between the "parts" and "whole" and "means" and "ends," and the "chain of propositions and reasonings" that are operative in the work (ST 240).

have a kind of priority over the capacities for feeling pleasure and making aesthetic judgments. In order to feel pleasure or make an aesthetic judgment about an item, we need to apprehend the item in the first place. To be sure, there are cases in which we might be feeling pleasure, or perhaps judging, concomitantly with the apprehension; so, the priority at issue here is not necessarily temporal. Nevertheless, there is still a kind of priority here such that a condition of being able to feel pleasure in or make an aesthetic judgment about something is having our capacities of apprehension bring the item into view for us.

The fourth general capacity that Hume and Kant take to be involved in appreciation is one I shall label a "capacity for reflective projection." More specifically, the kind of capacity at issue here is the capacity to reflectively project oneself out of one's private standpoint and into an impartial standpoint. By Hume and Kant's lights, there are various "prejudices" and "interests" that attach to our private standpoints that hinder us from judging objects on their own terms. For example, our personal "friendship" or "enmity" with an artist or our personal penchants for certain colors or sounds can bias our aesthetic judgment one way or the other (see ST 233, CJ 5: 224). Given the prejudices and interests that attach to our private standpoints, Hume and Kant argue that in aesthetic appreciation, we should make an effort to reflectively project ourselves out of our private standpoints and into an unbiased standpoint. For Hume, this standpoint is that of a "man in general,"[10] and for Kant this

[10] More specifically, Hume claims that "I must . . . considering myself as a man in general, forget, if possible, my individual being and my peculiar circumstances. A person influenced by prejudice, complies not with this condition; but obstinately maintains his natural position, without placing himself in that point of view which the performance supposes" (ST 239). This said, it is worth noting that on Hume's view, although we need to adopt the standpoint of a "man in general" to judge whether or not something is beautiful, he also allows for our "natural" standpoint to influence the "degree" of beauty that we ascribe to something (see ST 243). More specifically, he claims that a difference in "internal frame or external circumstance," that is, "age and country," can lead different judges to assign different degrees of beauty to objects (ST 243–244).

standpoint is a "**universal standpoint**" (CJ 5: 295).[11] And on both of their views, we need to exercise this capacity for reflective projection if we are to make aesthetic judgments in the unprejudiced and impartial way that they think we should.[12]

For Hume and Kant, this second commitment to general capacities for appreciation is connected to the first commitment to universal aesthetic value. They regard the general capacities for appreciation as capacities that are oriented toward appreciating beauty. Thus, on their view, the general capacities of appreciation are ones that have a universal orientation in the sense that they are oriented toward beauty, understood as a universal aesthetic value.[13]

3.2.3. The Aesthetic Ideal of Universality

With these first two classical commitments in view, we can now turn our attention to the picture of the so-called aesthetic ideal that

[11] More specifically, Kant takes the standpoint at issue to be one that we project ourselves into through an exercise of the capacity he calls "common sense" (*sensus communis*) and defines as "a faculty for judging that in its reflection takes account (*a priori*) of everyone else's way of representing in thought . . ., and putting himself into the position of everyone else" (CJ 5:293–294). For more on Kant's theory of common sense, see Matherne (2019, 2021a, 2023: sects. 3–4).

[12] More technically put, on Kant's view, when we make the type of aesthetic judgment he calls a "judgment of taste," we should proceed in this way. But he allows for us to be partial and biased when we make the type of aesthetic judgment that he calls a "judgment of the agreeable."

[13] There is a further question as to whether Hume and Kant conceive of these general capacities as universally shared ones that all human beings possess. On this question, Kant's answer is clear. He insists that the capacities that enable us to make judgments of the beautiful are capacities that all human beings share in common (e.g., CJ §38). It is less clear where Hume stands on the question of the universality of the general capacities of appreciation. On the one hand, Hume's remarks to the effect that "true judges" are "few" and "rare" suggest that it is only some people who have the general capacities for appreciation (ST 241). On the other hand, when we fail to respond to beauty as we should, Hume's diagnosis is not that we lack certain capacities for appreciation, but rather that there is a "defect" in the use of capacities we all nevertheless possess (see ST 234). Moreover, Hume's picture of practice can be read as suggesting that we all possess the relevant capacities, but might not all engage in the practice needed to develop them (see ST 237).

emerges within this framework.[14] As Nick Riggle (2015) has recently argued, although talk of "ideals" is more familiar in moral contexts, there is reason to think that we should also be concerned with the question of aesthetic ideals—that is, with ideals that guide our pursuit of aesthetic value and that we should aspire to in our aesthetic lives.[15]

Though Hume and Kant do not use language of "aesthetic ideals," per se, their aesthetics nevertheless provide us with one model of the aesthetic ideal, which hinges on an aesthetic life centered on beauty. *In nuce*, Hume and Kant's aesthetic ideal directs us toward becoming "true" judges who pursue and engage with beauty, qua a universal form of aesthetic value (ST 241).[16]

More specifically, we can tease out two related aspects of the classical view of the aesthetic ideal: an object-oriented aspect and a capacity-oriented aspect. The object-oriented aspect of the classical aesthetic ideal prescribes the pursuit of beautiful objects. That is to say, on the classical account, we should devote our aesthetic efforts to finding and engaging with the beautiful objects that anyone should find pleasing, whether these be things like world heritage sights, stretches of nature, or works of art that have "stood the test of time." Meanwhile, the capacity-oriented aspect directs us toward the development of capacities required in order to appreciate beauty in the first place. Indeed, since on the classical view, certain capacities are required for us to respond to beauty as we should, there is a kind of priority that the capacity-oriented aspect of the

[14] For recent discussions of this classical aesthetic ideal, see Levinson (2010) and Riggle (2015).

[15] Though aesthetic ideals involve a kind of aspiration, I do not think they involve the sort of "proleptic reasons" that Agnes Callard takes to be involved in "aspiration." For Callard, proleptic reasons are oriented "distally" to a specific value, like becoming a music appreciator, and "proximally" to whatever desires or preferences we currently have (2018: 73). By contrast, the reasons involved in aesthetic ideals are more coarse-grained. They are oriented toward pursuing some overarching good in aesthetic life, like appreciating beauty or self-expression, and they swing free from whatever our current desires or preferences are.

[16] In recent discussions of Hume, this kind of judge is referred to as an "ideal judge" or "ideal critic" (e.g., Levinson 2002).

aesthetic ideal has. If we are to be in a position to be able to fulfill the demand to pursue beautiful objects, then we need the capacities to take up such objects in the first place. On the classical view, activities like aesthetic exposure and aesthetic education thus have a pivotal role to play, not just in putting us in contact with beautiful objects but in enabling us to develop the capacities needed to appreciate such objects to begin with.[17]

Stepping back, the classical view of aesthetic universal that I have sketched in this section pivots on three commitments: the commitment to the universal nature of aesthetic value, the commitment to the general capacities for appreciation, and the commitment to the aesthetic ideal, as something that directs us both toward the pursuit of universal aesthetic value and toward cultivating the capacities for appreciation.

3.3. Objections to the Classical Account of Aesthetic Universality

The classical account of aesthetic universality has faced a number of objections, three of which I shall consider here.

The first objection is an ideological objection. According to this objection, instead of offering us something worthwhile to pursue, the universalism of Hume and Kant's aesthetics enshrines an ideology that privileges an elite, white, European, masculine perspective, which dismisses and denigrates anything that is "other." Criticizing Kant along these lines, Bourdieu says "Kant's analysis of the judgement of taste finds its real basis in a set of aesthetic

[17] Hume makes this explicit in his account of the "practice" and "comparison" needed to be a "true judge" in matters of taste (see ST 237–238). And Kant implicitly commits himself to this, for example, when he claims that "because [taste's] judgment is not determinable by means of concepts and precepts [taste] is most in need of examples of what in the progress of culture has longest enjoyed approval" (CJ 5:283). For a lengthier discussion of Kant's view of exposure and aesthetic education, see Matherne (2019, 2021a, 2023).

principles which are the universalization of the dispositions associated with a particular social and economic condition" (1979: 493; see also Shusterman 1989). Highlighting the racist and Eurocentric underpinnings of Hume and Kant's aesthetics, Monique Roelofs says

> Readers of Immanuel Kant will recall his view that black persons are incapable of fine feeling, an important condition for aesthetic perception, and they will also remember his comments about the relatively deficient apprehensive propensities of Native Americans, Caribbeans, and other non-Europeans. . . . Before Kant voiced these ideas, David Hume had already notified his readers of his denial of original thought to black people. (2017: 395–396)[18]

And emphasizing the sexist underpinnings of their aesthetics, Carolyn Korsmeyer says, although women were considered capable of developing fine taste, arguably the model of the ideal aesthetic judge, the arbiter of taste, was implicitly male, for men's minds and sentiments were considered to be more broadly capable than women's (2004: 47).[19]

Read in this light, the set of allegedly universal capacities that Hume and Kant identify as requisites of aesthetic appreciation are, in fact, the capacities possessed by white European men of a privileged social class, and the objects prized by those capacities are ones that appeal to this demographic. In so far as this is the case, far from championing a genuine form of universality, Hume and

[18] See also Hall (1997), Bindman (2002), and Roelofs (2014: ch. 2).
[19] Korsmeyer cites as an example Kant's claim in *Observations on the Feeling of the Beautiful and Sublime* that "The fair sex has just as much understanding as the male, only it is a beautiful understanding, while ours should be a deeper understanding, which is an expression that means the same thing as the sublime" (*Observations* 2: 228–229). See also Kneller (1993), Mattick (1995), and Klinger (1997). For discussion of Hume on this count, see Lind (1994, who also discusses his racism), Korsmeyer (1995), and Roelofs (2014: 31–32).

Kant's aesthetics champion a parochial taste, underwritten by an oppressive ideology. And once we recognize this ideological underpinning, per this objection, we do not have reason to pursue the ideal of universality that they put forth.

However, even if one is sympathetic to this ideological objection, one might try and rescue a Humean or Kantian view of aesthetic universalism that does not turn on the classism, racism, or sexism of Hume and Kant themselves. We find this sort of effort explicitly at work in attempts to appropriate Kant's aesthetics within a feminist framework.[20] And implicitly in the work of recent Neo-Humeans and Neo-Kantians, we find a defense of a Humean and Kantian aesthetics that swings free from the sort of prejudices of Hume and Kant themselves.[21] These efforts point toward the possibility of developing Humean or Kantian views of universality that do not fall prey to the ideological objection. Yet, even if this is possible, there are other reasons to worry about such revised accounts of aesthetic universality.

In one vein, some have objected that it is simply not possible to occupy an impartial or impersonal standpoint in aesthetic matters in the way universalist accounts prescribe. According to this objection, aesthetic engagement is, by nature, personal and/or socially situated. To think that we could ever occupy the position of a human being in general misunderstands what we are capable of. As Matthew Kieran makes this point in a personal vein,

> the way we appreciate a work can be as revealing about ourselves as much as it is about the work. This has implications not just for criticism as such, because a kind of impersonal appreciation and evaluation is shown to be a myth, but for a standard picture of fixing artistic value. If appreciation cannot but be personal in this

[20] See for example Kneller (1993), Battersby (1995), Kneller (1997), Moen (1997), and Brand (1998).
[21] The Neo-Humeans I have in mind include Shelley (1994, 1998, 2013), Levinson (2002, 2013), and (Ross 2008, 2020). And the Neo-Kantians I have in mind include Hamawaki (2006) and Gorodeisky (2021a, 2021b).

way, then the notion of an ideal appreciator divested of personal idiosyncrasies fixing the relative ordering merits of artworks is useless. (2008: 287)

Kieran argues that this is the case because aesthetic engagement involves "cognitive-affective responses" that are necessarily "inflected with personal history" (2008: 288). Meanwhile, in a more socially oriented vein, Katy Deepwell argues that what feminist criticism reveals is that it is not possible to be impartial or impersonal because our "readings" of art are "inevitably informed by political positions" (1995: 8). In so far as the classical account of aesthetic universality demands that we occupy the standpoint of a person "in general," per this line of critique, it demands something that is not possible.

Pursuing a third line of objection, others have argued that even if it is possible to occupy an impartial or impersonal standpoint in relation to aesthetic value, it is undesirable. As Alexander Nehamas articulates this objection, "If aesthetic judgment makes a claim to universal agreement, then, ideally, everyone would accept every correct judgment: in a perfect world, we would all find beauty in the very same places. But that dream is a nightmare" (2017: 83). The crux of the worry is that by privileging a universal orientation in aesthetic matters, we miss out on certain valuable aspects of aesthetic engagement that can be had only by orienting in more personal or local directions. This worry has been developed in different veins.

In one vein, some have pressed the concern that we need personal aesthetic attachments because these are central to who we are as individuals. As Riggle has developed this objection, there is a sub-set of aesthetic preferences that are bound up with our sense of who we are, our aesthetic "loves," which reflect what we are "meaningfully attached" to and express our personal "styles" (2015a: 434, 447).[22] And he worries that "the Hume-inspired ideal threatens to change those aspects of one's aesthetic sensibility that

[22] For other accounts that lay emphasis on the connection between our aesthetic preferences or sensibilities and our sense of who we are, see Levinson (2010: 228), Nehamas (2017: 85–86), Moran (2012: 236–237), Kubala (2018), and Ströhl (2022: ch. 4).

ground the meaningful connections one has with aesthetic objects, and thereby threatens one's sense of self" (2015a: 434). Suppose I love minimalist design, and this is bound up with my sense of who I am. And suppose that the ideal of universality directs me toward appreciating rococo design. In cultivating an appreciation for rococo in all its extravagance, it seems I may well lose my love for minimalist design in all its sparseness, and, thereby, lose an important part of my self.[23]

In a more social vein, the concern is that pursuing aesthetic universality requires that we give up on the value that is found in participating in local aesthetic communities. Here, a local aesthetic community is defined not in terms of geographical proximity but rather in terms of some shared aesthetic affinity.[24] For example, even if you and I have never met, if you are also a fan of the electro-pop group, Sylvan Esso, then we are both, in a sense, members of a local aesthetic community, the Sylvan Esso community. Many have noted the value we find in participating in such aesthetic communities. Ted Cohen, for example, argues that local aesthetic communities partially define us:

> Some [aesthetic objects] lead me into rather small groups, some lead me into large and varied groups. And it is my membership in these groups that locates me aesthetically . . ., that reflects the dimensions of my sensibility. . . . No doubt you have your own list of things you care about. . . . My absence from these groups you inhabit is just as important in defining me as your membership is in defining you. (1993: 154)[25]

[23] Levinson (2010, 2013) proposes a way out of this issue, suggesting that an "ideal" judge can still have personal preferences that reflect that path by which they came to be an ideal judge. For Riggle's rejoinder, see Riggle (2013, 2015).

[24] For discussions of aesthetic communities, see Cohen (1993: 155), Nehamas (2017: 81–82), Lopes (2018: 130), Riggle (2022: 26), Strohl (2022: 113–115, 119–122), and Cross (forthcoming).

[25] See also Nehamas's claim that "Beauty creates smaller societies, no less important or serious because they are partial, and from the point of view of its members, each one is orthodox – orthodox, however, without thinking of all others as heresies" (2017: 81). For discussion of the value of the aesthetic in "creating and maintaining black life-worlds," see Taylor (2016: 12).

Moreover, he claims that participating in these communities enables us to connect to the other members of this community in an "intimate" way (1993: 156). For example, being a fan of Sylvan Esso is something that not only partially defines me, but it is also something that binds me in an intimate way to other fans—an intimacy we might revel in if I discover you are a fan too. This recognition of the value of participating in local aesthetic communities puts pressure on universalist accounts to the extent that the demand to pursue universal aesthetic value requires that we relinquish our pursuit of local aesthetic value.[26] According to the aesthetic universalist, if Sylvan Esso's music is niche rather than of universal appeal, then it seems I should give up being a fan in order to pursue what does have universal appeal. But were I to give this up, wouldn't I be giving up on part of myself and missing out on the value of having an intimate connection to others who share this affinity?

Thus, even if it is possible to develop a Humean or Kantian view that does not fall prey to the ideology objection, there are other reasons to worry that aesthetic universalism promotes a view of aesthetic life that is either impossible or undesirable. Given these concerns, among others, it seems that we have reason to look elsewhere for a viable account of how to have a flourishing aesthetic life.

[26] See Cross (forthcoming) for a discussion of this worry in terms of the risk of "alienation," both personal and social. It is worth noting that Cohen himself defends a view of aesthetic universality, according to which calling something "art" involves taking it to be something that is "able to be the focus of a catholic community" (1988: 12). For Nehamas's criticism of this line of thought, see Nehamas (2017: 81–84).

3.4. A Diversity-Based Alternative

In recent years, there has been a proliferation of diversity-based accounts of aesthetic life, some of which emphasize the centrality of love, meaningful attachment, and style;[27] others of which emphasize the centrality of smaller communities[28] and participation in local aesthetic practices.[29] In spite of important differences between these diversity-based views,[30] in what follows, I want to tease out three commitments that animate these views that serve as counterparts to the three commitments that I attributed to classical aesthetic universalism above.

Let's begin with the diversity-based view of aesthetic value. Instead of restricting aesthetic value to only those items that should be appreciated by everyone, diversity-based views endorse a more inclusive view of aesthetic value as something that can speak to us variably, depending on our personal sensibilities, local communities, or aesthetic practices.[31] Matthew Strohl, for example, has recently argued that aesthetic value is indexed to diverse sensibilities. In so far as a work of art enables someone with a particular sensibility to engage in "valuable activities of engagement," it has aesthetic value (2022: 178). However, Strohl insists that this

[27] See for example Moran (2012), Riggle (2015), Cross (2017), Nehamas (2017), and Kubala (2018).

[28] See Nehamas (2017: 81, 84–85), Riggle (2022), and Strohl (2022: 25, 106, 121–122).

[29] See Lopes (2018) and Kubala (2021).

[30] For example, Lopes (2018), Riggle (2022), and Cross (forthcoming) present their accounts as alternatives to hedonist models of aesthetic engagement. Riggle (2022) and Cross (forthcoming) present a communitarian account as an alternative to the standard individualist bent manifest in views, including Lopes's.

[31] Some recent theorists have distinguished between whether something has aesthetic value "in general" or "in its own right" and whether something has aesthetic value for a particular person (see Riggle 2022: 27; Strohl 2022: 177–179). According to these views, something can have aesthetic value in the former sense if not in the latter; for example, even if engaging with a particular art form is not valuable for me, it can still be valuable "in general" or "in its own right" if it has value for some people, given their personal sensibilities or aesthetic communities. However, in so far as aesthetic value "in general" or "in its own right" is still indexed to personal sensibilities or communities on this view, I take it to count as a diversity-based view of aesthetic value.

"does not entail that [the work of art] will be valuable for every single person": It will only be valuable for someone with the relevant aesthetic sensibility (2022: 178). For example, on Strohl's view, even if I do not find it personally valuable to engage with the death metal music of Arch Enemy, this music has aesthetic value in so far as it enables valuable activities of engagement for people with the requisite sensibility.

In a different vein, Dominic McIver Lopes (2018) has argued that whether an aesthetic value gives an agent reason to aesthetically engage is a function of whether the agent can achieve with respect to the relevant aesthetic practice.[32] For example, on Lopes's view, the aesthetic value of Arch Enemy's music is reason-giving only for agents who can achieve with respect to the aesthetic practice of death metal. For agents who cannot achieve in this practice, this music does not give them reason to aesthetically engage.

Meanwhile, focusing specifically on art, Mohan Matthen has contended that the value of art depends on how successful a work is in generating aesthetic pleasure in an audience that engages with it in the "culturally learned manner" expected by the artist (2020: 311).[33] According to this account, the members of Arch Enemy have expectations for a "culturally learned" way in which their music should be experienced, say, as "death metal." And the value of their music is a function of whether listening to it in this way engenders aesthetic pleasure in the audience with the requisite cultural learning.

However, regardless of the different directions in which diversity-based views can be developed, a general commitment

[32] Technically put, Lopes claims that "an aesthetic value V, is reason-giving = the fact that x is V lends weight to the proposition that it would be an aesthetic achievement for some A to φ in C, where x is an item in an aesthetic practice, K, and A's competence to φ is aligned upon an aesthetic profile constitutive of K" (2018: 235). For an alternative "communitarian" view, see Riggle: "The communitarian answers: aesthetic value is what is worthy of aesthetic valuing, which is a practice structured by the value of aesthetic community, which requires aesthetically free individuals to cultivate their sensibilities and express themselves in free, open, expressive exchange" (2021: 27).

[33] Matthen's argument here builds on his 2017 account of aesthetic pleasure.

they share is to aesthetic value being something that speaks not to all human beings but to us diversely, depending on our personalities, communities, cultures, and practices.

In addition to this commitment to aesthetic value, diversity-based views involve a commitment to capacities needed in order to engage with aesthetic value, diversely defined. Depending on the view, these capacities include some general capacities, like a capacity to form meaningful aesthetic attachments, have style, or join in an aesthetic practice, or more specialized capacities, like those demanded by particular aesthetic loves, aesthetic practices, or culturally learned routines.[34] But unlike the general capacities of appreciation on the classical account, which are universally shared and oriented toward universal aesthetic value, the capacities prized by diversity-based views are ones that are shaped by our personal sensibilities, communities, cultures, and practices, and oriented toward the aesthetic value that speaks to us accordingly.[35]

Third, and finally, let's consider the diversity-based picture of the aesthetic ideal. Though different diversity theorists have promoted different accounts of the aesthetic ideal, there is a certain through line in these accounts that can be captured in terms of the idea that we should pursue a good I shall call the "good of resonance" in our aesthetic lives.[36] By "resonance," I have in mind the way in which certain aesthetic items "strike a chord" or "hit home" with us in a way that others do not. For example, though I can see the merit in

[34] See Lopes (2018) for emphasis on specialized over generalized capacities. See Matthen (2020) for culturally learned routines.

[35] See Nanay (2016: ch. 7, 2019) for discussion of the influence of cultural and perceptual learning on aesthetic capacities.

[36] Although I take diversity-based views in general to embrace the good of resonance, specific diversity-based views recognize other kinds of goods. For example, Riggle's (2015) and Nehamas's (2017) views recognize the goods of "love" and "style"; Lopes's (2018) view recognizes the good of achievement; Matthen's (2020) view emphasizes the good of pleasure; Riggle's (2021) view emphasizes the goods of individuality, aesthetic freedom, and aesthetic community; and other diversity-based views recognize goods like a work of art speaking to a particular historical moment or having social–political efficacy.

James Joyce's *Ulysses*, when I read it, it does not resonate with me in the way that Virginia Woolf's *Mrs Dalloway* does.[37] As I understand it, resonance is not just a matter of enjoying or appreciating something, or even enjoying or appreciating something intensely. Resonance marks aesthetic experiences that involve a kind of individual attunement to an aesthetic item: an attunement that turns on the value the item has for us given who we are as individuals.[38]

There are different ways diversity-based views account for the source of resonance. Some diversity-based views treat resonance as a function of our personal sensibilities. Items that fit with our personal taste tend to hit a chord with us in ways that items that fall outside that taste do not.[39] Other views treat it as a function of the local communities or practices that we participate in. Items that figure into our familiar communities or practices will hit home with us in ways that items from unfamiliar communities or practices will not.[40] And some views treat it as a function of the interaction of both our personal sensibilities and local communities.[41]

There are, moreover, different ways in which diversity-based views analyze why resonance is good. On some views, resonance is good in so far as it gives us a way to individuate and express ourselves.[42] For example, the way that *Mrs Dalloway* resonates with me and *Ulysses* does not express something about who I am and part of what is distinctive of me. On other views, resonance is good in so far as it involves achieving with regard to some aesthetic value.[43] Per this sort of analysis, the reason it is good that *Mrs Dalloway*

[37] I cannot, for example, find my way to the sort of resonance with *Ulysses* that Merve Emre describes here: https://www.newyorker.com/magazine/2022/02/14/the-seductions-of-ulysses.

[38] We may or may not endorse what resonates. For example, someone may find that Wagner "hits a chord" with them, even if they do not endorse this.

[39] See for example Riggle (2015) and Nehamas (2017).

[40] See for example Lopes (2018: ch. 11) and Matthen (2020).

[41] See for example Riggle (2022) and Strohl (2022).

[42] See for example Nehamas (2017: 86), Riggle (2015: 446), Riggle (2022: 25–28), Kubala (2018), and Strohl (2022: 101–102).

[43] See for example Lopes (2018).

resonates with me is because this resonance evinces a certain practical achievement. When I read the text and respond to its aesthetic value, I exercise practical competence with respect to the aesthetic profile of, say, modernist literature.

However, regardless of the different analyses of the specific source of resonance and kind of good it involves, its importance on diversity-based views ultimately points toward a picture of the aesthetic ideal, according to which we should organize our ongoing pursuit of aesthetic value around aesthetic items that resonate with us on a personal or local level. As was the case with the classical ideal of aesthetic universality, we can tease apart object-facing and capacity-facing aspects of the ideal of aesthetic diversity. The object-facing aspect directs us toward engaging with aesthetic objects that resonate with us.[44] For example, should I find myself faced with a choice between reading *Ulysses* or *Mrs Dalloway*, given that the latter resonates with me in a way the former does not, then this aesthetic ideal directs me to engage with the latter.[45] Meanwhile, the capacity-facing aspect of this ideal directs us toward developing the capacities required to engage with what resonates. As noted above, some of these capacities will be general capacities, like the capacity to have a personal sensibility or to join an aesthetic practice, and some will be specialized capacities, like a capacity to read Woolf's prose.

Though the good of resonance is an important part of our aesthetic lives, what I shall now argue is that there is another good that accounts of aesthetic diversity cannot adequately accommodate that we need to flourish: the good of aesthetic exploration.

[44] Riggle has recently expressed concern over casting the aesthetic ideal in terms of objects, rather than in terms of "the social values of aesthetic engagement and the ways in which aesthetic objects facilitate that engagement" (2022: 28).
[45] See for example Levinson (2010) and Riggle (2015).

3.5. The Good of Aesthetic Exploration

So, what is aesthetic exploration? By "aesthetic exploration," I mean the activity in which we engage with items of aesthetic value that are unfamiliar to us given our personal and local horizons. To be clear, by the "unfamiliar" I do not have in mind what is "exotic," understood in terms of what is "other" or "foreign."[46] By "unfamiliar," I have in mind something more minimal. Something is unfamiliar if it is new to us, qua something that we have not experienced or lack knowledge of. Given this minimal notion of the unfamiliar, opportunities for exploration abound even within our domestic sphere, as we are surrounded by numerous, say, culinary, sartorial, natural, or artistic items that we have not experienced or lack knowledge of.[47] And, to repeat, my worry about diversity-based views is that they cannot do justice to the good of aesthetic exploration in a flourishing aesthetic life.

To get this worry off the ground, let's consider an example. Suppose a publication you trust publishes a "best novels of the year" list. Since you have not read any of these novels, they will all be new to you; hence fodder for aesthetic exploration. What reason do you have to aesthetically explore these novels?

According to the diversity-based theorist, our reasons for aesthetically exploring these novels are ultimately tied to what we can resonate with.[48] If there is reason to think that these novels might resonate with us on a personal or local level, then we have reason

[46] See for example Said (1978) for a classical discussion of the problems with "exoticism."

[47] In contrast with Lopes's (2022) conception of aesthetic exploration, I take there to be room for aesthetic exploration in monocultures.

[48] For example, on Riggle's view, we should "constrain the pursuable domain of aesthetic value by that which we *could* love" (2015: 447). And according to Lopes's network theory, we have "derived aesthetic reasons" to explore unfamiliar aesthetic practices that we have "better prospects for aesthetic achievement" in given our "circumstances and existing competences" (2018: 206–207). In Lopes's (2022) account of aesthetic exploration, this is framed in terms of the "path-dependent" ways in which "outsiders" can become "insiders" in practices that "overlap" in their aesthetic profiles (2022: 71–72).

to explore them. But if there is reason to think we will not come to resonate with them, then we do not have reason to explore them.

In this vein, consider the following quote from the Irish novelist John Banville. When asked "How have your reading tastes changed over time," Banville answered: "I read very little new fiction these days, to my shame and regret. Somehow, now that I'm old, I don't seem to need whatever it is fiction offers. So much of it seems to me mere prattle. Isn't that awful?"[49] Here, Banville indicates that the reason he does not explore new fiction is that, given his age, fiction no longer seems to resonate with him.

Though this might seem to lend support to the diversity-based view that we only have reason to aesthetically explore if we think we might find resonance, notice that far from being sanguine about his lack of exploration, Banville suggests that there is something "awful" and, indeed, a source of "shame" and "regret," in feeling that fiction is "prattle." For Banville, then, it seems that the refusal to explore what is beyond his personal horizon has come at a cost. By my lights, what these considerations suggest is that our reasons for aesthetic exploration extend beyond what might come to resonate with us.

Call the kind of aesthetic exploration that is open to aesthetic value regardless of whether it might resonate with our personal sensibilities, local communities, or aesthetic practices "genuinely open" aesthetic exploration. We can thus cast the objection I am pressing against diversity-based views even more specifically in terms of the worry that they cannot do justice to the good that genuinely open aesthetic exploration brings into our aesthetic lives.

[49] https://www.nytimes.com/2021/11/04/books/review/john-banville-by-the-book-interview.html. Kenneth Walden has also suggested to me this other nice example of being averse to aesthetic exploration from Stella Gibbon's *Cold Comfort Farm* (1932), "Flora had also learned the degraded art of 'tasting' unread books and now, whenever her skimming eye lit on a phrase about heavy shapes, or sweat, or shawls or bedposts, she just put the book back on the shelf, unread" (1932: 67).

But why think that genuinely open aesthetic exploration makes our aesthetic lives better? Especially once we have set aside the hope of resonance, what can we aspire to gain through this kind of aesthetic exploration? In order to answer these questions, I would like to propose that genuinely open aesthetic exploration is ultimately good for us in so far as it involves being aesthetically open-minded, and being aesthetically open-minded is conducive to certain goods in our aesthetic lives.

Let's begin, then, with the claim that genuinely open aesthetic exploration involves aesthetic open-mindedness. By "aesthetic open-mindedness," I have in mind a character trait of being willing to engage with items that depart from our aesthetic "default," where that default reflects what is aesthetically familiar to us given our personal sensibilities, communities, cultures, or practices.[50] If we set the "aesthetic" modifier aside momentarily, we often regard open-mindedness as a desirable and admirable character trait in so far as it is conducive to certain goods. Intellectual and moral open-mindedness, for example, are treated as desirable and admirable in so far as they are conducive to intellectual and moral goods, like truth, understanding, or moral action.[51] Might a willingness to depart from our aesthetic default be likewise conducive to aesthetic goods? If so, then we have reason to regard the aesthetic species of open-mindedness as a desirable and admirable character trait as well. However, given that I have stipulated that genuinely open-aesthetic exploration is not motivated by the hope of resonance, what sort of aesthetic goods could being aesthetically open-minded be conducive to?

What I would like to propose is that being aesthetically open-minded promises us two types of non-resonant aesthetic experiences which are good for us: ordinary enjoyment and,

[50] For language of "default," see Baehr (2011: 202).

[51] For discussion of open-mindedness as an epistemic virtue, see Hare (1985), Baehr (2011), Kwong (2016), and Riggs (2019). For discussion of open-mindedness as a moral virtue, see Arpaly (2011), Cremaldi and Kwong (2017), and Song (2018).

what I shall call, "marveling." Let's turn, first, to aesthetic open-mindedness and ordinary enjoyment.[52] Often, when we engage in genuinely open aesthetic exploration, even if we do not come to resonate with things, we enjoy them. For example, when I read Cao Xueqin's *The Dream of the Red Chamber* for the first time, it did not hit a chord with me in the way that *Mrs Dalloway* does: I did not find it resonating with my personal sensibility, and, as a new-comer to eighteenth-century Chinese literature, I did not find it resonating with me in virtue of my familiar aesthetic practices. Nevertheless, I enjoyed reading it very much. Had I been close-minded to *The Dream of the Red Chamber*, as something that fell outside the horizons of my taste or local aesthetic practices, I would have missed out on this ordinary aesthetic experience of enjoy-ment. To be sure, this sort of enjoyment is not as "high-stakes" as resonance is; however, there are pleasures to be had when we expe-rience things at more of a remove. Considerations about resonance aside, then, we have reason to be aesthetically open-minded in so far as it promises us ordinary aesthetic experiences of enjoyment.

However, sometimes being aesthetically open-minded does not result in aesthetic experiences of enjoyment. I, for one, do not par-ticularly enjoy reading *Ulysses*. Nevertheless, I still have a certain kind of aesthetic experience of it. When I read it, I marvel at it and feel some astonishment or wonder that it exists. And what I would like to suggest is that having this sort of aesthetic experience of marveling is good for us.

To unpack the notion of marveling I am working with a bit more, as I understand it, marveling is an aesthetic experience in so far as it requires that we actually acquaint ourselves with the relevant item and engage with some of its aesthetic merits. Were I to, say, just read a description of *Ulysses*, I might feel intellec-tually impressed, but this does not amount to marveling in my

[52] See Irvin (2017) for a discussion of a kind of aesthetic exploration of bodies that seeks pleasure and that promises to help us resist body oppression.

sense. In order to marvel at *Ulysses*, I need to actually read it and engage with its aesthetic merits.[53] However, marveling is also not just a matter of engaging with the item and believing that there is some aesthetic merit in it; we need to experience some awe or wonder that this is the case.[54]

Marveling is nevertheless distinct from aesthetic experiences that involve ordinary enjoyment and resonance. When I marvel at *Ulysses*, this is not a matter of me enjoying reading it, nor is it a matter of *Ulysses* resonating with me in virtue of my personal sensibility, my local communities, or me achieving as a Joycean. When I marvel at *Ulysses*, I marvel at it in spite of myself. So understood, marveling is a more distanced mode of aesthetic engagement, which is distanced from who we are, with our particular hedonic preferences, personal tastes, and local ambits.

However, rather than thinking of this distance as a problem or disappointment, what I would like to suggest is that it is precisely in virtue of involving this sort of distance that aesthetic marveling is good for us. For what marveling enables us to do, in a way that neither enjoyment nor resonance does, is to open ourselves to aesthetic value that outstrips our personal and local horizons. In this way, marveling challenges our default, takes us beyond ourselves in aesthetic engagement, and opens us onto the wider world of aesthetic value that extends beyond us. And it is in virtue of this

[53] One might worry that this sort of aesthetic experience would count as resonating within Lopes's network theory. In so far as I am engaging with the aesthetic value of *Ulysses* aren't I achieving in the aesthetic practice of Joyce's literature by exercising competence with its aesthetic profile in the practice to which it belongs? However, as I understand marveling, it does not require that the aesthetic merits we are attuned to be the ones figured by the aesthetic profile constitutive of a certain aesthetic practice. Both a novice who knows nothing about Joyce and an underachiever who remains bumbling when it comes to Joyce can read *Ulysses* and find aesthetic merit in it, independent of the merit it has defined by the practice of Joycean literature. For more on novices and underachievers in relation to the network theory, see Matherne (2021b) and Lopes (2021) in reply.

[54] I thus take marveling to be thicker than what Hopkins calls a "thin" notion of judging beauty, namely, "forming a belief that something is beautiful, on the basis of some of its other features," but thinner than what he calls "savouring" beauty, which involves pleasure (1997: 181).

extension of ourselves beyond what is familiar and expansion of our aesthetic horizons that marveling brings about good in our aesthetic lives.

Piecing this together, we have reason to think our aesthetic lives are enriched by genuinely open aesthetic exploration because it involves aesthetic open-mindedness, and aesthetic open-mindedness, in turn, promises us non-resonant aesthetic experiences of ordinary enjoyment and marveling. The former experiences are good for us in so far as they involve enjoyment, and the latter are good for us in so far as they aesthetically push us beyond our default personal and local horizons. So, to recur to the new fiction case, even if we might feel that we do not personally need new fiction, we have reason to continue to aesthetically explore it in the spirit of open-mindedness and in the hope of aesthetic experiences of enjoyment or marveling. Should we refuse to explore, these are the goods we risk foregoing, potentially, to our shame and regret.

Returning now to diversity-based views, although these views promote an important good in our aesthetic lives, the good of resonance, I have been making the case that they do not do justice to the good of genuinely open aesthetic exploration. The only sort of exploration they can account for is exploration that is motivated by what might resonate with us. However, this results in an overly narrow picture of aesthetic exploration that restricts us to exploring only what might serve us given our personal and local horizons. This result is somewhat surprising, for it is precisely one of the aspirations of diversity-based views to provide a more inclusive view of aesthetic engagement, which rejects the parochialism of classical aesthetic universality. However, in limiting our pursuit of aesthetic value to what fits, or might fit, who we are, given our personalities, local communities, or aesthetic practices, the diversity-based aesthetic ideal threatens a contraction in our aesthetic lives. If we are to do justice to the good of genuinely open aesthetic exploration, then it seems we need to look elsewhere. And

what I shall now, perhaps also surprisingly, contend is that a radically revised version of aesthetic universality captures this good.

3.6. The Radically Revised Account of Aesthetic Universality

As I discussed in Section 3.2, the classical account of aesthetic universality rests on three commitments: a commitment to the universal nature of aesthetic value, a commitment to general capacities for appreciating universal aesthetic value, and a commitment to an aesthetic ideal that involves the demand to both engage with universal aesthetic value and develop the requisite capacities for doing so. In what follows, I propose a radically revised view of aesthetic universality that involves dropping the first commitment to the universality of aesthetic value and recasting the commitment to capacities for appreciation and the aesthetic ideal accordingly. I cast this view as a version of aesthetic universality particularly in virtue of it retaining a version of the second commitment about capacities. However, having dropped the first commitment to aesthetic universality, I suggest that these capacities should be understood not as capacities for appreciating universal aesthetic value, but as capacities for aesthetic exploration. I then consider the aesthetic ideal on the radically revised view, as orienting us toward the good of aesthetic exploration.

Let's begin, then, with what it means to drop the classical commitment to the universality of aesthetic value.[55] As I understand it, dropping this commitment amounts to remaining neutral regarding the possibility of universal aesthetic value. Perhaps there are certain sites in nature, like Big Sur or the starry heavens, or works of art, like the *Iliad* or Kiyomizu-dera, that can speak to all

[55] For an argument to the effect that a universalist account of aesthetic value can be reconciled with a commitment to aesthetic diversity, see King (2023).

human beings. Perhaps there aren't. But the radically revised view of aesthetic universality does not take a stand either way. Instead of universal aesthetic value, this view is concerned with unfamiliar aesthetic value—that is, with aesthetic value that is unfamiliar to us given our personal and local horizons. And what this view calls for is exploration of unfamiliar aesthetic value—a horizon that will vary from person to person.[56]

To be sure, dropping the commitment to the universality of aesthetic value is a radical departure from the classical view. Indeed, it may be so much of a departure, one may wonder whether it remains a kind of universalism at all. However, I consider the revised account to be continuous with the classical view largely in virtue of its retention of the second commitment concerning capacities. By my lights, this commitment of the classical view betrays an important insight not only into the foundational role that the possession of certain general capacities for aesthetic engagement have in our aesthetic lives but also why we need these capacities. Put another way, although the radically revised view parts way with the classical conception of the object of our aesthetic pursuits, it takes on board commitments to the importance of us, as subjects, developing a certain set of capacities. And it is in virtue of drawing on these insights about the aesthetic capacities of subjects that I take the radically revised view to be continuous with the classical view of aesthetic universality.

This said, the revised view of aesthetic universality as I understand it involves two specific revisions of the classical conception of the general aesthetic capacities. The first concerns the orientation of these capacities. In so far as the revised version drops the classical commitment to the universality of aesthetic value, it no longer makes sense to cast these capacities as capacities that are oriented

[56] It should also be noted that even in cases of marveling, the radically revised view is not committed to the claim that certain objects are ones that everyone should marvel at. What we should marvel at is a function of what will open us up beyond our personal and social horizons.

toward appreciating universal aesthetic value. Instead, within the revised framework, these capacities are to be understood as general capacities for genuinely open aesthetic exploration. So conceived they are a set of "all-purpose" capacities that enable us to get a toehold in items with aesthetic value that are new to us.

The second revision concerns the list of the general capacities once they are conceived of as capacities of aesthetic exploration. To begin, on the radically revised view, hedonic and evaluative capacities of the sort Hume and Kant emphasize no longer have a privileged role to play. That is to say, this view relinquishes a commitment to the centrality of the capacities for pleasure and making pleasure-based aesthetic judgments as capacities for aesthetic exploration.[57] By my lights, a rush to feel pleasure or issue a judgment is something that often hinders our ability to aesthetically explore. When we encounter something unfamiliar, we often do not know how to feel or what evaluation to make. But if we feel pressed to have some feeling or issue some judgment, then given the fact that what is unfamiliar often makes us confused or uncomfortable, we will default into a negative stance which, in turn, hinders exploration. Suppose, for example, I do not listen to death metal, but I go to an Arch Enemy concert. I will likely be "confused" and "hesitant" in precisely the way Hume describes as I listen to the music (ST 237). And if I were pressed to land on some hedonic feeling or issue some aesthetic judgment at the end of the show, given this confusion and hesitation, I would likely assert a feeling of displeasure and issue a negative judgment. Given this negative feeling and judgment, I would, in turn, be less likely to continue exploring death metal. In this way, the pressure to feel pleasure or issue judgment can thus hinder, rather than promote aesthetic exploration.

To be clear, I am not denying that pleasure and aesthetic judgments can sometimes play a role in aesthetic exploration.

[57] See Nanay (2018) for the argument that judgment should not be accorded the privileged place in aesthetic engagement that it is traditionally accorded.

Sometimes, they are a part of the act of exploration, for example, when I feel pleasure when I see an unfamiliar textile. And sometimes, they are downstream from aesthetic exploration; for example, although I might initially find a new cuisine confusing, over time I might come to feel and judge it to be aesthetically pleasing. Indeed, as the discussion of aesthetic exploration above suggests, one of the reasons that we aesthetically explore is in the hope of aesthetic experiences of ordinary enjoyment. However, according to the radically revised view, exercising these hedonic and evaluative capacities is not necessary for an act of aesthetic exploration. You can aesthetically explore without feeling pleasure and issuing evaluative judgments either during or downstream from the exploration. Given that exercising these hedonic and evaluative capacities is not constitutive of, and possibly a hindrance to, acts of aesthetic exploration, they need not be regarded as foundational capacities for aesthetic exploration.

The revised view does, however, retain a commitment to the capacities of apprehension and reflective projection having a central role to play in aesthetic exploration. Beginning with the former, in order for aesthetic exploration to happen, we need perceptual, imaginative, and intellectual capacities for apprehension that give us a grip on items of aesthetic value in the first place. To apprehend Ralph Ellison's *Invisible Man*, for example, I need to not only perceive the words on the page but also imagine the narrator in college, in Harlem, or underground, and think about themes like the relationship between visibility, invisibility, and racism. Or to apprehend a desert landscape, I need perceptual capacities to see, smell, and feel my surroundings and perhaps intellectual capacities to think about the cacti, rock formations, and sweeping vistas that I am seeing. To be clear, not everyone will develop their capacities for apprehension in the same way. One person may be particularly adept at apprehending haiku, another at apprehending hawks. So the point is not that specialized capacities for apprehension are required for aesthetic exploration. The point is that general capacities

for apprehension—that is, basic perceptual, imaginative, and intellectual capacities—are required for trying to open-mindedly come to grips with an unfamiliar item of aesthetic value. Suppose, once again, that I find myself at an Arch Enemy concert. Even if my ear is not skilled in apprehending death metal, I can try and listen to the music or think about how those sounds convey themes. And in exercising these general capacities for apprehension, I am exploring the music in an open-minded way.

What then of the fourth capacity on the classical view, the capacity for reflective projection? Recall that both Hume and Kant endorse the idea that in order to be able to make an unbiased or unprejudiced aesthetic judgment, we need the capacity for reflectively projecting ourselves out of a private standpoint and into the impartial standpoint of a "man in general" or into a "universal standpoint." As I see it, there are two, albeit related, purposes that this capacity serves in the classical account. First, projecting into an impartial standpoint is something that is needed in order to attune us to universal aesthetic value. For it is from this standpoint that we can appreciate what is pleasing not just for us, as private persons, but what should be pleasing to everyone. Second, projecting into the universal standpoint is a means through which we attempt to set aside the prejudices, biases, and interests that might make us partial in matters of taste. For Hume and Kant, these two ideas are related. Bracketing our prejudices, biases, and interests is crucial for being properly attuned to universal aesthetic value. Given that the radically revised version of aesthetic universality drops the commitment to universal aesthetic value, there is no need to reflectively adopt a universal standpoint that attunes us to universal aesthetic value. Moreover, given worries about the impossibility of ever being able to set aside all prejudices, biases, and interests discussed in Section 3.3, there is no need to posit the standpoint of a "man in general" or "universal standpoint" as the one we must adopt in aesthetic engagement. Nevertheless, there are a set of prejudices, biases, and interests that are of concern on the revised

view: prejudices, biases, or interests that prevent us from engaging in aesthetic exploration in an open-minded way. If I have the prejudice that death metal is just noise and not music, then I will not be willing to aesthetically explore it. An effort to overcome these prejudices, biases, and interests through some means is thus important on the revised view. But exactly what sort of effort is required here?

Though there are various ways we might attempt to resist the sort of prejudices, biases, and interests that hinder exploration, the radically revised view endorses the classical claim that reflection is one way to go about this. However, instead of projecting into the standpoint of a "man in general," I take there to be another type of reflective projection that we can avail ourselves of: reflectively projecting ourselves into the standpoint of someone (actual or possible) who is attuned to the aesthetic value of the relevant item.[58] Suppose I find myself on a mountain hike with my sister, who happens to be attuned to nature's aesthetic value. As long as I am locked in my own standpoint, rather than being open to nature, I am probably preoccupied with how uncomfortable nature feels and sighing over the mimosas I am missing at brunch. But I can also try to see the hike through my sister's eyes, perhaps asking her what she notices or how it makes her feel. And when I project myself into her standpoint, as someone who is attuned to the hike's aesthetic value, I can begin to aesthetically explore the mountain landscape. Or perhaps I could even go on a hike by myself and reflectively project into what someone who might appreciate it would notice and observe, and thereby commence aesthetically exploring vis-à-vis projection into a possible standpoint.

Per the radically revised version of aesthetic universalism, then, reflective projection into the standpoint of someone attuned to

[58] Note that I here use the language of the standpoint of someone who is "attuned" to the aesthetic value, not the standpoint of someone who "resonates" with the aesthetic value.

an item's aesthetic value can serve as a means to try and bracket the prejudices, biases, and interests that preclude us from aesthetically exploring something, and to open ourselves up to it. To be clear, the revised view is not committed to us being able to fully inhabit the latter standpoint. I, for example, cannot fully inhabit my sister's standpoint, let alone the standpoint of someone from a culture that is dramatically different from my own. So, there will be limits to the extent to which we can occupy the standpoint of someone attuned to the relevant aesthetic value. It is also often the case that reflectively projecting into an attuned standpoint requires some education, whether through study, conversation, or immersion. Nevertheless, according to the revised view, making the effort to reflectively project into such a position is a helpful way to begin opening up to an item of aesthetic value that we may otherwise be closed off to. And it is this version of the capacity for reflective projection that the radically revised view of aesthetic universality takes on board as a part of the suite of capacities of aesthetic exploration.

However, in addition to the capacity for reflective projection, there is another capacity that plays a crucial role in keeping us open in the way required for aesthetic exploration, which I have referred to as the capacity of "volitional openness."[59] By the capacity for volitional openness, I have in mind a capacity to choose to engage with items of aesthetic value, regardless of whether they fit, or might fit, our familiar aesthetic personalities and practices. So understood, the capacity for volitional openness involves the disposition to "say yes" to items of aesthetic value that extend us beyond our aesthetic horizons. Suppose, for example, I walk into the Victoria & Albert Museum and find myself with the choice of seeing a Balenciaga retrospective or a Pink Floyd retrospective. I came for the Balenciaga, but the line for the Pink Floyd is

[59] This account of volitional openness is in the spirit, if not the letter of Schiller's account of "aesthetic freedom" in the *Aesthetic Letters*. See Matherne and Riggle (2020–21). See also Riggle (2022).

impressive. Though I love Balenciaga and am quite confident that I will never come to have this sort of attachment to Pink Floyd, if I exercise my capacity for volitional openness, then I would choose the Pink Floyd retrospective.

What is more, the capacity of volitional openness has a kind of priority over either the capacities of apprehension or reflection, for it is only if we exercise volitional openness and choose to engage with an unfamiliar item in the first place that we can have anything to apprehend or reflect in relation to. To be clear, there will no doubt be countless reasons we cannot, and should not, exercise our capacity of volitional openness all the time. Perhaps we have other more pressing obligations, perhaps we have moral reason not to engage, perhaps we just need some aesthetic comfort, and so on. Nevertheless, I take the capacity of volitional openness to be another general capacity for aesthetic exploration, which often opens the door to unfamiliar horizons in the first place.

Stepping back, according to the radically revised version of aesthetic universality I have proposed, there are three general capacities for aesthetic exploration that we share: capacities for apprehension, reflective projection, and volitional openness. These capacities are to be understood as a set of all-purpose capacities that enable us to at least attempt to aesthetically take up items of aesthetic value that are unfamiliar to us.

So far, I have put forth a radically revised view of aesthetic universality that drops the classical commitment to the universal nature of aesthetic value and that recasts our general capacities for appreciating beauty as general capacities for aesthetic exploration. But what of the classical view of the aesthetic ideal? Recall that on the classical view in order to flourish in our aesthetic lives, we should be like "true" judges who seek out items of universal aesthetic value (the object-facing aspect) and strive to develop the capacities for engaging with universal aesthetic value (the capacity-facing aspect). Given that universal aesthetic value no longer plays a foundational role in the radically revised framework, this picture

of the aesthetic ideal needs to be reformulated. At the heart of this new aesthetic ideal is the idea that in order to aesthetically flourish, we need to pursue the good of aesthetic exploration and so organize our ongoing pursuit of aesthetic value around exploring the unfamiliar horizon of aesthetic value in an open-minded way.

To be clear, this aesthetic ideal is not to be confused with the ideal of "being cosmopolitan" or "being cultured." Though the ideal of being cosmopolitan or being cultured also directs us toward engaging with unfamiliar aesthetic value, I take these ideals to be motivated by a desire to be a certain sort of person who is conversant in other cultures and a "citizen of the world."[60] The ideal of aesthetic exploration, by contrast, is motivated by a desire to be aesthetically open-minded in the hope of aesthetic experiences of ordinary enjoyment and marveling.

As above, we can distinguish two components of the revised aesthetic ideal: an object-facing component and a capacity-facing component. According to the object-facing component, we should seek out unfamiliar items of aesthetic value. This is admittedly vague and does not guide us toward particular objects in the way the classical view does. It, instead, guides us toward a horizon that is populated by items of aesthetic value that are unfamiliar to us. This horizon will, in turn, vary from person to person, given what is familiar to each of us. And within that horizon, it is up to us to pick which particular items to engage with. To this end, we might read recommendations or take up the invitation of friends. We might also simply respond to an aesthetic situation we happen to stumble into. However, we should also expect that various non-aesthetic reasons will guide our choice of particular objects. For example, if the item is morally objectionable, if the item would require traveling too far, or if the item would require too much time, then we will have reason to pick something else to explore. The object-facing

[60] For a recent defense of a morally responsible form of aesthetic cosmopolitanism, see Rings (2019).

component of the ideal of aesthetic exploration thus does not tell us exactly what objects to pursue; it simply directs each of us toward the horizon of unfamiliar aesthetic value.

Meanwhile, the capacity-facing component guides us toward developing the general capacities for exploration. It directs us toward cultivating our capacities for perceiving, imagining, and thinking in relation to unfamiliar items; reflectively projecting into the standpoint of someone who is attuned to such an item; and being volitionally open to such items. And in these ways, the revised version of the aesthetic ideal of universality orients our ongoing pursuit of aesthetic value around exploration of the unknown horizon of aesthetic value and developing the skills needed for doing so.

All told, the radically revised view of aesthetic universality drops the classical commitment to universal aesthetic value, while retaining a commitment to the importance of certain general aesthetic capacities to not only interact with aesthetic items but also overcome the sort of prejudices, biases, and interests that might prevent us from doing so. However, instead of treating these capacities as capacities of appreciation, the revised view casts them as capacities for aesthetic exploration. This view, in turn, aligns the aesthetic ideal with aesthetic exploration, directing us to explore the horizon of unfamiliar aesthetic value in an open-minded way and to cultivate our capacities for doing so as a key to a flourishing aesthetic life.

3.7. The Complementarity of Aesthetic Universality and Diversity

With this radically revised version of aesthetic universality in view, let's return to the question with which we began (what is a flourishing aesthetic life) and the putative either/or we face in answering this question. We can now precisify this either/or more in light of the discussion of aesthetic ideals. As long as we hold fast to the

classical view of aesthetic universality, it seems we are faced with a choice between organizing our aesthetic lives either around the pursuit of universal aesthetic value or around the pursuit of what resonates with us on a personal and local level. The classical view tells us to opt for the former and the diversity-based view tells us to opt for the latter if we are to flourish. However, what I shall argue in this section is that if one endorses the revised view of aesthetic universality, then this putative either/or dissolves. Our aesthetic lives will go better for us if we pursue both the revised ideal of aesthetic universality and ideal of aesthetic diversity.

Perhaps the first step toward recognizing the complementarity between these two aesthetic ideals is adopting a diachronic rather than a synchronic perspective. For I take it to be the case that at any given moment in time there often is tension between pursuing both ideals. If I only have an hour at the V&A, then I am, indeed, faced with a choice between pursuing something that fits my aesthetic style and opting for the Balenciaga, or exploring the unfamiliar and opting for the Pink Floyd. From the synchronic point of view, then, we are often faced with the either/or between these two ideals. However, aesthetic ideals are ideals that govern our temporally extended pursuit of aesthetic value. So even if internal to a particular moment, we may be faced with an either/or, it does not follow that in our aesthetic lives we are faced with an either/or. If there is complementarity to be had, then we need to look for it from the diachronic, rather than the synchronic, perspective.

Let's thus consider the relationship between the two aesthetic ideals from the diachronic perspective. The aesthetic ideal of diversity orients us both toward engaging with items that resonate, or might resonate, with us given our personal sensibilities, local communities, and aesthetic practices, and toward developing capacities for engaging with such items. Meanwhile, the aesthetic ideal of universality directs us toward engaging with the horizon of unfamiliar items of aesthetic value and developing general capacities for genuinely open aesthetic exploration. Although from

the synchronic perspective these prescriptions may come into con-flict, why think they conflict from a diachronic perspective? Aren't our aesthetic lives long enough to accommodate us sometimes choosing items and cultivating capacities oriented toward what resonates with who we are and sometimes choosing unfamiliar items of aesthetic value and cultivating capacities for exploring such items?

Still one might worry that rather than being able to accom-modate both pursuits, our aesthetic lives are too short for this.[61] Suppose I want to be the most adventurous aesthetic explorer I can be in the fashion world. Were I to spend some of my time engaging the fashion of Balenciaga or Virgil Abloh that is more familiar to me, rather than exploring, say, the fashion scene in Dakhar that is unfamiliar to me,[62] I would fall short of this goal. Or suppose I am a Jane Austen superfan. I might feel there is never enough time to read and re-read her novels, watch and re-watch adaptions, or visit and re-visit Janeite meccas, so why would I waste time exploring? Don't these sorts of scenarios suggest that even if we adopt a dia-chronic perspective, the two aesthetic ideals remain in conflict?

What I now hope to show is that in spite of these concerns, there is nevertheless a deep complementarity between the ideals of aes-thetic universality and diversity. More specifically, I shall make the case that these two ideals are complementary not only with respect to a flourishing aesthetic life but also with respect to each other.

Beginning with the first kind of complementarity, I take these ideals to complement one another, in part, because pursuing both guides us toward better aesthetic lives. For one thing, each ideal promises a distinctive good in our aesthetic lives. The ideal of aesthetic diversity promises the good of resonance and the possibilities of self-expression, group affiliation, and achievement that come along with resonance. Meanwhile, the revised ideal of

aesthetic universality promises the good of aesthetic exploration and the open-mindedness and valuable experiences of enjoyment and marveling that come along with it. Pursuing both ideas is thus conducive to an aesthetic life in which there are more goods.

More than this, pursuing the good of aesthetic exploration and good of aesthetic resonance promises balance in our aesthetic lives as a whole. To see this, it is perhaps helpful to imagine an extreme scenario in which one is governed by one good or the other. If all we did was pursue the good of aesthetic exploration, there is a worry that we would become like Faust, without a place to rest.[63] But if all we did was pursue the good of aesthetic resonance, then we threaten to become contracted like Emma Bovary, obsessed by the single kind of aesthetic value with which we identify.[64] By pursuing aesthetic value in a way that balances the goods of aesthetic exploration and resonance, however, we are able to bring both openness and intimacy, breadth and depth, into our aesthetic lives. Granted, each of us will have to sort through how exactly to strike this balance, but the claim is that this balance can, and should, be struck. Our aesthetic lives on the whole will be better for it.

However, in addition to pursuit of the ideals of aesthetic universality and diversity being complementary with respect to a flourishing aesthetic life, they are also complementary with respect to each other. That is to say, pursuing the ideal of aesthetic universality is something that enhances our pursuit of the ideal of aesthetic diversity, and vice versa.

Let's begin with the idea that pursuing the ideal of aesthetic universality is instrumental with respect to the ideal of aesthetic diversity. In order to come to have a personal sensibility or be embedded in a local community or practice at all, we must begin by exploring items of aesthetic value that are unfamiliar. Indeed, I take it that the point of much aesthetic education is to provide us with a forum for

[63] I am grateful to Bengt Molander for suggesting this comparison to Faust.
[64] See Flaubert's *Madame Bovary*.

aesthetic exploration, which serves as a launching pad for us developing our personal sensibilities and finding our preferred practices. The first time I read Woolf, for example, was not because I had a sense I would resonate with her; it was simply one among a pile of books assigned in a course in college.

However, it is not just that pursuing the object-facing aspect of the ideal of aesthetic universality serves us in pursuing the ideal of diversity, pursuing the capacity-facing aspect also serves us. For as much as honing our capacities for apprehension, reflective projection, or volitional openness can enhance our engagement with unfamiliar aesthetic value, this can also enhance our engagement with what is familiar. For example, the more developed my capacity for sensuously, imaginatively, and intellectually apprehending literature is, the more I will be able to see, imagine, and think when I read *Mrs Dalloway*. Exercising the capacities of apprehension in this way not only enables us to have a richer grasp of what resonates but also enables us to return to it again and again with something new to find. As Elisa Gabbert makes this point about W. H. Auden's "Musée des Beaux Arts,"

> No matter how familiar a poem is, rereading it always gives me a sense of first encounter, as though I've gone back to sleep and re-entered the dream through a different door. Each time I return to this one, I've read a lot of other poems in the interim, which change and expand my reading.[65]

And I take it that this kind of "expanded reading" through aesthetic exploration is something that serves us in engaging with what resonates.

Meanwhile, the pursuit of the ideal of aesthetic diversity enhances the pursuit of the ideal of aesthetic universality. Once

[65] https://www.nytimes.com/interactive/2022/03/06/books/auden-musee-des-beaux-arts.html

again, this enhancement can take place at both the level of objects and capacities. On the object level, we often find items to aesthetically explore by using what resonates with us as a point of departure.[66] For example, someone who resonates with "Musée des Beaux Arts" might scroll through Gabbert's digital analysis of it and jot down the following unfamiliar items to explore: Breughel, Icarus, "Census at Bethlehem," the Auden group, Brussel's Royal Museum of Fine Arts, Book VIII of Ovid's *Metamorphoses*, Auden's "Epitaph on a Tyrant," and so on.[67] In this way, we can use what resonates with us as a guide to items to explore in the wide horizon of the unfamiliar.

Moreover, on the capacity level, it is typically in the context of engaging with something we personally prefer or a practice that we are familiar with that we develop the all-purpose skills that we can then use in relation to things that are unfamiliar to us. I take this to be the case especially with respect to the skills of apprehension, as we learn how to perceive, imagine, or think about items we are drawn to given our personalities or practices. For example, for me, engaging with German Expressionist painting helped me develop the skill of apprehending color—a much needed skill not just for the aesthetic exploration of painting but for apprehending color in all its aesthetic manifestations. However, even with respect to the skills of reflective projection, understanding what it means to have a standpoint which is attuned to the aesthetic value of an item is something that we often first arrive at as a result of finding ourselves attuned to the aesthetic value of something we resonate with. And in so far as the all-purpose skills of exploration are ones that we can continually enhance, and in so doing, continually expand our horizon of exploration, the ongoing pursuit of the aesthetic ideal

[66] See for example Lopes (2018: 206–207, 2022).
[67] https://www.nytimes.com/interactive/2022/03/06/books/auden-musee-des-beaux-arts.html

of diversity, as a means to enhancing those skills, instrumentally serves us in the pursuit of aesthetic universality.

Once we embrace the radically revised model of aesthetic universality, we thus find that not only are the aesthetic ideals of aesthetic universality and diversity complementary with respect to a flourishing aesthetic life as a whole but also with respect to one another. In so far as this is the case, in order for our aesthetic lives to go well for us, far from needing to choose either/or, our ongoing pursuit of aesthetic value should be guided by both.

3.8. Conclusion

So, what is a flourishing aesthetic life and how do we come to have one? As long as we operate within the framework of classical aesthetic universality, then it seems that we must pursue either aesthetic value that appeals to us as human beings in general or aesthetic value that resonates with us on a more personal or local level. However, in this chapter, I argued that if one adopts a radically revised view of aesthetic universality, then the need to make such a choice evaporates. To this end, I claimed that our aesthetic lives go better if we are responsive to both the universality-based ideal, which orients us toward the good of aesthetic exploration, and the diversity-based ideal, which orients us toward the good of aesthetic resonance. Indeed, I contended that pursuing both ideals gives our aesthetic lives a richer texture, as we sometimes orient inward toward what speaks to us given our personalities, communities, cultures, and practices, and sometimes orient outward toward what extends us beyond those personal and local horizons.

Thinking of these different dimensions along which we can flourish in our aesthetic lives, in turn, points toward a more complex model of a flourishing aesthetic life than we might otherwise be tempted toward. The synthesis of diversity- and universality-based views encourages us to recognize that our aesthetic life is a

way for us to express and distinguish ourselves as individuals, to join and achieve in local communities, and to explore the wider world of aesthetic value in a way that opens us up. And it is in this prospect beyond the either/or, in which we strike the balance between the depth of resonance and the breadth of exploration, that we aesthetically flourish.[68]

References

Arpaly, Nomy. 2011. "Open-Mindedness as Moral Virtue," *American Philosophical Quarterly* 48.1: 75–85.

Baehr, Jason. 2011. *The Inquiring Mind*. Oxford University Press.

Battersby, Christine. 1995. "Stages on Kant's Way: Aesthetics, Morality, and the Gendered Sublime," in *Feminism and Tradition in Aesthetics*, eds. Peggy Zeglin Brand and Carolyn Korsmeyer, pp. 88–114.

Bindman, David. 2002. *Ape to Apollo: Aesthetics and the Idea of Race in the 18th Century*. Reaktion Books.

Brand, Peggy Zeglin and Carolyn Korsmeyer, eds. 1995. *Feminism and Tradition in Aesthetics*. Penn State University Press.

Callard, Agnes. 2018. *Aspiration: The Agency of Becoming*. Oxford University Press.

Cohen, Ted. 1993. "High and Low Thinking about High and Low Art," *Journal of Aesthetics and Art Criticism* 51.2: 151–156.

Costelloe, Timothy M. 2003. "Hume, Kant, and the Antinomy of Taste: A Hume-Kant Issue," *Journal of the History of Philosophy* 41.2: 165–185.

Cremaldi, Anna and Kwong, Jack. 2016. "Is Open-Mindedness a Moral Virtue?" *Ratio* 3: 343–358.

Cross, Anthony. forthcoming. "Social Aesthetic Goods and Aesthetic Alienation," *Philosophers' Imprint*.

Deepwell, Katy, ed. 1995. *New Feminist Art Criticism*. Manchester University Press.

Gibbons, Stella. 1932. *Cold Comfort Farm*. Penguin Books.

[68] While writing this chapter, I have had the good fortune of having invaluable feedback from Whitney Davis, Diego Fernández, Joshua Landy, Jennifer Lena, Dom Lopes, Mohan Matthen, Bence Nanay, Jacinto Páez, Jem Page, Isaijah Shadrach, Nick Riggle, Kenny Walden, and audiences at the Hampton Court Workshop, the History and Philosophy of Aesthetics group at the University of Pittsburgh, the New School for Social Research, UC Berkeley, Universidad Diego Portales in Santiago, and Uppsala University.

Ginsborg, Hannah. 2017. "In Defence of the One Act View: Reply to Guyer," *British Journal of Aesthetics* 57.4: 421–435.

Gorodeisky, Keren. 2021a. "On Liking Aesthetic Value," *Philosophy and Phenomenological Research* 102.2: 261–280.

Gorodeisky, Keren. 2021b. "The Authority of Pleasure," *Noûs* 55.1: 199–220.

Guyer, Paul. 2017. "One Act or Two? Hannah Ginsborg on Aesthetic Judgment," *British Journal of Aesthetics* 57.4: 407–419.

Hall, Kim. 1997. "Sensus Communis and Violence: A Feminist Reading of Kant's Critique of Judgment," in Feminist Interpretations of Kant, ed. Robin Schott. Penn State University Press, pp. 257–74.

Hamawaki, Arata. 2006. "Kant on Beauty and the Normative Force of Feeling," *Philosophical Topics* 34.1–2: 107–144.

Hare, William. 1995. *In Defence of Open-Mindedness.* McGill Queen's University Press.

Hein, Hilde S., and Carolyn Korsmeyer, eds. 1993. *Aesthetics in Feminist Perspective.* Indiana University Press.

Hopkins, Robert. 1997. "Pictures and Beauty," *Proceedings of the Aristotelian Society* 97.2: 177–194.

Hume, David. 1985 [1757]. "Of the Standard of Taste," in Essays: Moral, Political, and Literary, ed. Eugene F. Miller. Liberty, pp. 226–249. [ST].

Kant, Immanuel. 2000. *Critique of the Power of Judgment,* ed. Paul Guyer, trans. Paul Guyer and Eric Matthews. Cambridge University Press. [CJ].

Kieran, Matthew. 2008. "Why Ideal Critics are not Ideal," *British Journal of Aesthetics* 48.3: 278–294.

King, Alex. 2023. "Universalism and the Problem of Aesthetic Diversity," *Journal of the American Philosophical Association*: 1–20.

Klinger, Cornelia. 1995. "The Concepts of the Sublime and the Beautiful in Kant and Lyotard," *Constellations* 2.2: 207–223.

Korsmeyer, Carolyn. 1995. "Gendered Concepts in Hume's Standar of Taste," in Feminism and Tradition in Aesthetics, eds. Peggy Zeglin Brand and Carolyn Korsmeyer, pp. 49–65.

Kneller, Jane. 1993. "Discipline and Silence: Women and Imagination in Kant's Theory of Taste," in Aesthetics in Feminist Perspective, eds. Hilde Hein and Carolyn. Indiana University Press, pp. 179–192.

Kubala, Robbie. 2018. "Grounding Aesthetic Obligations," *British Journal of Aesthetics* 58.3: 271–285.

Kubala, Robbie. 2021. "Aesthetic Practices and Normativity," *Philosophy and Phenomenological Research* 103.2: 408–425.

Kulenkampff, Jens. 1990. "The Objectivity of Taste: Hume and Kant," *Noûs* 24.1: 93–110.

Kwong, Jack. 2016. "Open-Mindedness as Engagement," *Southern Journal of Philosophy* 54.1: 70–86.

Irvin, Sherri. 2017. "Resisting Body Oppression: An Aesthetic Approach," *Feminist Philosophy Quarterly* 3.4: 1–25.

Levinson, Jerrold. 2002. "Hume's Standard of Taste: The Real Problem," *Journal of Aesthetics and Art Criticism* 60.3: 227–238.

Levinson, Jerrold. 2010. "Artistic Worth and Personal Taste," *Journal of Aesthetics and Art Criticism* 68.3: 225–233.

Levinson, Jerrold. 2013. "Reply to Nicholas Riggle's 'Levinson on the Aesthetic Ideal,'" *Journal of Aesthetics and Art Criticism* 71.3: 281–282.

Lind, Marcia. 1994. "Indians, Savages, Peasants and Women: Hume's Aesthetics," in *Modern Engendering: Critical Feminist Readings in Modern Western Philosophy*, ed. Bat-Ami Bar On, pp. 51–67.

Lopes, Dominic McIver. 2018. *Being for Beauty: Aesthetic Agency and Value.* Oxford University Press.

Lopes, Dominic McIver. 2021. "Normativity, Agency, and Value: A View from Aesthetics," *Philosophy and Phenomenological Research* 102.1: 232–242.

Lopes, Dominic McIver. 2022. "Getting Into It: Adventures in Aesthetic Life," in *Aesthetic Life and Why It Matters* by Dominic McIver Lopes, Bence Nanay, and Nick Riggle. Oxford University Press, pp. 61–86.

Lopes, Dominic McIver, Bence Nanay, and Nick Riggle. 2022. *Aesthetic Life and Why It Matters.* Oxford University Press.

Maples, Amanda. 2022. "Divas and Dynamos: Decolonizing Senegalese Histories through Fashion," *International Journal of Fashion Studies* 9: 317–337.

Matherne, Samantha. 2019. "Kant on Aesthetic Autonomy and Common Sense," *Philosophers' Imprint* 19.24: 1–22.

Matherne, Samantha. 2021a. "Aesthetic Autonomy and Norms of Exposure," *Pacific Philosophical Quarterly* 102.4: 686–711.

Matherne, Samantha. 2021b. "Aesthetic Learners and Underachievers," *Philosophy and Phenomenological Research* 102.1: 227–231.

Matherne, Samantha. 2023. "Aesthetic Humility: A Kantian Model," *Mind* 132.526: 452–478.

Matherne, Samantha and Nick Riggle. 2020–21. "Schiller on Freedom and Aesthetic Value," *British Journal of Aesthetics* 60.4: 375–402 and 61.1: 17–40.

Matthen, Mohan. 2017. "The Pleasure of Art," *Australasian Philosophical Review* 1.1: 6–28.

Matthen, Mohan. 2020. "Art Forms Emerging: An Approach to Evaluative Diversity in Art," *Journal of Aesthetics and Art Criticism* 78.3: 303–318.

Mattick, Jr., Paul. 1995. "Beautiful and Sublime: 'Gender Totemism' in the Constitution of Art," in *Feminism and Tradition in Aesthetics*, eds. Peggy Zeglin Brand and Carolyn Korsmeyer. Penn State University Press, pp. 28–48.

Moen, Marcia. 1997. "Feminist Themes in Unlikely Places: Re-Reading Kant's *Critique of Judgment*," in *Feminist Interpretations of Immanuel Kant*, ed. Robin Schott. Penn State University Press, pp. 213–256.

Moran, Richard. 2012. "Kant, Proust, and the Appeal of Beauty," *Critical Inquiry* 38.2: 298–329.

Mothersill, Mary. 1984. *Beauty Restored*. Oxford University Press.

Nanay, Bence. 2016. *Aesthetics as Philosophy of Perception*. Oxford University Press.

Nanay, Bence. 2019. *Aesthetics: A Very Short Introduction*. Oxford University Press.

Nehamas, Alexander. 2017. *Only a Promise of Happiness: The Place of Beauty in a World of Art*. Princeton University Press.

Riggle, Nick. 2013. "Levinson on the Aesthetic Ideal," *Journal of Aesthetics and Art Criticism* 71.3: 277–281.

Riggle, Nick. 2015. "On the Aesthetic Ideal," *British Journal of Aesthetics* 55.4: 433–447.

Riggle, Nick. 2022. "Toward a Communitarian Theory of Aesthetic Value," *Journal of Aesthetics and Art Criticism* 80.1: 16–30.

Riggs, Wayne. 2019. "Open-Mindedness," in *The Routledge Handbook of Virtue Epistemology*, ed. Heather Battaly. Routledge, pp. 141–154.

Rings, Michaels. 2019. "Aesthetic Cosmopolitanism and the Challenge of the Exotic," *British Journal of Aesthetics* 59.2: 161–178.

Roelofs, Monique. 2014. *The Cultural Promise of the Aesthetic*. Bloomsbury.

Ross, Stephanie. 2008. "Humean Critics: Real or Ideal?" *British Journal of Aesthetics* 48.1: 20–28.

Ross, Stephanie. 2020. *Two Thumbs Up: How Critics Aid Appreciation*. University of Chicago Press.

Said, Edward. 1978. *Orientalism*. Routledge.

Savile, Anthony. 1982. "Beauty: A Neo-Kantian Account," in *Essays in Kant's Aesthetics*, eds. Ted Cohen and Paul Guyer. Chicago: University of Chicago Press, pp. 115–147.

Savile, Anthony. 1993. *Kantian Aesthetics Pursued*. Edinburgh: Edinburgh University Press.

Schaper, Eva. 1983. *Pleasure, Preference, and Value: Studies in Philosophical Aesthetics*. Cambridge University Press.

Schott, Robin May. 1997. *Feminist Interpretations of Immanuel Kant*. Penn State University Press.

Shelley, James. 1994. "Hume's Double Standard of Taste," *Journal of Aesthetics and Art Criticism* 52.4: 437–445.

Shelley, James. 1998. "Hume and the Nature of Taste," *Journal of Aesthetics and Art Criticism* 56.1: 29–38.

Shelley, James. 2013. "Hume and the Joint Verdict of True Judges," *Journal of Aesthetics and Art Criticism* 71.2: 145–153.

Shusterman, Richard. 1989. "Of the Scandal of Taste: Social Privilege as Nature in the Aesthetic Theories of Hume and Kant," *Philosophical Forum* 20.3: 211–229.

Song, Yujia. 2018. "The Moral Virtue of Open-Mindedness," *Canadian Journal of Philosophy* 48.1: 65–84.

Strohl, Matthew. 2022. *Why It's OK to Love Bad Movies*. Routledge.

Taylor, Paul C. 2016. *Black Is Beautiful: A Philosophy of Black Aesthetics*. Wiley.

4

Everyday Aesthetic Injustice

Bence Nanay

The aim of this chapter is to show that we are all in danger of being culpable of aesthetic injustice on a daily or maybe even hourly basis. More specifically, if we accept the following three premises, the conclusion of everyday aesthetic injustice follows: (A) We can never fully be "participants" in a different culture; (B) we engage, on a daily basis, with works from different cultures; and (C) aesthetic judgment has a degree of intersubjective normativity. If the argument is valid, then in order to avoid being culpable of everyday aesthetic injustice, we would need to discard (at least) one of (A), (B), or (C). I argue that our best option is to reject (C) and approach works from cultures that are not our own with a fair amount of aesthetic humility.

4.1. Introduction

The starting point of this chapter is an influential characterization of cultural appropriation by the First Nations film director Loretta Todd, according to which cultural appropriation happens "when someone else speaks for, tells, defines, describes, represents, uses or recruits the images, stories, experiences, dreams of others for their own. Appropriation also occurs *when someone else becomes the expert on your experience and is deemed more knowledgeable about who you are than yourself*" (1990: 24–26, my emphasis).

The Geography of Taste. Dominic McIver Lopes, Samantha Matherne, Mohan Matthen, and Bence Nanay, Oxford University Press 2024. © Oxford University Press 2024. DOI: 10.1093/oso/9780197509067.003.0005

I want to focus on the second half of this famous quote. Much has been written about cultural appropriation in the form of using images, tunes, and motives from other cultures. But in the second sentence of the quoted text, Todd highlights a much less obvious, but much more pervasive form of cultural appropriation.

For simplicity, I call this attitude, the attitude of someone feeling more of an expert in someone else's experience than that person, the "expert attitude." It is important that one can have the expert attitude without ever saying a word that would express this attitude. Pontificating about someone else's experience (especially to this person) is of course especially bad, but the expert attitude could be there even if you never express it.

Further, and relatedly, while Todd talks about the "expert" being deemed more knowledgeable than the people they are expert on, it is not entirely clear who takes them to be more knowledgeable—society in general, some influential group, or merely the "expert" herself.[1] Here, again, I want to give the least demanding interpretation of Todd's claim: If I take myself to be more of an expert in someone's experience than that person herself, then this counts as cultural appropriation and aesthetic injustice. If I don't have to express my expert attitude in order for it to count as expert attitude, then it does not have to be universally or even locally recognized. If it is recognized by myself, that's already a form of aesthetic appropriation.

This chapter is about aesthetic injustice, not about cultural appropriation, and I will leave aside the complex debates about the relation between these two concepts (whether all cultural appropriation counts as aesthetic injustice, e.g., see Matthes [2016], Nguyen and Strohl [2019], and Lopes MS). According to Miranda Fricker, "hermeneutical injustice can mean that someone is socially

[1] See the related ongoing debate about cosmopolitanism (including aesthetic cosmopolitanism) concerning whether it is the social arrangement or the individual choices that constitute cosmopolitanism or the lack thereof (see Rings [2019] for a summary).

constructed as . . . something they are not" (2007: 168). If someone's *experience* is "socially constructed as something it is not," this would constitute a form of injustice—in this case, aesthetic injustice. And when I "become the expert on your experiences," this entails that I claim to know your experiences better than you do. When I declare myself to be an expert on your experiences, I thereby deny or at least question your expert status. This amounts to a form of silencing, which then would be a prime example of aesthetic injustice. In short, I assume that the phenomenon Todd describes counts both as cultural appropriation and as a particularly insidious form of aesthetic injustice.

The problem I want to raise is that if we assume, with Todd, that the expert attitude amounts to aesthetic injustice, then we are all in danger of being culpable of aesthetic injustice on a daily or maybe even hourly basis. More specifically, if we accept the following three premises, the conclusion of everyday aesthetic injustice follows:

(A) We can never fully be "participants" in a different culture
(B) We engage, on a daily basis, with works from different cultures
(C) Aesthetic judgment has a degree of intersubjective normativity.

The conclusion is that:

(D) Our (intersubjectively normative) aesthetic judgment of works from different cultures amounts to expert attitude, thus, is an instance of aesthetic injustice.

I will spend the chapter arguing for the plausibility of the premises of this argument and how they hang together, but if the argument is valid, then in order to avoid being culpable of everyday aesthetic injustice, we would need to discard (at least) one of (A), (B), or (C). I argue that our best option is to reject (C) and approach works

from cultures that are not our own with a fair amount of aesthetic humility.

I will close with brief observations about just how easy it is to give up premise (C) as it is a non-representative feature of some Western aesthetic traditions that is not at all shared by many other aesthetic traditions.

A brief note on terminology before we proceed. I have been using the term "culture" and "cultural" quite liberally and will continue to do so throughout the chapter, so it is important that I do not take "culture" to be an essentialist concept. Cultures can overlap and a work or a person could be part of very different cultures. There can be more or less cultural distance between two works or two persons (see Sewell [2005] for a good overview of how the concept of culture can and should be used in a way that is devoid of essentialist connotations). I will also bracket the thorny question of how cultures are individuated, as I hope to show, when I return to the question of cultures and subcultures in Section 4.3, that this makes little difference from the point of view of my argument.

4.2. Premise (A): We Are Always Observers, Never Participants

The terms "observers" and "participants" in the formulation of premise (A) are borrowed from Michael Baxandall, who made a distinction between the participants and the observers of a culture. As he says, "the participant understands and knows [her] culture with an immediacy and spontaneity the observer does not share. [She] can act within the culture's standards and norms without rational self-consciousness" ([1985: 109], see also Matthen [2017]). Baxandall was extremely pessimistic about whether we can bridge the gap from the way an observer engages with artifacts from a culture to the way a participant does. I am even more pessimistic and

the reason for this is mainly empirical: the top-down influences on perception and perceptual learning.

Here is a question many museum-goers ask of themselves: What are we looking for when we are encountering artifacts from different cultures? Take West African sculpture from Benin. What do we do when we enter a room in a museum full of sixteenth-century Beninese sculptures?

My guess is that we are trying to make sense of these objects in a way we can, namely, by relating them to artworks we know.[2] In the case of West African sculpture, this reference frame, for many of us, is likely to be European modernist sculpture. We might be drawn to some sculptures from Benin because of their Brancusi-esque qualities, for example. And we could take a fair amount of aesthetic pleasure and maybe even aesthetic experience out of this.

What may have seemed like a made-up example has some historical precedent. The famous or maybe infamous 1984 Primitivism exhibition at the Museum of Modern Art in New York City was curated and organized exactly with an eye on helping or maybe even pushing the audience to make comparisons of this kind by putting twentieth-century modernist sculptures (including Brancusis) next to sculptures from Africa (like Nukuoro carvings) (see Karp 1991).

I made a descriptive, or, if you like, sociological, claim: I described how we do in fact engage with objects of this kind. But there are obvious normative claims in the vicinity as well. I want to bracket such normative claims about both this specific exhibition and the more general practice of trying to relate artworks from different cultures to features we are familiar with in our own culture. These objects were not meant to be experienced like a Brancusi, and in their original context they were not

[2] There may be other ways, for example, by focusing on the formal features of the object. The same argument applies in the case of this form of aesthetic engagement; focusing on formal features is also alien from the original context of the Benin bronzes.

experienced like a Brancusi. So is it wrong to see them in a way we see Brancusis? At this point of the argument, I will not address these normative claims—the conclusion of the argument of this chapter is exactly about the nature and scope of such normative claims—but what we are concerned with at this point of the argument are descriptive claims about cultural distance and possible ways of bridging it.

A similar, but maybe even more salient question we encounter on a daily basis is this: What are we looking for when we are encountering artifacts from a different time period? Going to a museum almost always implies that you will encounter artifacts from a different time period. Same for many instances of listening to music or reading literature. What do we do when we do this?

Again, my descriptive claim is that we are trying to experience these works in a way that we can relate to: in ways we are familiar with from our engagement with works from our present. When we look at a Giotto painting, we are trying to look at it in a way that was shaped by our encounter with very different kinds of (say, twentieth century) paintings. Clement Greenberg (1961) even took this to be an important explanandum about modernism in general: That modernism made us rediscover some Old Masters, like Giotto or Domenico Veneziano. We tend to look at these works in a way we look at modernist paintings (by, say, Giorgio de Chirico). Again, we could ask: Is it wrong if we do so? But I want to postpone that question and deal with the descriptive claim, namely, that there are psychological reasons why (whether it is wrong or not) we do indeed do exactly this when we encounter works from far away countries or other historical periods.

The reason for this is the well-documented top-down influences on our perceptual experiences, which include top-down influences on our aesthetic engagement with any work of art. The people who were looking at the Benin bronzes in their original context (the sculptor and the people in the same village) had very different top-down influences on their aesthetic engagements from the ones

I have. This makes it very unlikely that we're engaging the way the original producers and consumers of the artifact did. But couldn't we at least try to bridge this gap? We could try. And we certainly should try. Needless to say, it can be immensely rewarding to learn about other cultures and their artifacts. But there is a systematic reason why full cultural immersion is impossible, and it is perceptual learning.

Perceptual learning is the psychological phenomenon that perceiving a certain kind of stimulus leaves a mark on the perceptual system, so next time you perceive a similar kind of stimulus, your perception of it will be different. Because of perceptual learning, our aesthetic engagement depends on past aesthetic engagements and past perceptual episodes in general—on what works (as well as everyday objects and scenes) we've encountered before.[3] Our imprinted perceptual history (dictated by what we have encountered in early formative years) is not just difficult, but impossible to shake. To put it very simply, the difference between participants and observers is their perceptual history. And perceptual history is not something we can change.

We can spend decades exploring a different culture in situ. In fact, this is what many global art historians do: If they research, say, Indonesian art, then they move to Indonesia for many years or even decades, exposing themselves to the cultural milieu and the stimuli in that milieu that might be very different from the stimuli they are used to. And this can, at least partially, revert perceptual learning (more on this in Section 4.2.1). But life is short: Even if you get as fully immersed in, say, Indonesian culture as humanly possible,

[3] I should emphasize that the importance of our perceptual history in aesthetic engagement is not necessarily a bad thing. I fully agree with Matthew Kieran's observation on this, who says the following: "We are temporal agents whose emotional life is partly constituted by our autobiography. How we understand certain features of art works, and the ways we respond to them, is sometimes a function of our autobiography. This is not to claim that all personal construal and response is legitimate" (2008: 290).

that would still mean that you would be completely lost at an exhibition of Mayan art.

In the next two subsections, I elaborate on these points concerning the top-down influences and perceptual learning, respectively.

4.2.1 The History and Geography of Vision

The starting point of the argument for the claim that we can only be observers when engaging with artifacts from a different culture is that we can't just assume that artifacts are perceived everywhere and in every historical era the way they are perceived here and now. And this goes against a traditional view in aesthetics, according to which aesthetics as a discipline is about universal truths: It examines ways of engaging with artworks and other aesthetic objects that are independent of the cultural background of the subject. In fact, art historians often accuse aestheticians of this form of cultural universalism (e.g., Davis 2011). And this universalism of aesthetics is even more heavily emphasized by recently fashionable neuroscientifically inspired aesthetic research, which often aims to find the neural correlates of various forms of aesthetic appreciation in a way that does not depend on the cultural background of the subjects (e.g., Zeki 1998; Ramachandran and Hirstein 1999; Zeki 2000).

My claim is that if we take the empirical sciences of the mind seriously, what they should teach us is that we should abandon cultural universalism altogether. The reason for this is the well-documented top-down influences on perception. We know from thousands of studies in psychology and neuroscience that even the earliest stages of visual processing are influenced in a top-down manner (see Teufel and Nanay [2017] for a summary). There are top-down influences on perceptual processing already in the primary visual cortex (Murray et al. 2002; Gandhi, Heeger, and Baynton 1999;

Kok, Failing, and de Lange 2014; Kok et al. 2016) and even the thalamus (O'Connor et al. 2002). So what we know and believe already influences the earliest stages of visual processing. And given that we know and believe different things depending on what culture and what time period we grew up in, our perception will also be different depending on what culture and what time period we grew up in.

The question is how these top-down influences on perception work and what processes mediate them. I will talk about two such mechanisms, attention and mental imagery. Both attention and mental imagery depend heavily on our higher-order mental states, such as beliefs and knowledge. And both attention and mental imagery influence our perception and our aesthetic engagement.

In other words, there are cross-cultural variations in attention and mental imagery. And given the importance of attention and mental imagery in our aesthetic engagement, this guarantees that there will be cross-cultural variations in our aesthetic engagement. In short, knowing what we know about how the mind works, universalism is not an option. We can't assume that our engagement is the same as the engagement practiced by the local producers and consumers of the artifact.

What we are attending to and how we do so very much depend on our background beliefs, knowledge, expectations, and perceptual skills, all of which are culturally specific. So our patterns of attention are also culturally specific (see Nanay 2016, 2019). But given that our experience of artworks depends heavily on what we are attending to, this leads to the conclusion that there is significant cross-cultural variation in our experience of artifacts.

The second mediator of the top-down influences on our perceptual experience is mental imagery. Our mental imagery very much depends on what we know and believe and what kind of stimuli we have perceived. When you visualize an apple, the way this apple looks depends on what kinds of apples you've seen in your life. And mental imagery plays an important role in our experience of

artworks (see Nanay [2023] and Nanay [forthcoming b] for a longer treatment of this point).

Different people with different cultural backgrounds will use different mental imagery. And this means that different people with different cultural backgrounds will have very different experiences of the very same artwork. Of course, there are also intra-cultural variations as people within the same culture but with exposure to different visual stimuli or different ideas will also have different mental imagery and attention (I'll return to this point in Section 4.3). But the variations between cultures are even more significant.

Mental imagery is involved in almost all experiences of artworks. This is especially clear in many non-"Western" aesthetic traditions. A key concept in Japanese aesthetics is that of "hidden beauty" or *yugen*, the appreciation of which involves something akin to mental imagery (see Izutsu and Izutsu 1981; Saito 1997). Imagery of the hidden also plays a key role in African aesthetics (Wingo 1998). And the eleventh-century Islamic philosopher Avicenna also heavily emphasized the importance of imagery in our experience of beauty (see Gonzales 2001: esp. 16–18).

Heinrich Wölfflin famously claimed that "vision itself has its history, and the revelation of these visual strata must be regarded as the primary task of art history" (1932 [1915]: 11). While a lot has been said about this provocative statement (Crary 1992; Danto 2001; Carroll 2001; Davis 2001), there is one sense in which this claim is just empirically true: Given that attention and mental imagery have histories, vision, which is influenced by these, also has a history (see Nanay 2015).

Further, if vision has a history in this sense, then vision also has a geography. Given that attention and mental imagery are exercised depending on what culture we have grown up in, vision, which is influenced by these, also depends on our cultural background.

In short, universalism is not an option: My aesthetic engagement with an artifact might be very different from the aesthetic engagement people practiced in the original context where the artifact was

made. When I am looking at an artifact that was created long ago or far away from where I grew up, I can't assume that my aesthetic engagement is the kind of aesthetic engagement that happened in the original context (see also Matthen 2020, Nanay forthcoming d).

So the interim conclusion is a form of skepticism about the possibility of bridging the distance between my aesthetic engagement and the aesthetic engagement people practiced in the original context where the artifact was made. But this in itself does not give a full justification for premise (A). In fact, one might argue that we can acknowledge this form of skepticism while still denying premise (A) as long as we take the artist's intention seriously: If I know what kind of aesthetic engagement the artist intended, I could get things right.

One thing to note is that very often (especially in the case of artifacts created many centuries ago) the artist's original intention is unknown—so even if the artist's intention somehow fixes and determines the "right" way of engaging with the artifact, this is of not much use to us.

But even if the artist's intention is known (or inferred), that is still not going to be enough to guarantee that we would have the "right" kind of aesthetic engagement. The artist's intention is just one of their many mental states. But in order to even make sense of this intention, we would need to know the way the artist perceived the world—and this, as we have seen, depends on their cultural background, which we can't reconstruct on the basis of their intentions.[4]

By reading up on distant cultures, we can bring them a little bit closer and this can open up thus far unknown aesthetic experiences.

[4] An additional consideration here is that trying to see what the artist wanted to achieve with the artwork and why they did what they did is a very different kind of experience than the one that the intended audience is supposed to have (who are very unlikely to try to see what the artist wanted to achieve with the artwork and why they did what they did—with the exception of some very recent artworks). I give a longer treatment of this point in Nanay (forthcoming a).

But nobody should be deluded into thinking that by doing so we can become participants rather than more or less distant observers.

The only way we can have a well-informed shot at having the aes thetic engagement people practiced in the original context where the artifact was made is if we can see the way these people did. But it is not enough to know the artist's intention for this. We would need to have the very same perceptual history as these people—and this is not a feasible task. The reason why it is not a feasible task is the subject of the next subsection: perceptual learning.

4.2.2 Perceptual Learning

Perception is not a fixed mechanism. It changes over our lifetime. What you perceive now influences how you perceive the world later. In some cases, this influence can be quite radical. Consider the example of perceptual discrimination (see Stokes and Nanay 2020). Fingerprint experts can differentiate two very similar fingerprints quickly and reliably—in a way novices cannot. Before undergoing extensive forensic fingerprint training, the expert looked at the very same stimulus she does now, but her perceptual processes and her perceptual experience are very different. We know from a number of empirical studies that this change entails a change in the way her perceptual system works (see Busey and Parada [2010]; Jarodska et al. [2010]; see also Matthen [2015] for a philosophical summary).

The effects of perceptual learning are the most impressive when it comes to perceptual expertise, like in the fingerprint example (or in the case of expert radiologists, who can, above chance, identify an anomaly in a radiographic image in 200 ms [Evans et al. 2013]). But perceptual learning is not limited to these examples (see Stokes 2021). What you see and how you see is not determined by the object and its properties (and the illumination conditions). It depends heavily on your perceptual history.

People with different perceptual histories will see the very same object very differently. When I look at a *kanga* pattern from rural southeast Tanzania, my perceptual history is very different from those who made this *kanga* pattern or for whom it was made. My perceptual history is very different from those living in rural southeast Tanzania. And I can't just erase my own perceptual history. I can't just magically acquire the perceptual history of a rural southeast Tanzanian observer. I can, of course, move to rural southeast Tanzania and live there for decades, and that may help me to acquire something reminiscent of the relevant perceptual history (although even this is doubtful). But it will still not erase my own perceptual history.

One way of seeing this is to focus on one particularly well-studied sub-species of perceptual learning, the mere exposure effect. The mere exposure effect (one of the handful of psychological findings not affected by the recent replication crisis) is that repeated previous exposure to a stimulus makes the positive appraisal of this stimulus more likely (Fechner 1876; Titchener 1910; Zajonc 1968: 2001).

Even unconscious exposure increases the probability of positive appraisal—say, if the stimulus is flashed for a very short time (under 200 ms) or if the stimulus is masked (a couple of milestone examples from the vast literature: Bornstein and D'Agostino [1992]; Elliott and Dolan [1998]; Kunst-Wilson and Zajonc [1980]; Mandler, Nakamura, and Van Zandt [1987]; Monahan, Murphy, and Zajonc [2000]).

The mere exposure effect is also present in the aesthetic domain. The most important work on this was done by James Cutting (2003, 2006a, 2006b, 2007) in a series of articles. He showed that there is a correlation between exposure to a certain painting and the likelihood of judging it positively. Cutting's experimental setup was the following. During a class on visual perception, he showed images of paintings for a couple of seconds, without any explanation or comment throughout the semester and at the end

of the semester, he made the students judge the paintings. These judgments showed clear correlation with the frequency of exposure (see Meskin et al. [2013] and Nanay [2017] for more discussion of these findings).

It is easy to see the relevance of the mere exposure effect for the prospects of understanding artifacts from other cultures. Because of the mere exposure effect, our aesthetic evaluations depend on what works we have encountered. And this makes it difficult to tear ourselves out of our own cultural milieu and enable ourselves to see a work in a way it was seen in the original context.

Can we reverse or cancel out perceptual learning and the mere exposure effect? It seems that we can, at least locally (Becker and Rinck 2016). But these reversal techniques only work for cancelling out very specific stimuli. In order to revert the effects of decades of perceptual learning and mere exposure on our global aesthetic preferences in general, we would need decades of reversal training. We can, of course, decide to live as part of the culture we are trying to engage with for many years and decades. Art historians of southeast Tanzanian art might move to southeast Tanzania, and there they would undergo the mere exposure effect to that environment and that material culture. More worryingly, neither perceptual learning nor the mere exposure effect is linear. Exposure in childhood has a much more significant effect on our later processing and preferences than later exposure (although often not on childhood preferences, see Cantor [1968]; Bornstein [1989]; Rubenstein, Kalakanis, and Langlois [1999]; Bowker and Sawyers [1988]). This early perceptual learning and mere exposure effect cannot be reversed or fully counteracted later in life. If we put all these claims together, what we get is claim (A): We can never fully be "participants" in a different culture.

I should make some clarificatory remarks about this seemingly very strong claim. First of all, it is a claim about our experiences.

It is our experiences that depend on perceptual history, and it is our experiences that depend on top-down influences. Not our aesthetic judgments. So nothing I have said here should make one question that we can make correct aesthetic judgments about artifacts produced by other cultures. We surely can if we read up on them. But we will not be able to experience these artifacts the way participants do. Importantly, everyday aesthetic injustice concerns experiences, not judgments, as we have seen in Section 4.1 (see also Nanay 2018). So we can make judgments, including various comparative judgments, and trace causal influences between artifacts from different cultures (which is exactly what global art historians do). What we can't do is to acquire the way participants experience these artifacts.

Further, we have seen all the difficulties concerning changing our entire perceptual history in a way that we would see an artifact from a distant culture the way a participant of this culture would see it. But the more specific a certain experience is, the better chances we have to get close to the experience a participant would have. We have some experimental results about how perceptual learning is easier to reverse if we restrict the domain of the experience that we are trying to learn or unlearn (Becker and Rinck 2016). So we can make great progress acquiring the perceptual history of looking at a very specific kind of objects, say, the depiction of sea monsters in Haida carvings, which would be quite similar to the perceptual history of a Haida participant. But that is a very narrow slice of my (and the Haida participant's) entire perceptual history, and the rest of our perceptual history will still diverge.

Nonetheless, the fact that we can get close to having very similar experiences to a participant as long as the experience is narrowly individuated enough is enough not to discourage us from engaging with works from other cultures and to keep on trying to decrease the distance between our observer perspective and the participant's perspective.

4.3. Premise (B): The Ubiquity of Cross-Cultural Engagement

If premise (A) is true, then we can never bridge the cultural distance between ourselves and an artifact from a different culture. What to do then? One straightforward option would be to just not engage aesthetically with any artifacts from different cultures. The first thing to note about this option is how much we would lose if we go down this route (see Lopes et al. [2022] for an argument for the enriching effect of engaging with works that are far from our comfort zone).

But the real problem with rejecting premise (B) is not that it impoverishes our aesthetic life but that it is virtually impossible to achieve. To see this, I want to take a brief detour in the philosophy of language.

Quine famously argued that no facts of the matter determine the correct translation manual from one language to another. If I go to a distant forest encountering a group of people speaking a language I don't know, I could translate their words into my own language, but I can't be sure that I use the "correct" translation manual. If they say "gavagai," I might translate it as "rabbit" or I might translate it as "undetached rabbit parts," and there is no fact of the matter that could decide between these two translations. This is the Quinean view of "radical translation."

I do not want to endorse Quine's claim. The reason why radical translation is important in the present context is the way Quine uses these considerations about two very distant cultures that speak very different languages to argue that radical translation begins at home. As he says:

> Now it should be noted that even for the earlier examples the resort to a remote language was not really essential. On deeper reflection, radical translation begins at home. Must we equate our neighbor's English words with the same strings of phonemes in

our own mouths? Certainly not; for sometimes we do not thus equate them. Sometimes we find it to be in the interests of communication to recognize that our neighbor's use of some word, such as "cool" or "square" or "hopefully," differs from ours, and so we translate that word of his into a different string of phonemes in our idiolect. (1969: 46)

Without endorsing either the "radical translation" claim or the "radical translation begins at home" claim, I want to use Quine's strategy of starting from the comparison between different cultures and then bringing this closer to home.

In Section 4.2, I argued for the claim that we can never be participants in a different culture. But how should we individuate this different culture? In the examples I used throughout the chapter, this culture was assumed to be something rather coarse-grained: Western culture versus sub-Saharan African culture, for example. But as we have seen in Section 4.1, the concept of culture is much more fluid and much less course-grained.

Crucially, the argument for the claim that we can never be participants in a different culture also applies to different subcultures. If my neighbor has been listening only to death metal since she was eight, her perceptual experience of this musical genre will be very different from mine—she will attend to different features and appreciate different nuances. And she is not from a different culture, she's my neighbor. So we can be only observers of, and not participants in, another subculture.

Here is an example. The anthropologist Franz Boas spent a very long time among the Haida in northern British Columbia, and on the basis of conversations with the local carvers, he had an extremely sophisticated understanding of the Haida system of depiction. But he observed that when he showed the very same drawing to carvers who lived in neighboring villages, or even two carvers in the same village but from different generations, they often gave very different descriptions of the depicted animals (Boas 1927).

One said sea monster, the other one bear. This shows that extremely small nuances can make a huge difference not just how one sees these carvings, but also whether one sees a sea monster or a bear in them. Needless to say, those who have little or no familiarity with Haida art will see these carvings very differently from either of these (see also Nanay forthcoming c).

It is the differences in our higher-order mental states (because of the top-down influences) and the things we have perceived throughout our lives (because of perceptual learning and the mere exposure effect) that played a crucial role in the argument in Section 4.2. I formulated this argument in terms of a comparison between people from very different cultures, because this contrast makes it salient how different both the higher-order mental states and the perceptual past of two people from different cultural backgrounds can be. But my perceptual past can also be very different from someone who lives next door. And my beliefs too. Like radical translation, everyday aesthetic injustice also begins at home.

In other words, we get a more gradualist picture, according to which there is always a distance between the aesthetic engagement of two different people, but the more different their perceptual/cultural background is, the more difficult it is to bridge the gap between these different aesthetic engagements.

If we put premise (A) and premise (B) together, what we get is that in the vast majority of our aesthetic engagements, we are not participants, but observers. We are outsiders, not insiders. This, in itself, would not lead to everyday aesthetic injustice. For that we need premise (C).

4.4. Premise (C): Interpersonal Normativity

Aesthetics is very often compared to ethics. Aesthetics is about aesthetic values, and ethics is about moral values. And ethics is about moral reasons and normativity, while aesthetics is about aesthetic

reasons and normativity. Both philosophical subfields are in the domain of "ought" not of "is." They are not about how things are, but about how things should be.

Aesthetic normativity has become quite a popular term in contemporary analytic aesthetics (see Lopes [2018]; Kubala [2021]; Cross [2022] for summaries). This centrality of aesthetic normativity also often leads to some form of interpersonal normativity. So when I have an aesthetic reason to do something (to, e.g., engage aesthetically with an object in a certain way), this is not just an aesthetic reason for me. It is also (or at least should be) an aesthetic reason for everyone else—so the Kantian line of argument goes. As Kant says, when someone

> pronounces that something is beautiful, then he expects the very same satisfaction of others: he judges not merely for himself, but for everyone, and speaks of beauty as if it were a property of things. Hence he says that the thing is beautiful, and does not count on the agreement of others with his judgment of satisfaction because he has frequently found them to be agreeable with his own, but rather demands it from them. He rebukes them if they judge otherwise, and denies that they have taste, though he nevertheless requires that they ought to have it; and to this extent one cannot say, "Everyone has his special taste". (2000 [1790]: 5:212–213)

While this line of thinking is associated with Kant (see Matherne 2019), it goes back at least to David Hume's "Of the Standard of Taste" (1985 [1757]), and it is still the dominant view in contemporary (Western) aesthetics (see Budd [2007] for an especially clear statement, Gorodeisky [2021] for a contemporary angle, and Herrstein Smith [1991] for an argument about the deeply seated Kantian roots of all Western aesthetics).

If we add intersubjective aesthetic normativity to premise (A) and premise (B), we do have a problem. From premise (A) and

premise (B), it follows that in the vast majority of our aesthetic engagements, we are not participants, but observers. And the intersubjective aesthetic normativity of premise (C) makes this observer "demand the same delight from others," as Kant put it, and the category of "others" very much includes the actual participants of the culture that produced the artwork. But this just amounts to what I called the expert attitude. To paraphrase Loretta Todd, the observer becomes the expert on the participants' experience and is deemed more knowledgeable about who the participants are than the participants themselves.[5]

We had an empirically solid case for premise (A), and we have also seen that giving up premise (B) is neither desirable nor feasible. So if we want to avoid everyday aesthetic injustice, we need to reject premise (C).

Giving up premise (C) may be justified independently of the considerations presented here—I will come back to this issue in Section 4.5. But what would giving up premise (C) amount to? If we put premise (A) and premise (B) together, all that follows is that in the vast majority of aesthetic engagements, we are outsiders, not insiders. But as long as we are not trying to force—by means of the alleged intersubjectivity of aesthetic judgment—our outsider perspective on the insiders, this is not itself an instance of everyday aesthetic injustice.

In other words, we can go to the museum, look at the Benin bronzes, and try to make sense of them in terms of our own modernist background, as long as our aesthetic engagement has no intersubjective appeal, implicitly or explicitly. This does not entail that I, the observer, become the expert on the participants' experience and I am deemed more knowledgeable about who the participants are than the participants themselves. As long as we

[5] While it needs to be acknowledged that intersubjective normativity does not imply universal normativity (see Chapter 3), the Quinean argument I gave in Section 4.3 shows that restricting intersubjective normativity to a narrower group would not help with the general worry about everyday aesthetic injustice.

reject intersubjective aesthetic normativity, we can engage with works as outsiders without the expert attitude.

In Section 4.3, I used Quine's classic indeterminacy of translation argument to illustrate that everyday aesthetic injustice begins at home. That analogy was not mere rhetorical flourish. One of the standard responses to the Quinean pessimism is by Donald Davidson, who countered Quine's radical translation argument with the help of the concept of triangulation. As he says, "Our sense of objectivity is the consequence of [a] sort of triangulation, one that requires two creatures. Each interacts with an object, but what gives each the concept of the way things are objectively is the base line formed between the creatures by language" (1982: 327).

We can use a version of the triangulation argument to address the Quinean argument that everyday aesthetic injustice begins at home. Just as we can learn the meaning of the term "gavagai" if we spend enough time triangulating, we can also understand more about how people from different cultural backgrounds look at artifacts if we spend time interacting with the artifact together with people from different cultural backgrounds. I look at the artifact, see how I react, observe you looking at the artifact, see how you react differently, and so on. And this is, in fact, what we do much of the time when we engage with art: We go to exhibitions together, stand in front of the same painting, and talk about it. This is a form of triangulation concerning our aesthetic engagement. This is easier if the cultural background of the two agents are more similar.[6]

But this Davidsonian line points in a direction that is the exact opposite of intersubjective aesthetic normativity. In order to

[6] How would this work when it comes to learning about the aesthetic engagement of, say, fifteenth-century Mayans, who are no longer here to consult or to triangulate with? In these cases, our only option is to internalize this triangulation. We do know some rudimentary facts about the way Mayans looked at various artifacts, and when I look at these artifacts, I can be aware of, and acknowledge, the difference between the way I react and the way I believe (on the basis of what I know about Mayans) they would react. This internalized triangulation, as we have seen, is not going to get us to fully understand the aesthetic engagement of Mayan people, but it could be a step in that direction.

understand how people who are different from me engage with an artwork, the first step is to acknowledge just how different their engagement is from mine—this is, in fact, the precondition of triangulation (as a triangle needs to have three sides).

I have been using Baxandall's terminology of "observers" and "participants" to frame the discussion in this chapter. But Baxandall's own take on how we can overcome the challenges of being an observer (by acknowledging what he calls "the terrible carapace of false familiarity" [1985: 114]) points in the same direction as Davidsonian triangulation. Baxandall writes: "The first task in the historical perception of a picture is therefore often that of working through to a realization of quite how alien it and the mind that made it are; only when one has done this is it really possible to move to a genuine sense of its human affinity with us" (1985: 114–115). Davidsonian triangulation can remind us of just how different our response is from the response of the people in the original context where the artifact was made.

This Davidsonian response also allows us to see that we can engage as outsiders without risking everyday aesthetic injustice. It is still a good idea to read up on distant cultures and forms of art production as it can be immensely rewarding. By reading up on distant cultures, we can bring them a little bit closer and this can open up thus far unknown aesthetic experiences. But nobody should be deluded into thinking that by doing so we can become participants rather than mere distant observers. So we need to behave accordingly: with aesthetic humility and not with intersubjective demands.[7]

[7] An important contrast to this point is Samantha Matherne, who has argued in a series of papers for a distinctively Kantian conception of aesthetic humility. See Matherne (2021, 2023).

4.5. Conclusion: Global Aesthetics versus Everyday Aesthetic Injustice

To conclude, I want to briefly consider the price of giving up premise (C), the premise of intersubjective aesthetic normativity. And I argue that this price is not too high. In fact, we have independent reasons to be skeptical of the premise of intersubjective aesthetic normativity to begin with, namely, that it seems to be a contingent, non-representative feature of some strands in the "Western" aesthetic tradition, and if we widen the scope of aesthetic inquiry to include other aesthetic traditions as well, it will seem somewhat unmotivated (see Nanay [2022, forthcoming a] for a more detailed treatment of this).

The first thing to note is that the very idea of normativity is not at all central in many of these traditions. In Chinese aesthetics, for example, arguably following Zhuangzi's extreme skepticism about the very idea of normativity, aesthetic normativity is systematically ignored, dismissed, or at the very least downplayed (Hansen 1992). Islamic aesthetics is a through and through descriptive exercise about how our sense organs and mind produce certain effects. It is not about what we should or ought to do or what experiences we should or ought to have (Gonzales 2001). This is even more explicit in the amazingly non-judgmental and non-prescriptive Yoruba tradition (Abiodun 2014).

But it is undeniable that many aesthetic traditions use (often overuse) terms like "should." Japanese aesthetics is a case in point (another example is *rasa*, where similar arguments apply; see Coomaraswamy (1956 [1934]), but see also Higgins [2007] for some wrinkles). But the normativity in these traditions is very different from the normativity in the "Western" traditions. Take Sei Shōnagon's *Pillow Book*, the most important source of aesthetic sensibility in tenth-century Japan. It is full of normative claims. In fact, most of its famous "lists" implicitly, or sometimes explicitly, give normative claims about how "oxen should have very small

foreheads" or lists about "things that should be short," "things that should be large," and so forth. But it is very clear from a number of passages that these normative claims apply to one person and one person only: Sei Shōnagon. They do not apply to anyone else (e.g., chapter 170 about her dislike of women wearing sleeves with unequal width). So while the normativity is undeniable, this is not intersubjective normativity (see also Saito 1999, 2007).[8] She writes on a number of occasions that her normative claims explicitly contradict what is fashionable (or even fashionable in good society she very much identified with). Interpersonal aesthetic normativity is not something many aesthetic traditions, other than the "Western" one, endorse. We can let go of it without any regret.[9]

References

Abiodun, Rowland. 2014. *Yoruba Art and Language: Seeking the African in African Art*. Cambridge University Press.

Baxandall, Michael. 1985. *Patterns of Intention: On the Historical Explanation of Pictures*. Yale University Press.

Becker, Eni S., and Mike Rinck. 2016. "Reversing the Mere Exposure Effect in Spider Fearfuls," *Biological Psychology* 121.B: 153–159.

Boas, Franz. 1927. *Primitive Art*. Dover.

Bornstein, Robert F. 1989. "Exposure and Affect: Overview and Meta-Analysis of Research, 1967–1987," *Psychological Bulletin* 106.2: 265–289.

Bornstein, Robert F., and Paul R. D'Agostino. 1992. "Stimulus Recognition and the Mere Exposure Effect," *Journal of Personality and Social Psychology* 63.4: 545–552.

[8] See also Cova et al. (2019) for a cross-cultural study of the intersubjective appeal of aesthetic judgments of more than 2000 respondents in nineteen countries, which found that intersubjective aesthetic normativity is very much a uniquely Western idea.

[9] This work was supported by the ERC Consolidator grant [726251], the FWF-FWO grant [G0E0218N], the FNS-FWO grant [G025222N], and the FWO research grant [G0C7416N]. I presented a much earlier version of this paper (often with different titles) at Freie Universität Berlin, the University of Crete, the University of Murcia, the University of Glasgow, and the University of Cyprus. I am also grateful to the audiences at these talks. I am also grateful for detailed written comments by Joshua Landy and Jakub Stejskal.

Bowker, Jeanette E., and Janet K. Sawyers. 1988. "Influence of Exposure on Preschoolers' Art Preferences," *Early Childhood Research Quarterly* 3.1: 107–115.

Budd, Malcolm. 2007. "The Intersubjective Validity of Aesthetic Judgements," *British Journal of Aesthetics* 47.4: 333–371.

Busey, Thomas A., and Francisco J. Parada. 2010. "The Nature of Expertise in Fingerprint Examiners," *Psychonomic Bulletin and Review* 17.2: 155–160.

Cantor, Gordon N. 1968. "Children's 'Like–Dislike' Ratings of Familiarized and Non-Familiarized Visual Stimuli," *Journal of Experimental Child Psychology* 6.4: 651–657.

Carroll, Noël. 2001. "Modernity and the Plasticity of Perception," *Journal of Aesthetics and Art Criticism* 59.1: 11–17.

Coomaraswamy, Ananda Kentish. 1956 [1934]. *The Transformation of Nature in Art*. Dover.

Cova, Florian et al. 2019. "*De Pulchritudine Non Est Disputandum?* A Cross-Cultural Investigation of the Alleged Intersubjective Validity of Aesthetic Judgment," *Mind and Language* 34.3: 317–338.

Crary, Jonathan. 1992. *Techniques of the Observer: On Vision and Modernity in the Nineteenth Century*. MIT Press.

Cross, Anthony. 2022. "Aesthetic Commitments and Aesthetic Obligations," *Ergo* 8.38: 402–421.

Cutting, James E. 2003. "Gustave Caillebotte, French Impressionism, and Mere Exposure," *Psychonomic Bulletin and Review* 10.2: 319–343.

Cutting, James E. 2006a. "Mere Exposure, Reproduction, and the Impressionist Canon," *Partisan Canons*, ed. Anna Brzyski. Duke University Press, pp. 79–94.

Cutting, James E. 2006b. *Impressionism and Its Canons*. University Press of America.

Cutting, James E. 2007. "The Mere Exposure Effect and Aesthetic Preference," *New Directions in Aesthetics, Creativity, and the Psychology of Art*, ed. Paul Locher, Colin Martindale, and Leonid Dorfman. Baywood, pp. 33–46.

Danto, Arthur C. 2001. "Seeing and Showing," *Journal of Aesthetics and Art Criticism* 59.1: 1–9.

Davidson, Donald. 1982. "Rational Animals," *Dialectica*, 36.4: 317–327.

Davis, Whitney. 2001. "Arthur Danto and the Historicity of the Eye," *Journal of Aesthetics and Art Criticism* 59.1: 29–38.

Davis, Whitney. 2011. *A General Theory of Visual Culture*. Princeton University Press.

Elliott, Rebecca and Raymond J. Dolan. 1998. "Neural Response during Preference and Memory Judgments for Subliminally Presented Stimuli: A Functional Neuroimaging Study," *Journal of Neuroscience* 18.12: 4697–4704.

Evans, Karla K., Diane Georgian-Smith, Rosemary Tambouret, Robyn L. Birdwell, and Jeremy M. Wolfe. 2013. "The Gist of the

Abnormal: Above-Chance Medical Decision Making in the Blink of an Eye," *Psychonomic Bulletin and Review* 20.6: 1170–1175.

Fechner, Gustav T. 1876. *Vorschule der Aesthetik*. Breitkoff und Hartel.

Fricker, Miranda. 2007. *Epistemic Injustice*. Oxford University Press.

Gandhi, Sunil P., David J. Heeger, and Geoffrey M. Boynton. 1999 "Spatial Attention Affects Brain Activity in Human Primary Visual Cortex," *Proceedings of the National Academy of Sciences* 96.6: 3314–3319.

Gonzales, Valerie. 2001. *Beauty and Islam*. Tauris.

Gorodeisky, Keren. 2021. "On Liking Aesthetic Value," *Philosophy and Phenomenological Research* 102.2: 261–80.

Greenberg, Clement. 1961. *Art and Culture: Critical Essays*. Beacon Press.

Hansen, Chad. 1992. *A Daoist Theory of Chinese Thought: A Philosophical Interpretation*. Oxford University Press.

Herrstein Smith, Barbara. 1991. *Contingencies of Value*. Harvard University Press.

Higgins, Kathleen M. 2007. "An Alchemy of Emotion: *Rasa* and Aesthetic Breakthroughs," *Journal of Aesthetics and Art Criticism* 65.1: 43–54.

Hume, David. 1985 [1757]. "Of the Standard of Taste," *Essays: Moral, Political and Literary*, ed. Eugene Miller. Liberty, pp. 142–154.

Izutsu, Toshihiko and Toyo Izutsu. 1981. *The Theory of Beauty in the Classical Aesthetics of Japan*. Martinus Nijhoff.

Jarodzka, Halszka, Katharina Schieter, Peter Gerjets, and Tamara van Gog. 2010. "In the Eyes of the Beholder: How Experts and Novices Interpret Dynamic Stimuli," *Learning and Instruction* 20.2: 146–154.

Kant, Immanuel. 2000 [1790]. *Critique of the Power of Judgment*, ed. Paul Guyer, trans. Paul Guyer and Eric Matthews. Cambridge University Press.

Karp, Ivan. 1991. "How Museums Define Other Cultures," *American Art* 5.1–2: 10–15.

Kieran, Matthew. 2008. "Why Ideal Critics Are Not Ideal: Aesthetic Character, Motivation and Value," *British Journal of Aesthetics* 48.3: 278–294.

Kok, Peter, Michael Failing, and Floris P. de Lange. 2014. "Prior Expectations Evoke Stimulus Templates in the Primary Visual Cortex," *Journal of Cognitive Neuroscience* 26.7: 1546–1554.

Kok, Peter, Lauren J. Bains, Tim Van Mourik, David G. Norris, and Floris P. de Lange. 2016. "Selective Activation of the Deep Layers of the Human Primary Visual Cortex by Top-Down Feedback," *Current Biology* 26.3: 371–376.

Kubala, Robbie. 2021. "Aesthetic Practices and Normativity," *Philosophy and Phenomenological Research* 103.2: 408–425.

Kunst-Wilson, William R., and Robert B. Zajonc. 1980. "Affective Discrimination of Stimuli That Cannot Be Recognized," *Science* 207.4430: 557–558.

Lopes, Dominic McIver. 2018. *Being for Beauty: Aesthetic Agency and Value*. Oxford University Press.

Lopes, Dominic McIver, Bence Nanay, and Nick Riggle. 2022. *Aesthetic Life and Why It Matters*. Oxford University Press.

Lopes, Dominic McIver. MS. *Aesthetic Injustice*.

Mandler, George, Yoshio Nakamura, and Billie J. Van Zandt. 1987. "Nonspecific Effects of Exposure on Stimuli That Cannot Be Recognized," *Journal of Experimental Psychology: Learning, Memory, and Cognition* 13.4: 646–648.

Matherne, Samantha. 2019. "Kant on Aesthetic Autonomy and Common Sense," *Philosophers' Imprint* 19.24: 1–22.

Matherne, Samantha. 2021. "Aesthetic Autonomy and Norms of Exposure," *Pacific Philosophical Quarterly* 102.4: 686–711.

Matherne, Samantha. 2023. "Aesthetic Humility: A Kantian Model," *Mind* 132.526: 452–478.

Matthen, Mohan. 2015. "Play, Skill, and the Origins of Perceptual Art," *British Journal of Aesthetics* 55.2: 173–197.

Matthen, Mohan. 2017. "The Pleasure of Art," *Australasian Philosophical Review* 1.1: 6–28.

Matthen, Mohan. 2020. "Art Forms Emerging: An Approach to Evaluative Diversity in Art," *Journal of Aesthetics and Art Criticism* 78.3: 303–318.

Matthes, Erich Hatala. 2016. "Cultural Appropriation without Cultural Essentialism?" *Social Theory and Practice* 42.2: 343–366.

Meskin, Aaron, Mark Phelan, Margaret Moore, and Matthew Kieran. 2013. "Mere Exposure to Bad Art," *British Journal of Aesthetics* 53.2: 139–164.

Monahan, Jennifer L., Sheila T. Murphy, and Robert B. Zajonc. 2000. "Subliminal Mere Exposure: Specific, General, and Diffuse Effects," *Psychological Science* 11.6: 462–466.

Murray, Scott O., Daniel Kersten, Bruno A. Olshausen, Paul Schrater, and David L. Woods. 2002. "Shape Perception Reduces Activity in Human Primary Visual Cortex," *Proceedings of the National Academy of Sciences of the United States of America* 99.23: 15164–15169.

Nanay, Bence. 2015. "The History of Vision," *Journal of Aesthetics and Art Criticism* 73.3: 259–271.

Nanay, Bence. 2016. *Aesthetics as Philosophy of Perception*. Oxford University Press.

Nanay, Bence. 2017. "Perceptual Learning, the Mere Exposure Effect and Aesthetic Antirealism," *Leonardo* 50.1: 58–63.

Nanay, Bence. 2018. "Against Aesthetic Judgment," *Social Aesthetics and Moral Judgment*, ed. Jennifer McMahon. Routledge, pp. 52–65.

Nanay, Bence. 2019. *Aesthetics: A Very Short Introduction*. Oxford University Press.

Nanay, Bence. 2022. "Going Global: A Cautiously Optimistic Manifesto," *Contemporary Aesthetics*. Special Volume 10: 5.

Nanay, Bence. 2023. *Mental Imagery: Philosophy, Psychology, Neuroscience.* Oxford University Press.

Nanay, Bence. forthcoming a. *Global Aesthetics.* Oxford University Press.

Nanay, Bence. forthcoming b. "Perception and Mental Imagery in Our Engagement with Art," *Art and Philosophy,* ed. Alex King. Oxford University Press.

Nanay, Bence. forthcoming c. "Franz Boas and the Primacy of Form," *British Journal of Aesthetics.*

Nanay, Bence. forthcoming d. "Aesthetic Experience as Interaction," *Journal of the American Philosophical Association.*

Nguyen, C. Thi and Matthew Strohl. 2019. "Cultural Appropriation and the Intimacy of Groups," *Philosophical Studies* 176.4: 981–1002.

O'Connor, Daniel H., Miki M. Fukui, Mark A. Pinsk, and Sabine Kastner. 2002. "Attention Modulates Responses in the Human Lateral Geniculate Nucleus," *Nature Neuroscience* 5.11: 1203–1209.

Quine, W. V. O. 1969. *Ontological Relativity and Other Essays.* Columbia University Press.

Ramachandran, V. S., and William Hirstein. 1999. "The Science of Art: A Neurological Theory of Aesthetic Experience," *Journal of Consciousness Studies* 6.6–7: 15–51.

Rings, Michael. 2019. "Aesthetic Cosmopolitanism and the Challenge of the Exotic," *British Journal of Aesthetics* 59.2: 161–178.

Rubenstein, Adam J., Lisa Kalakanis, and Judith H. Langlois. 1999. "Infant Preferences for Attractive Faces: A Cognitive Explanation," *Developmental Psychology* 35.3: 848–855.

Saito, Yuriko. 1997. "The Japanese Aesthetics of Imperfection and Insufficiency," *Journal of Aesthetics and Art Criticism* 55.4: 377–385.

Saito, Yuriko. 1999. "Japanese Aesthetics of Packaging," *Journal of Aesthetics and Art Criticism* 57.2: 257–265.

Saito, Yuriko. 2007. *Everyday Aesthetics.* Oxford University Press.

Sewell, William Jr. 2005. "The Concept(s) of Culture," *Logics of History.* University of Chicago Press, pp. 35–61.

Stokes, Dustin. 2021. *Thinking and Perceiving.* Routledge.

Stokes, Dustin and Bence Nanay. 2020. "Perceptual Skills," *Routledge Handbook of the Philosophy of Skill and Expertise,* ed. Ellen Fridland and Carlotta Pavese. Routledge, pp. 314–323.

Teufel, Christoph and Bence Nanay. 2017. "How to (and How Not to) Think about Top-Down Influences on Perception," *Consciousness and Cognition* 47: 17–25.

Titchener, Edward B. 1910. *Textbook of Psychology.* Macmillan.

Todd, Loretta. 1990. "Notes on Appropriation," *Parallelogramme* 16.1: 24–33.

Wingo, Ajume H. 1998. "African Art and the Aesthetics of Hiding and Revealing," *British Journal of Aesthetics* 38.3: 251–264.

Wölfflin, Heinrich. 1932 [1915]. *Principles of Art History: The Problem of the Development of Style in Later Art*, trans. M. D. Hottinger. Dover.

Zajonc, Robert B. 1968. "Attitudinal Effects of Mere Exposure," *Journal of Personality and Social Psychology, Monograph Supplement* 9.1: 1–27.

Zajonc, Robert B. 2001. "Mere Exposure: A Gateway to the Subliminal," *Current Directions in Psychological Science* 10.6: 224–228.

Zeki, Semir. 1998. "Art and the Brain," *Proceedings of the American Academy of Arts and Sciences* 127.2: 71–104.

Zeki, Semir. 2000. *Inner Vision: An Exploration of Art and the Brain*. Oxford University Press.

Discussion: The Allure of Universals and How Far Should We Resist?

Bence Nanay: I have a few questions. The first one is, why are we doing this volume?

Mohan Matthen: The question that I've had in mind for some years—it's something that you address quite centrally, Bence— is whether we can really respond to the work of people from a culture that we didn't grow up in. My view of cultural learning suggests that it isn't straightforward. And if there are significant obstacles beyond just sensitization to a new idiom, what sort of modifications does that require in aesthetic theory, broadly speaking? We have different ideas about this. I'm intrigued by that, and I thought it would be interesting for us each to lay out how we approach the question of cultural variation.

Dominic McIver Lopes: We can also approach the question institutionally. Philosophical aesthetics has acknowledged that artistic and aesthetic practices vary by culture. But that fact hasn't been exploited to do any work in helping us to think about what aesthetic engagement is or why it matters. Even as, in recent years, we've become interested in aesthetic theory from non-European cultures, that hasn't been matched by interest in the artistic and aesthetic practices of those places. Looking beyond philosophy to the academy more widely, we see specialization by culture. Scholars work on South Asian dance or East Asian painting. This is good, of course, but it makes it hard to understand why there's global differentiation in the first place. Differentiation is the starting point, taken for granted in the departmentalization of the academy, rather than a mystery to be solved. (Maybe this is changing with world art history.) Filling gaps produced

by our fundamental, methodological assumptions can be especially fruitful. I hope this volume is evidence of that. So I think it's not surprising what Mohan just said, namely that we all end up taking quite different approaches.

Samantha Matherne: The motivation for me was related to concerns that Dom just mentioned: certain gaps in philosophical aesthetics concerning the issue of aesthetic diversity. Especially as someone who often works on figures like Hume and Kant, hence on a historical tradition in which aesthetic universalism has its home, I was eager for the opportunity to theorize from a standpoint that takes as its starting point a recognition of the value of aesthetic diversity, instead. And being able to theorize about this alongside you three has been revelatory, especially in light of the blend of descriptive and normative approaches to aesthetic diversity that have emerged. Mohan's and Dom's chapters are variations on descriptive accounts, and my and Bence's chapters are variations on normative accounts. The result, I think, is an aesthetic discourse that pivots on diversity rather than universality, and that represents possibilities for theorizing the aesthetic and aesthetic value in a way that takes diversity seriously.

BN: I originally intended my question to be about what it is that we're trying to achieve. But I think that you all three have answered the much more important and interesting question about why you as individuals are motivated to do this. So the question is about where we're coming from rather than what direction we're going. So, for symmetry, I'm just going to also say something brief about where I'm coming from and maybe later we can return to the other question about where we think we're going with this project.

So where I'm coming from is the body of evidence from perceptual psychology and neuroscience about how we experience the world very differently depending on our perceptual history or our background knowledge. And both of these are determined by where we grew up. This has very important

implications for how we experience artworks or for aesthetic experiences in general as this introduces a very basic sense of diversity in all things aesthetic: People from different cultural backgrounds will experience the same artwork very differently. I'm trying to think through the implications of this very simple fact about our mind for aesthetics.

DML: Let me pick up on something that Samantha just said. She pointed out that we've combined descriptive and normative treatments of diversity. It occurs to me that the gaps that I was talking about might come from a reluctance to do exactly that. In philosophy and other disciplines, there's been an excess of caution about making normative claims in the wake of the horrible history that we describe in the Introduction. But normativity doesn't have to be universalist, and striving to speak of universals doesn't have to be domineering.

MM: Universalism is a natural starting point for people thinking philosophically about art, if they have only been exposed to one culture. For someone like Hume, there's a well-established cultural scene, and he's trying to describe his relationship to it. And it's the same for *rasa* theorists. Neither has much reason to think about different cultures. So universalism is everybody's first approach.

DML: Isn't it surprising that, knowing the history of colonialism, we've been reluctant to think about why difference matters? I doubt we can fully understand the character of the diversity we're interested in without understanding why it would matter, because that's going to be part of the story about its origins and its persistence. And I don't think we can really understand why it matters without understanding what the phenomenon is in the first place. Maybe this is a breakthrough: We're bringing the normative and the descriptive angles together.

BN: Maybe I can say something about what I'm hoping this book to achieve. I think that there has been, there is, and there certainly will be some kind of turning away from hard universalism. So

I don't think that this book is absolutely necessary to encourage that. That would happen anyway. And that's a good thing. Where I think this book could achieve something distinctive is to figure out, at a very abstract level, what the possible alternatives are. Because if we reject universalism, as we should, there is a real danger of what I call the fragmentation of art historical and aesthetic discourse. So we would have a separate study of, say, southeast Tanzanian clothing patterns, together with its theoretical framework rooted in local discourse. And this would have nothing to do with, say, the study of Inca statuettes and their aesthetic theory. If we're going all local, then we get a fragmented ensemble of myriads of local aesthetic traditions, with few possibilities of cross-talk between them. And that's not a good option either, especially when we're trying to understand the more and more intricate cultural exchanges between these aesthetic traditions. So we need to find some kind of middle ground between universalism and this kind of extreme particularism that sees the aesthetic domain as a hodgepodge of non-communicating local fragments. And I think that if you look at the problem of aesthetic diversity from a very high-level philosophical or abstract point of view, which is what this book does, then we can figure out how we can somehow occupy a middle ground between the two unattractive positions: universalism and fragmentation.

DML: I wonder if it's helpful to think about language studies. Languages are diverse, so there are philological studies of each language, which are attuned to the perspective of that language. That's compatible with general linguistics, the study of how human languages work, which is done through case studies of particular languages. This is a model of how to situate differences within a framework where you have similarity, and where the framework makes sense of and doesn't neglect the diversity.

MM: So do you think that there's a strict analogy there? I mean Chomsky's linguistic theory posits a common framework for all languages. Do we think that there's a common theoretic framework for all aesthetic cultures or artistic cultures?

BN: Or, alternatively, is the idea perhaps that some kind of Chomskian universal grammar is the equivalent of the hardcore universalism that everyone is going against?

DML: I don't think that we need to be looking for a deep grammar of art or the aesthetic, though we shouldn't rule out that there could be deep grammars of some specific artistic or aesthetic phenomena. Fred Lerdahl and Ray Jackendoff have proposed a generative theory of tonal music.

BN: I think this is a great analogy in more than one way. First of all, there has been a lot of recent stuff in linguistics that takes the lead not from the way Indo-European languages work but from thus far under-researched language groups. Here is an example from the iconicity of language literature. The standard story used to be that there's a completely arbitrary connection between syntax and semantics. But in many non-Indo-European languages, syntax is not at all arbitrary; it tracks semantic content in a quasi-iconic manner. That's a nice shift in linguistics away from using the Indo-European languages as the prototype and then tweaking the language model when applying to other languages. The alternative is to look at a wide variety of languages, their little quirks and weird features, and come up with the language model that covers them all. And the same goes for aesthetic practices and aesthetic traditions. The result is not necessarily some kind of universal trait that each and every one of the different languages or aesthetic traditions have. But this methodology can help us understand the terrain. It can help us understand the range of possibilities and variations, but also the invariant elements. So that's the sense in which what we're studying really is the geographies of taste.

DML: The use of small samples worries me too. Philosophers have relied too much on works from one tradition—in fact, the supposedly "greatest" works of that tradition. We shouldn't reason either from just one tradition or from outliers, where it's really hard to know what's going on. This volume underlines how important it is, when we're thinking about artistic and aesthetic cultures, to embrace all the possibilities—all the dimensions along which they vary, as Bence just said. That's the way to understand aesthetic and artistic life.

SM: While we are all suspicious of what Bence called "hard universalism," one thing I'm trying to think through is whether there is, nevertheless, a thin universalist framework that we are converging toward, which could elucidate the space of possibility for aesthetic diversity and variation. It strikes me that more traditional frameworks for universalism assume that we have some universal set of capacities for appreciation and these go hand in hand with being able to make aesthetic judgments about universal aesthetic value, for example, judgments about what everybody should find beautiful. It seems to me that we're all, to varying degrees, skeptical about the latter aspect of this traditional picture. So one potential result of the volume is sidelining the thought that judgment of this sort is the site of universality in aesthetic theory.

But this still leaves open the question about capacities and if we want to endorse there being some sort of universal framework for capacities in which diversity manifests. It seems to me that Mohan gives a cultural analysis of the common origins of shared capacities that then manifest in diverse ways through evolution and cultural learning. I think that when Bence talks about perceptual learning and top-down processes, he is also talking about a universal process that then gets inflected in diverse ways in individuals. And then, for Dom, it seems that whether you want to call them universal or not, the sort of patterns of hedonic, aesthetic, and artistic cultures you highlight

are common patterns in a thin framework of universality that allows for multiplicity in particular cultures.

So, back to one potential result of the volume: If there are prospects for aesthetic universality, embracing a traditional emphasis on judgment about universal aesthetic value isn't the way forward. And if there's going to be any residual universalism, then we need to be thinking about it in terms of capacities or cultural patterns that pave the way to diversity, rather than to commonality.

MM: Speaking of the universal framework that I utilize—it's not an aesthetic framework. There are no assumptions about aesthetic theory there. Ditto for Bence, I think. That's less so for Dom, I guess. He assumes that certain practices are aesthetic, and he frames things in these terms. I talk more about mental capacities—the capacity to attend to something, for example. These are not aesthetic capacities as such.

SM: I take it that one could leave open whether the sort of universal capacities have to be specified aesthetically or not.

DML: We're all appealing to general purpose—that is, not uniquely aesthetic—capacities. For Samantha, it's openness of mind. For me, it's social cooperation and norm following, which are both grounded in affective and perceptual capacities, as well as capacities to engineer our environment to shape our behaviors. For Bence, it's perception, and for Mohan, it's learning.

BN: Yes, it's nice that from very different starting points, we've all ended up at a place that, at least from a very big picture point of view, looks quite similar. But within analytic aesthetics, are we still the outliers?

DML: One foil would be those who take beauty to be a worldly property that isn't constituted in any way by our individual or collective responses. Our responses simply detect the property. They must think that the capacity for detecting beauty in the world is a special purpose capacity that's not reducible to any general purpose set of capacities.

I think we've just made a discovery here. Samantha pointed out that we can think about universality at the level of the values or at the level of capacities. And now we've realized that commitment to universality at the level of the values implies a commitment to universality at the level of the capacities as well. Not vice versa.

BN: The way I see this project and something that unites the otherwise very different approaches of the four of us is that we are all somewhere between traditional analytic aesthetics, on the one hand, and visual studies or global art history, on the other. We're trying to be somehow less dogmatically universalist than analytic aesthetics has traditionally been (obviously there are and always have been exceptions). But we're also trying to have more of a unified (and less fragmented) framework than at least many approaches in visual studies or global art history. So I see all four of us somewhere in the middle. We're coming from very different directions, but ended up in the same general ballpark.

SM: I wonder if we can combine the methodological point Bence just made with what Dom was saying about how one's theory of aesthetic value might influence one's theory of capacities. If one takes their cue in thinking through values from the diversity that's explored in something like global art history, this might lend itself to coming up with a theory of the general purpose capacities that allow for that sort of diversity. But if one has a more realist account of aesthetic value, then this might lead to theorizing capacities in a more specialized way.

DML: Right, so we've independently arrived at a similar solution to the problem of where to make a break with tradition and where to maintain continuity. We're all committed to there being general human capacities that are implicated in aesthetic and artistic engagement. In that way, we're continuous with the tradition. And we're emphasizing difference—and it's not as if the tradition wasn't aware of difference. But, for the tradition, what matters is what you get on the universal level. So when people

from different walks of life come together, what they should do is find what they share in common. What matters for all four of us is that when people come together, their differences can be a point of engagement. They might look for similarities, but they shouldn't do that at the price of their differences, especially in artistic and aesthetic life.

BN: This is a nice tie-in for my next question. We are all against some kind of industrial strength universalism. But what about those aspects of our aesthetic life where universality seems most appealing or most tempting? Physical beauty, natural beauty? K-pop? Proust? Are there things that make you say "wow, this is amazing all around—no matter where you're coming from, you'll love this!"? Does this ever happen to you?

MM: I think it does. It is one of the things that one has to take into account—that there are some things that appeal to people across cultures. Samantha, you have a pithy way of putting it: universally valued things but not universal values—or something like that. Everybody loves Big Sur, apparently, but this doesn't imply that everybody values it for the same reasons. Isn't that your contrast? So, the fact that everybody regardless of culture likes certain things doesn't imply universalism, at least not in the sense that we want to reject it. We might all have different approaches to these overlaps of taste. (I invoke common origins to explain at least some.)

SM: Yes, I suggest that there might be some aesthetic things that have universal appeal, but that we should not think that aesthetic value itself is, or should be, universal. But to keep pursuing the former line of thought, let me sketch a potential way someone might develop the idea that some things have universal aesthetic appeal that is in keeping with the picture of aesthetic diversity we are sympathetic to. Instead of thinking of these things as what can be valued regardless of one's culture, we could think of them as things that can be valued precisely because of one's culture. For example, one way we might think about the aesthetic

richness of, say, the *Iliad* or the *Odyssey* or Big Sur or the starry heavens is that they keep offering an invitation to us, as we come at them in our culturally situated ways. In keeping with how we were just discussing how universal capacities open up the space for possibility and multiplicity of aesthetic diversity, one possible way to think about aesthetic things that have universal appeal is in terms of the idea that they open up this space of possibility for people, not regardless, but because of their cultural background, to find something productive and fruitful in them in diverse ways. This might be one way to think about the possibility of certain aesthetic things having universal appeal that doesn't preclude diversity.

DML: Nowadays, there's a new idea of universality in some quarters. The old idea is that there's one privileged perspective that is supposed to be taken by everybody. From that perspective, we'll see what the truly great works are. The new idea accepts that there are lots of perspectives, none privileged, but there are some special items that really open themselves up to all or most of those perspectives. These are the items around which we could come together. So these are now supposed to be the cross-cultural great works. I'm skeptical of this new idea too. Probably there are some items like this, but I don't think that we should privilege them either in our theorizing or in our individual lives as engagers.

MM: I think this is really important. So you are making the very important distinction between a privileged item that can be appreciated from a number of different perspectives as against something that is appreciated from some privileged perspective. I'm sympathetic to there being a privileged perspective. It's quite limited; it's not going to take in everything in every culture, but it's possible that there are some values common to all. I don't see any reason to deny that.

BN: I think it's a very important distinction that Dom has just made about the two different kinds of universalism. And I'm also

skeptical about both of these kinds. But maybe the complexity of the aesthetic reaction in question is an important parameter here. I think both Dom and I doubt that people from all aesthetic traditions would have the very same reaction *of a certain complexity* toward an object. But it may very well be possible that some very simple aesthetic reactions happen in all aesthetic traditions, and that's something that Mohan's been talking about. The more complex these aesthetic reactions are, the less likely it's going to be that there's going to be a resonance with all aesthetic backgrounds.

DML: Apparently everyone reacts very strongly to the interval of the fifth in music. What do we do with that as scholars or appreciators? It's just so thin. Are any universally good things thick?

SM: Perhaps we could return to the *Iliad*. Here's an argument someone could make. What explains the universal appeal of the *Iliad* is something thick and complex: its treatment of human phenomena and human concerns, such as rage and grief. Whether we think of Achilles' grief over Patroclus or Priam's grief over Hector, one could argue that it is precisely because the *Iliad* so powerfully treats of grief that it's of broad appeal. If this is right, then the broad universal appeal of the *Iliad* wouldn't be based in something thin but rather in something thick and complex: an epic treatment of grief that speaks to us as humans, culturally situated as we are, who grieve.

BN: What is interesting about the *Iliad* is that it's such a stable part of the aesthetic history or perceptual history for so many of us. So many other works are based on it in the last centuries, some even in other aesthetic traditions. And this makes it a pretty solid part of our aesthetic sensibility. At this point in the twenty-first century, it's very difficult not to find it aesthetically valuable. But that may not have always been the case. I think that's another thing that we may want to talk about: The level of cultural exchange between different aesthetic traditions is

very different now than it used to be even a hundred years ago, let alone two hundred years ago. So now we can have and do have aesthetic phenomena that travel the entire world, maybe the *Iliad*, or maybe K-pop. But things were very different, say, in tenth-century Japan, where I don't think the *Iliad* would have been much appreciated.

MM: The degree of hybridization that we've seen in the last, say, fifty years is much greater than it has ever been before. I mean, since the 1970s or something like that. So it's very difficult to talk about the local context in literature or even music after the late twentieth century. Globalization and hybridization have really become absolutely endemic.

DML: I worry about confounders. One confounder is globalization, especially when it's colonizing, imposing uniformity. But another confounder is socioeconomic status. The *Iliad* has extremely narrow appeal, even among students made to read it. Stephen King and K-pop: Those are realistic examples.

SM: But are we looking for a descriptive example here? The case that I was imagining someone could make for the *Iliad's* broad appeal was not an argument to the effect that everybody who reads the *Iliad* will, in fact, be profoundly moved by its presentation of grief. The case I was imagining was for the possibility that the *Iliad*, in virtue of its complex treatment of grief, opens up the space of possibility for people, culturally situated as they are, to find something moving and revelatory about a common human experience like grief that gets refracted in culturally diverse ways.

DML: I think we really are divided on the question where there are some items that have some value from all or most perspectives. For me, the answer is, if any, very few and not very interesting.

BN: And I agree with that. And Mohan and Samantha are on the other side.

SM: I wasn't trying to take a side per se. I was trying to explore a case that could be made for the possibility that some aesthetic

things, and some interesting aesthetic things, might have universal appeal. But if there are some cases, I certainly agree that they shouldn't be privileged over things that have local appeal.

MM: What do you mean by privileged? As a point of basic theory? Is that what you mean?

SM: I take it that in Kant and Hume's frameworks if you ask what is beautiful, they will say it is only that which has universal appeal. That's the privilege. And I don't think that's right. If there are things that have universal appeal, then I don't think there's reason to think that they are more worth our time or more valuable than things that only have local appeal.

MM: This raises another question for me. Is there something about the creative arts that makes them intrinsically diverse? I think of them as constantly splitting and diversifying. That's in their nature. So, they are diverse, even though they started out from the same place. Dom, you think of them as just organized around principles which might have been quite different right from the start. They are just arbitrary principles which are principles only because somebody has held them, not for any objective reason. Is that right? You think about artistic cultures as unified by the practices that they happen to coalesce around. There's no reason for them to be unified in any particular way. So Dom and I think, though for different reasons, that art is essentially diverse. There is something in that practice that doesn't come from one place; it has by its very nature many manifestations. Whereas I don't think that's Samantha's view. Not sure about Bence.

BN: I think that the kind of diversity of aesthetic practice Dom and Mohan talk about is very straightforwardly presupposed in my account. Artists make art for an audience. They have expectations about the reactions of the audience, because that's what they're catering for. So if there's diversity in the audience's reaction, then that's going to be diversity in the artistic practices. What I myself am interested in is the diversity in the audience's reaction—I'm always interested in the reception side rather than

the production side. But given that the production isn't independent from the reception, but rather is catering to the reception, there's going to be a non-trivial but straightforward step from diversity in the reception to diversity in the production.

SM: In my chapter, I don't express a view about how to think about artistic practices. In part, this goes back to the issue of capacities that we were discussing earlier. When I discuss general capacities for exploration, I don't take them to be geared into any specific artistic practice, let alone into art- or non-art objects. I take them to be "general" in the sense of being "all-purpose" capacities that allow us to explore aesthetic items more generally.

DML: Samantha, clearly your account of exploration commits you to aesthetic and artistic cultures being diverse as a matter of fact. There would be no point in exploration without diversity! The question that Mohan's raising is whether your account of exploration requires that the cultures be diverse by nature. One might think the following. People have additional reason to explore fields that are by nature diverse. The reason is that exploring requires being attentive to the nature of the field. It wouldn't be aesthetic or artistic exploration if it was cavalier about the nature of the aesthetic or artistic.

SM: I see where you're coming from. But the way that I present exploration is not in terms of exploring aesthetically or artistically diverse cultures, but rather in terms of exploring what's new or unfamiliar to us, which may include items from more familiar or more distant cultures. So I need to think more about whether that newness or unfamiliarity coincides with the notion of the diversity of aesthetic or artistic culture that you were just talking about.

DML: Take a Woolf reader who pushes through and explores *Ulysses*. In exploring something unfamiliar, she flourishes. But then she declines a friend's copy of Kālidāsa, and it turns out that she's not exploring beyond English modernism. Is she still flourishing?

SM: An important dimension of flourishing that I'm trying to bring out is aesthetic open-mindedness, which requires willingness to depart from our default. It seems that in the case you just raised, what's shown is the refusal to depart from one's default, and so failing to be aesthetically open-minded in the way that, at least, one aspect of a flourishing aesthetic life calls for. But if aesthetic open-mindedness involves willingness to depart from one's aesthetic default, and we're thinking about this, in part, in terms of departing from one's cultural default, then, in just the way Dom was suggesting, aesthetic open-mindedness is ultimately going to require the willingness to engage with aesthetic and artistic cultures that are diverse. I am becoming convinced!

MM: We're all opposed to universalizing aesthetic values, whether they be thin (e.g., beauty) or thick (e.g., gracefulness). We all agree that these values have decidedly different descriptive content in different cultures. That said, Mohan and Samantha allow that there might be some components of aesthetic and artistic universals that are unmodified by local culture, whereas Dom and Bence are more inclined to think that the anti-colonialist project (which we all subscribe to) has entirely rid aesthetic and artistic universality of any plausibility. Despite these differences, we all believe that philosophical aesthetics doesn't, on the whole, take diversity seriously enough. We also believe that the question of universality cannot be settled a priori; we hope that our chapters provide starting points for another kind of debate. Understanding the diversity of aesthetic and artistic cultures as products of perceptual plasticity, pleasure in learning, and social cooperation points us to ideas about their significance for us as individuals and for our interactions with others. It's in the details of the kinds of accounts that each of us offers that we'll find the truth about the scope and limits of commonality and diversity. We're not saying this volume suffices. We hope to have the first word, not the last word. There's lots more work to be done, and we hope to show a path forward.

Index

For the benefit of digital users, indexed terms that span two pages (e.g., 52–53) may, on occasion, appear on only one of those pages.